THE MONSTER BOOK OF MANGA

BOYS

THE MONSTER BOOK OF MANGA

BOYS

Edited by Ikari Studio

COLLINS DESIGN
An Imprint of HarperCollinsPublishers

THE MONSTER BOOK OF MANGA: BOYS
Copyright © 2009 by COLLINS DESIGN and **maomao** publications

HarperCollins books may be purchased for educational, business, or sales promotional use.
For information, please write: Special Markets Department, HarperCollins*Publishers*,
10 East 53rd Street, New York, NY 10022.

First edition published by **maomao** publications in 2009
Via Laietana, 32, 4th fl, of. 92
08003 Barcelona, Spain
Tel.: +34 93 268 80 88
Fax: +34 93 317 42 08
mao@maomaopublications.com
www.maomaopublications.com

English language edition first published in 2009 by
Collins Design
An Imprint of HarperCollins*Publishers*
10 East 53rd Street
New York, NY 10022
Tel.: (212) 207-7000
Fax: (212) 207-7654
collinsdesign@harpercollins.com
www.harpercollins.com

Distributed throughout the world by:
HarperCollins*Publishers*
10 East 53rd Street
New York, NY 10022
Fax: (212) 207-7654

Publisher:
Paco Asensio

Editorial Coordination:
Anja Llorella Oriol

Ilustrations:
Daniel Vendrell, Santi Casas and Iban Coello

Texts:
Lorena Carvalho, Carol Ortiz, Santi Casas and Daniel Vendrell

Translation:
Francesc Zamora

Art Direction:
Emma Termes Parera

Layout:
Esperanza Escudero

Library of Congress Control Number: 2009930548

ISBN: 978-0-06-173298-0

Printed in Spain

First Printing, 2009

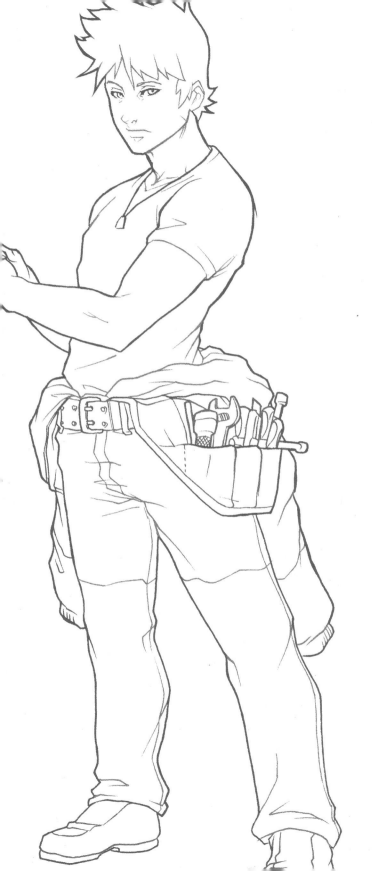

CONTENTS

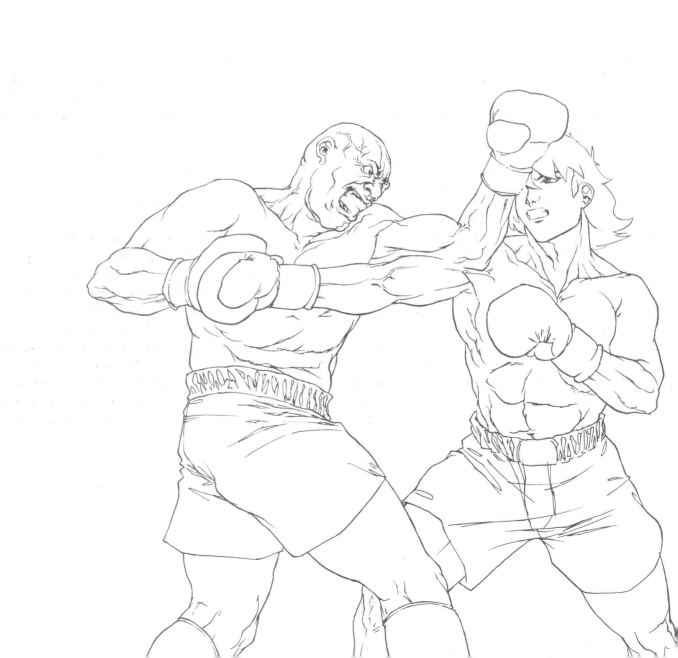

WHAT IS MANGA?

At this point, if you have a copy of this book, it is likely that you have a clear idea about why you prefer "manga" and "anime" rather than other forms of comic or non-Japanese animation productions. It is likely that you know the names of the most influential authors.

This introduction is the fifth that we have written for the collection *The Monster Book of Manga,* born from a concept much more didactic and that, progressively, has become a gigantic catalog of examples. Our intention is nothing but to encourage and inspire those who have felt passionate about manga and the necessity to forget about the world, putting all the effort in the epic battle against a white sheet of paper.

This time, however, we are looking towards something much more personal. Specifically, we shall focus on Ikari Studio's story, very similar to that of many of us who have grown up under the influence of Toriyama's adventures and humor and his *Dragon Ball.* We have followed the epic tales of Buronson and Hara, and the Hokuto No ken; we have felt the passion of Masami Kurumada's characters who teach us never to surrender before difficulty; and we have appreciated the sensuality and eroticism of hundreds of authors such as Hagiwara, Urashihara, U-Jin, Rin-Sin, and many more.

For each step we make, we keep feeling the strength of each of his stories. There are influences, trends, and tastes that expire. But what unites us to the majority of the "manga people" is not the fact that we draw large eyes on young girls with school uniforms way too short, or that we intensely enjoy action and violence. If anything really generates a feeling of unity and affinity that prevents these delicate generational bonds to break between readers of different times who have grown up with manga, it is without a doubt passion.

Male characters of manga are usually the main characters in most stories. The thought evolution of our species through the centuries decided that everything had to revolve around the human being. And there is manga breaking this rule, giving back to women their right to become protagonists. But the fundamental passion and the fanatic desire for improvement of manga's male protagonists are, without doubt, their greatest signs of identity, channeling that spirit which, we, as authors, try to inject into our stories so that with every frame, with every drawing, with every bullet, our readers have a passion for living, for not giving up, for believing in the impossible, for friends and strength.

And this is manga!

EVERYDAY

KODOMO

The *kodomo manga,* or manga for kids, is the introduction to manga reading for the Japanese public. In these manga the main characters are usually boys and girls about the same age as the readers. They tell the story of the everyday life of any child. But the routine is, on many occasions, transformed by a fantastic character. The rapid and diverse growth of children allows us to use different types of proportions when the time comes to draw these characters. In this exercise, we opt for a child about seven years old and for a pre-adolescent of about 12 so that we may see the differences in their builds.

1. Shape

We draw curves and foreshortened figures to emphasize movement. The adolescent is close to the eight-head proportion of an average adult.

We draw the youngest with a body proportion of about five heads.

2. Volume

The easiest way to draw the foreshortened figures is by reducing t he parts of the body we want to draw to simple volumes and start sketching from the farthest point of view, overlaying the volumes.

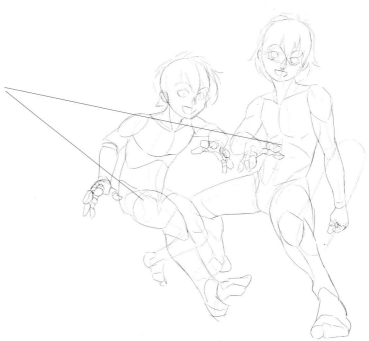

To better block out the build of the characters, we soften the lines of the drawing and turn volumes into muscles, except in the zones where the bone structure is obvious, for which we opt for sharper and more angular lines.

We opt for an urban and sporty look, drawing roller skates and a skateboard, very popular among tweens. To provide the clothes with movement and looseness, we use ample lines and curves.

The volumes must suggest the textures of the elements in the illustration. The skin is drawn with softer lines than those for the folds on the synthetic fabrics. We use softer forms for the natural objects and sharper for the synthetics.

Source of light

6. Color

As a visual reference, we can refer to fashion magazines and catalogs. For the bases, it is recommended not to use excessively saturated colors, although we want to achieve brighter tones.

To model the shadows by means of color, we follow the steps of the lighting section since it originates the color of the shadow. In this case, it is a tone slightly darker and more saturated than that on the base.

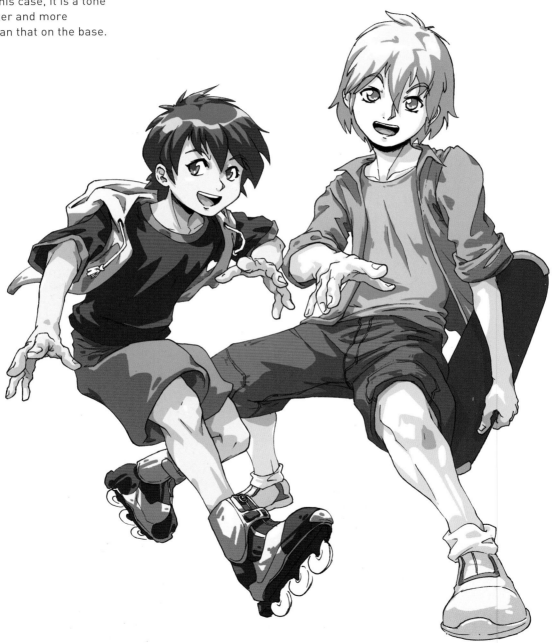

We add patterns of the clothes
and we adapt them to the shapes.
The tones complement the
volumes of the shadows with
darker colors and hues a little
more saturated.

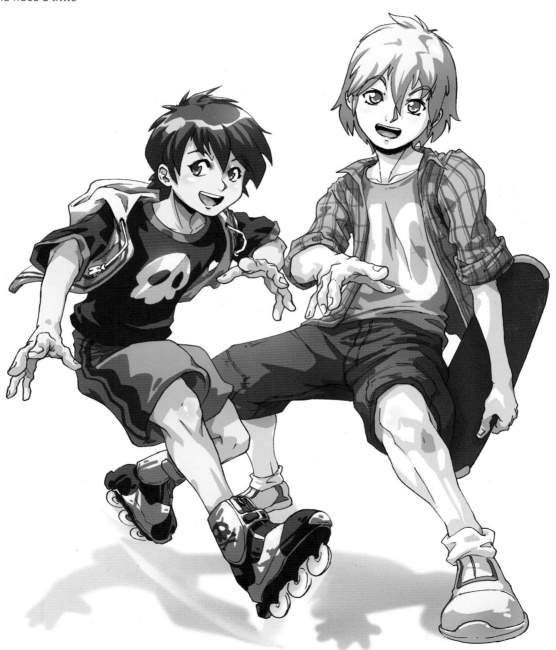

BISHONEN

The adolescent students are the prime protagonists in the *bishonen* genre. In this type of manga male characters are the center of attention in order to attract the interest of the female public, generally high-school girls. These manga stories show the power of adolescents, their vitality, and their love affairs. These are stories that feed on reality. And these youngsters' reality is what takes place at school and in their classrooms. The characters usually wear the typical Japanese school uniform and are the image of a regular student so to reach a maximum number of readers.

1. Shape

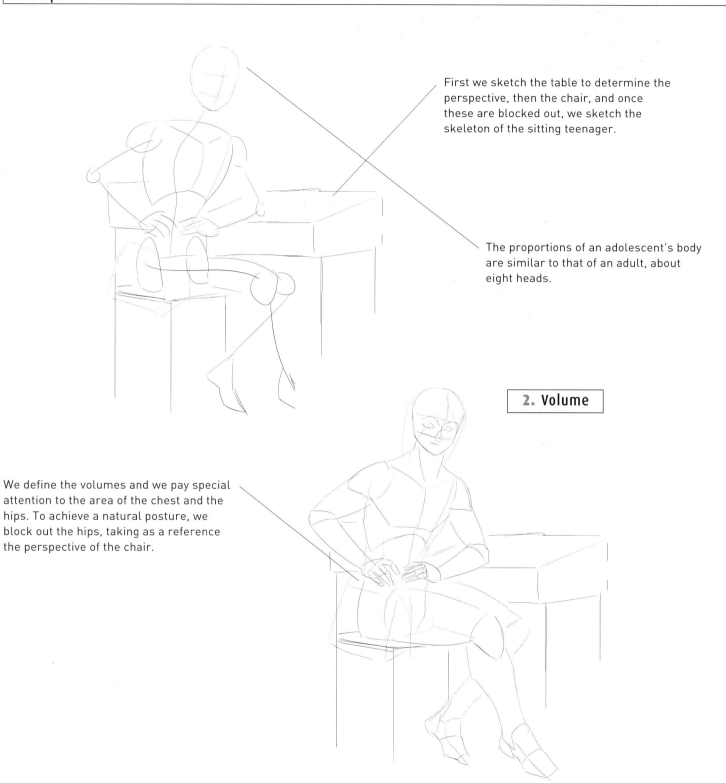

First we sketch the table to determine the perspective, then the chair, and once these are blocked out, we sketch the skeleton of the sitting teenager.

The proportions of an adolescent's body are similar to that of an adult, about eight heads.

2. Volume

We define the volumes and we pay special attention to the area of the chest and the hips. To achieve a natural posture, we block out the hips, taking as a reference the perspective of the chair.

The character slightly leans over, so the torso seems shorter. His body stars showing visible signs of adulthood, but we only subtly insinuate them, drawing a lean physique with long arms and legs.

4. Clothes

The *gakuran* is the Japanese school uniform. The cut is military style, with a long collar jacket and black trousers. But here we opt for a traditional cut suit and tie. We also draw the books.

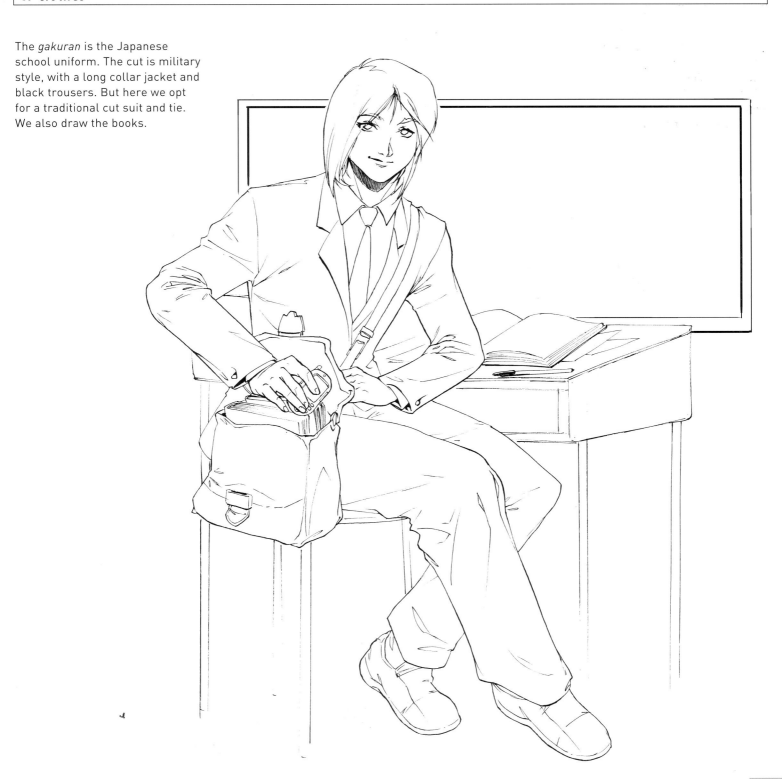

Source of light

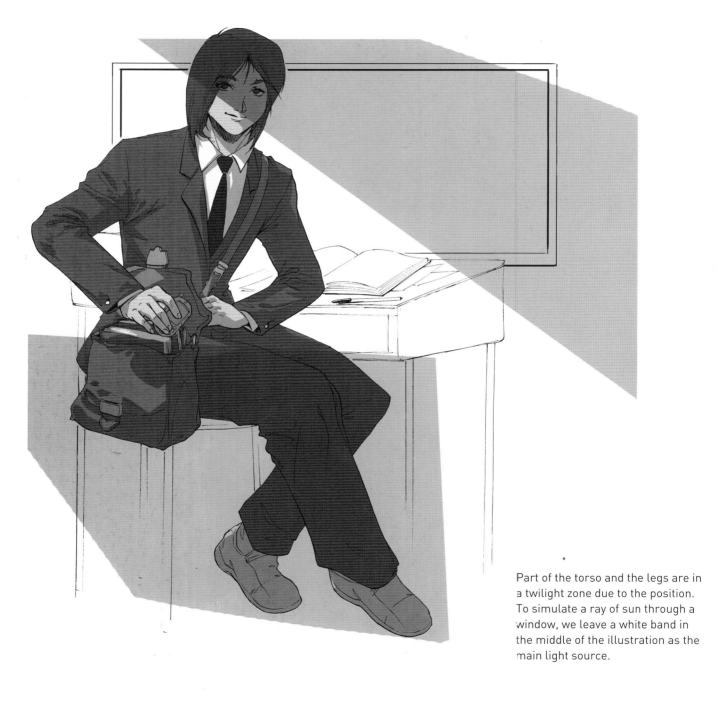

Part of the torso and the legs are in a twilight zone due to the position. To simulate a ray of sun through a window, we leave a white band in the middle of the illustration as the main light source.

6. Color

When rendering images in which one single color range predominates, it is important to play with contrast to emphasize some element in the image. In this case, the hair and the school bag.

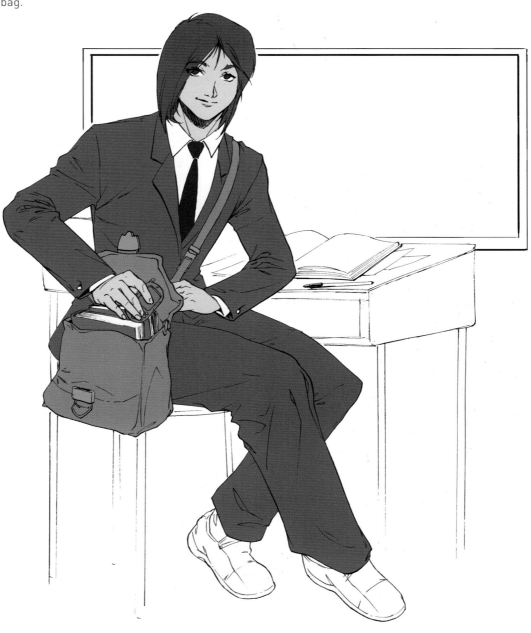

The application of the successive shadow tones has to be done following steps in the lighting sections, although we add details when applying a second tone of shadow to the clothes.

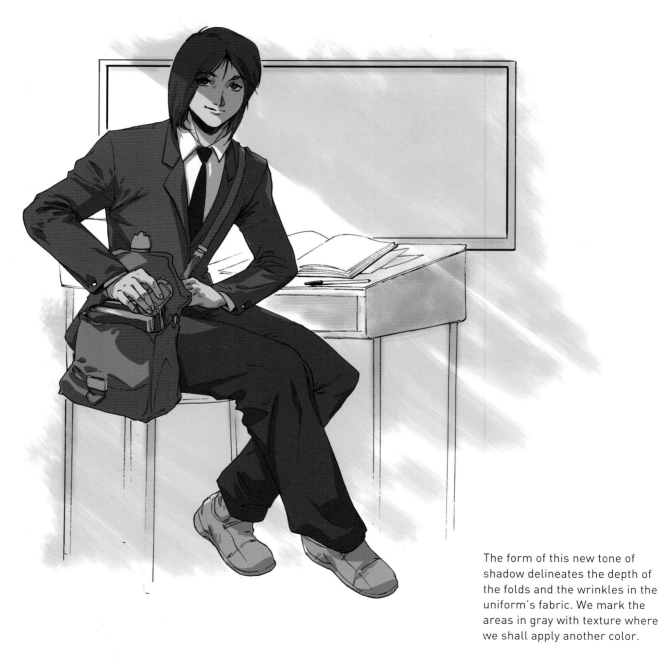

The form of this new tone of shadow delineates the depth of the folds and the wrinkles in the uniform's fabric. We mark the areas in gray with texture where we shall apply another color.

Even if we draw one single figure, the fact that we add shadows or objects such as the blackboard helps us locate the character in the space and add value to the drawing. A white stroke, not too contrasting, is a chalk line.

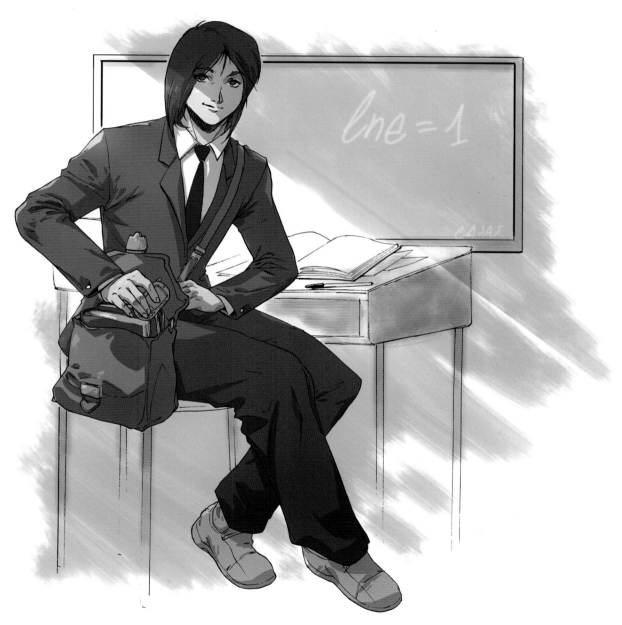

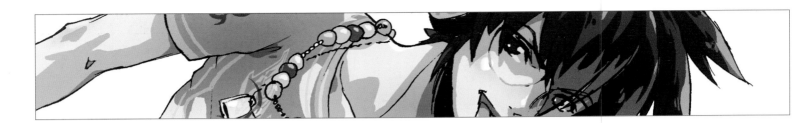

FASHION BOY

In modern Japan, like everywhere else in the world, many young people are fashionistos. There we can find many styles and trends, but at the end of the day, the goal is the same: to be considered very cool. These adolescents' obsession is image, and to achieve their objectives they spend large sums of money on clothes and accessories. Many are still students who invest an important part of their time and effort in creating a unique and modern image for themselves. Music and their idols are often the main aesthetic references that they follow. Normally, their attire is extravagant and eye-catching, mixing colors, elements, and trends.

1. Shape

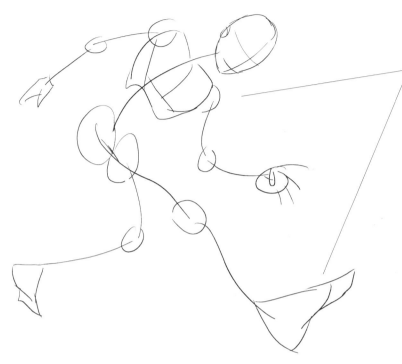

We decide for a similar pose to that in a fashion magazine. To achieve an informal and juvenile image we exaggerate the foreshortened figures and the poses. The greater the movement, the better.

2. Volume

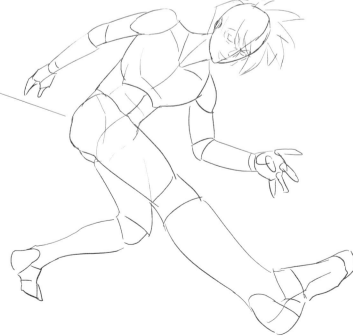

The biggest difficulty that we have with this type of pose is in the hidden areas behind the foreshortened parts; in this case, the hip.

We want to approach the ideals
of *bishonen* (pretty boy), the
Japanese aesthetic concept of the
ideal man. They are usually fairly
thin young men and not too
muscular, with fine features
and a feminine or androgynous
appearance.

The accessories require special
attention given that, in this case,
they differentiate and personalize
the character. We draw him with
modern headphones, as a nod to
the music world.

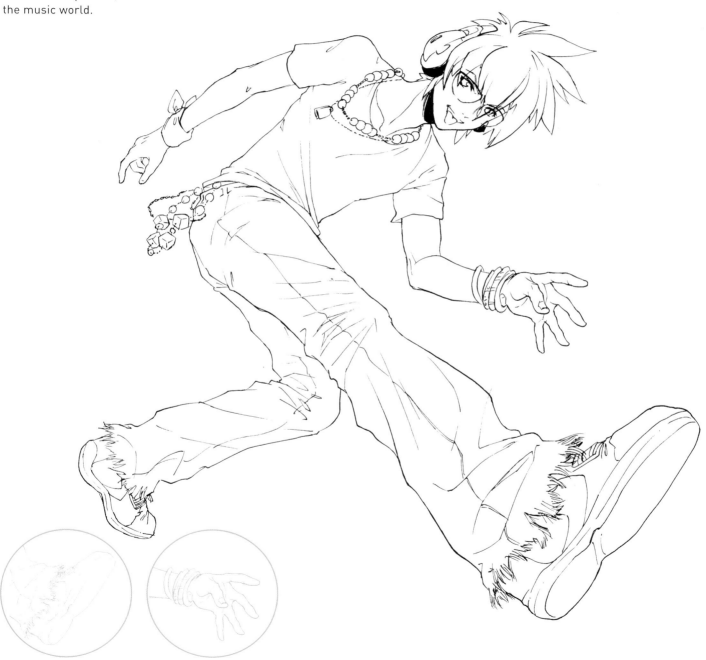

Source of light

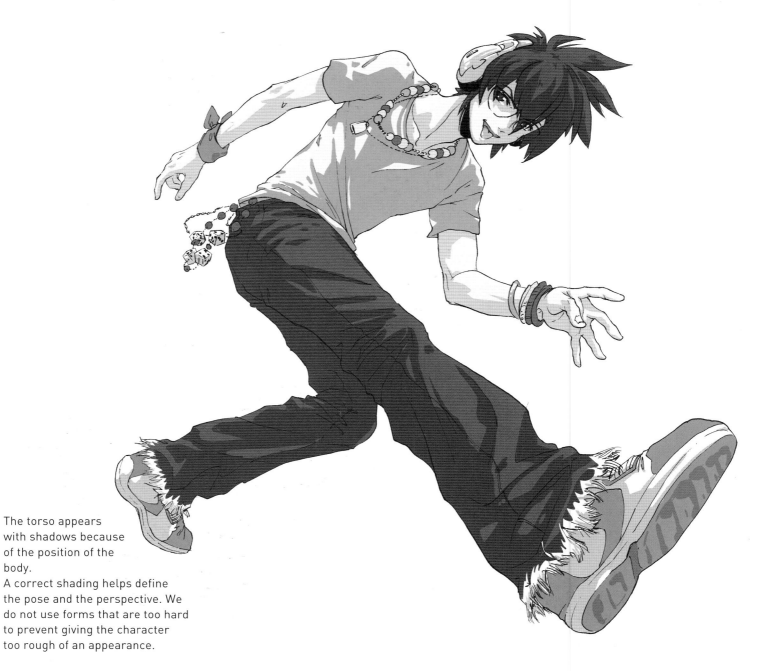

The torso appears
with shadows because
of the position of the
body.
A correct shading helps define
the pose and the perspective. We
do not use forms that are too hard
to prevent giving the character
too rough of an appearance.

To choose color, we research in fashion magazines although their styles are always in danger of becoming too quickly outdated. It is common to see radical changes in wardrobes when we watch styles change in the fashion world.

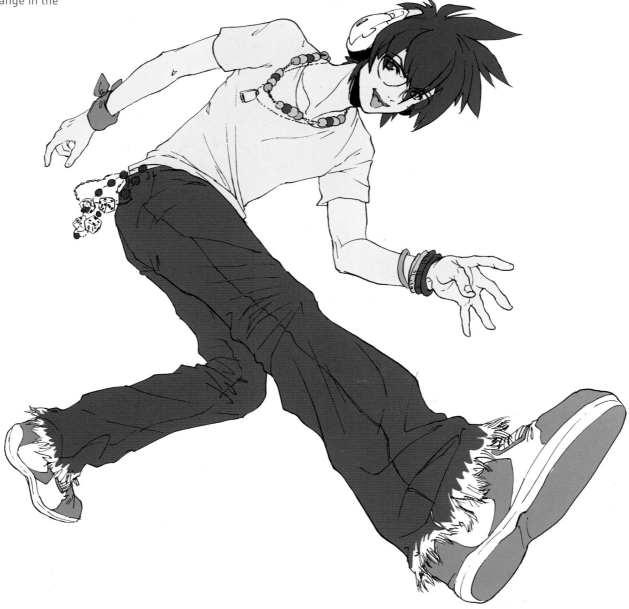

We use soft colors without overdoing it since we always see the high contrasts on the bright surfaces (earphones, hair, and jewelry). We add highlights to the skin to bring it out from the matte texture of the clothes.

The patterns follow the perspective of the surface they decorate. The foreshortened leg is shown a little exaggerated with the text printed on the pants. We add a yellow touch on the eyes to indicate the light going through the glasses.

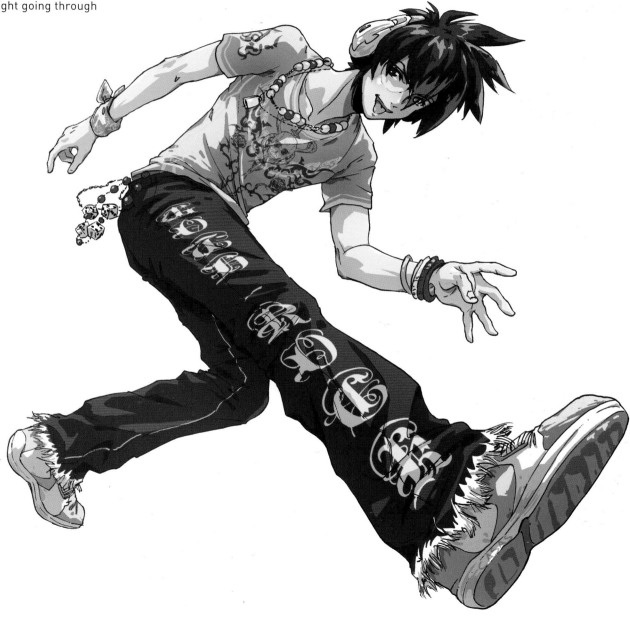

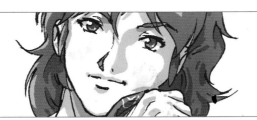

STRONG BOY

With this character, we practice the adult's physique. Our main character satisfies all the requirements for attractive and good-looking young men. Manga exploits the archetypes that readers find so easy to identify and establish a connection with. The characters who represent simple outlines of personality often facilitate the story, providing information about their character and their vital course by means of their physical aspect. The main character is a model of masculinity that gives the reader visual pleasure.

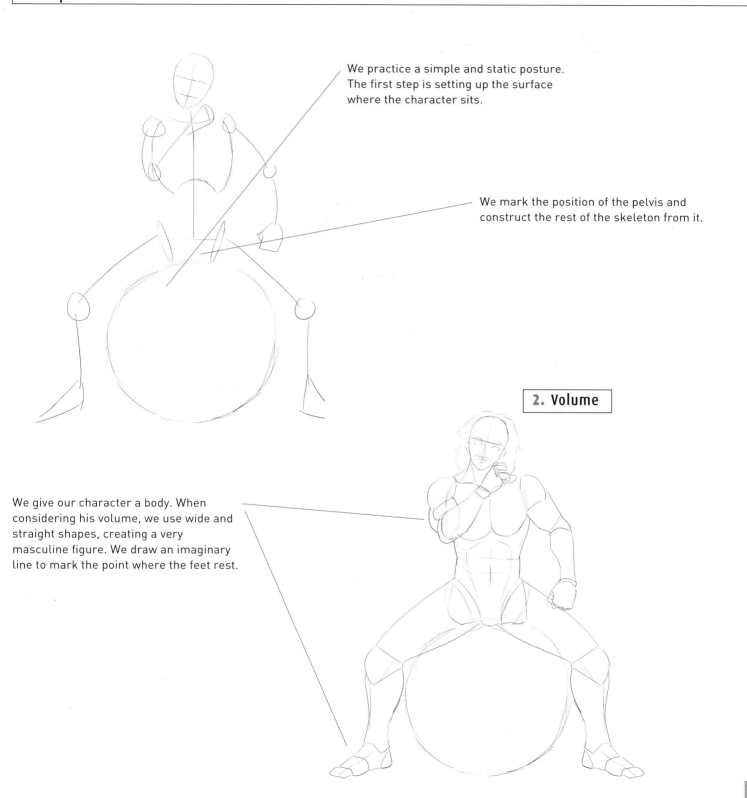

We practice a simple and static posture. The first step is setting up the surface where the character sits.

We mark the position of the pelvis and construct the rest of the skeleton from it.

2. Volume

We give our character a body. When considering his volume, we use wide and straight shapes, creating a very masculine figure. We draw an imaginary line to mark the point where the feet rest.

Anatomy is fundamental in this character. We delineate the body by drawing well-developed muscles, proportionate and pleasant to the eye, but with no exaggeration. The hand's position and the tilted head add to the attractiveness of this character.

4. Clothes

The clothes must reinforce the character's attributes. A very tight sleeveless shirt shows off his arms and chest. The lowered suspenders of his overalls is a "sexy" solution. The wheel indicates his profession.

The overhead lighting further emphasizes the attributes of the character. The light falls directly over the body, delineating the volume and defining more accurately his anatomy. The shadow on the ground creates the surface on which the wheel rests.

Source of light

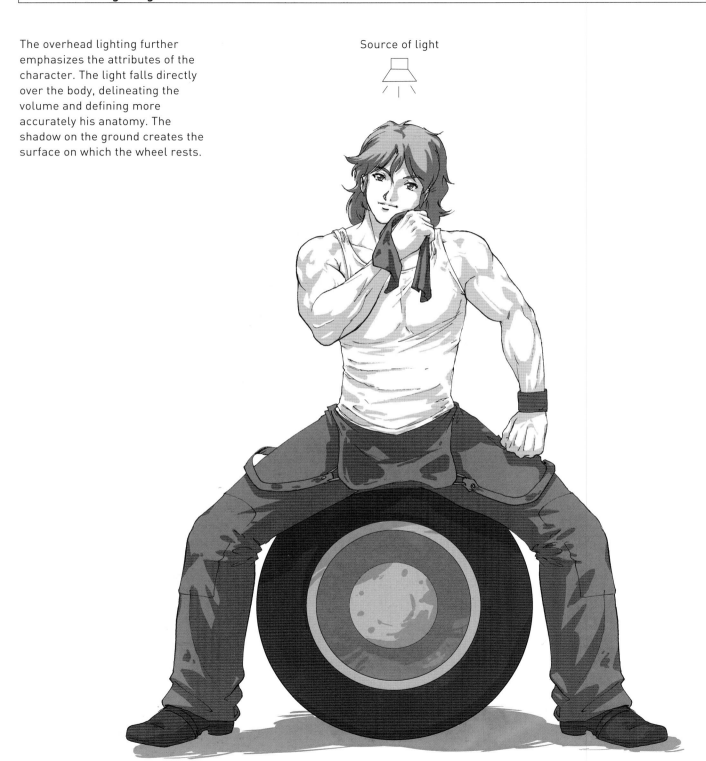

We apply a very traditional
color base. We choose blue that
references the typical jumpsuit
that mechanics wear and use
dark yellow for the hair to provide
the character with a childlike look
and a sweet expression.

The contrast of colors is more obvious in the shiny areas such as the hair, the boots, and the wheel's hubcap. The red handkerchief provides the illustration with a touch of color and attracts the reader's look to the character's face.

We apply successive shadow tones. We add a second tonality to the shadows on the clothes, especially on the folds in the pants, to better define the shapes in the denim fabric.

8. Finishing Touches

To provide the illustration with realism, we add textures.
We smudge our mechanic with black stains blended to look like motor grease. These stains must be adapted to the volumes and the wrinkles drawn previously.

SALARY MAN

This is the word that the Japanese use to designate a low-level executive. The English term is actually typically Japanese, and it is never used in the English language. In this exercise we draw the dream of most of these salary men: become a successful executive at 30. And this success is usually embodied in material goods, like a good sports car and elegant clothes. Many of them belong to generations who have grown up reading manga, and their reference of what it means to be a successful person is usually associated with their childhood heroes which, in many cases, were Hollywood stars.

We focus on the upper part, which is intended to suggest a relaxed and confident attitude. Our executive shows us his goods; in this case, his car. The posture of the protagonist brings out the nice clothes.

2. Volume

In spite of being a successful and athletic man, we have drawn a body with proportions that are rather stylized, as this is often used in manga to embellish the characters.

He is a man who plays sports, is concerned about his physique, and uses his strength to accentuate his charisma. Far from the stereotype of the *bishonen*, we use a form more masculine, more mature, and with angular facial features.

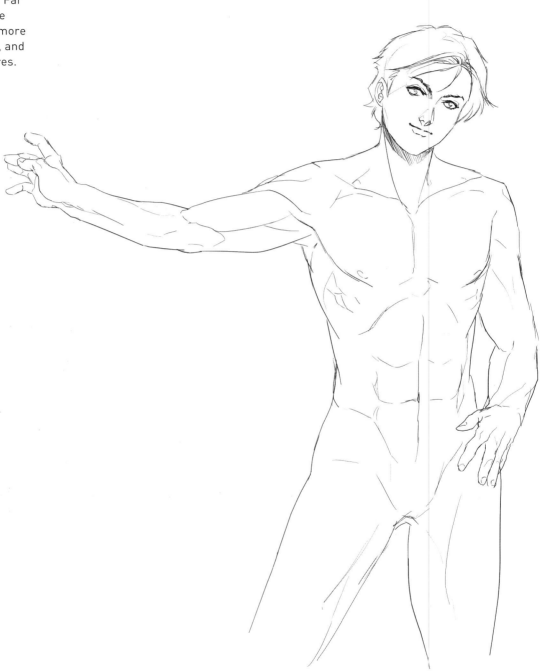

The executives usually wear elegant dark suits and ties, but we decide to show a more informal side of this type of character, unbuttoning his jacket, taking off his tie, and giving him a youthful-looking goatee.

Given that the illustration is set on the street and there is natural light (the sun), a difference in contrasts is established between the shaded zones and those that are well lit.

Source of light

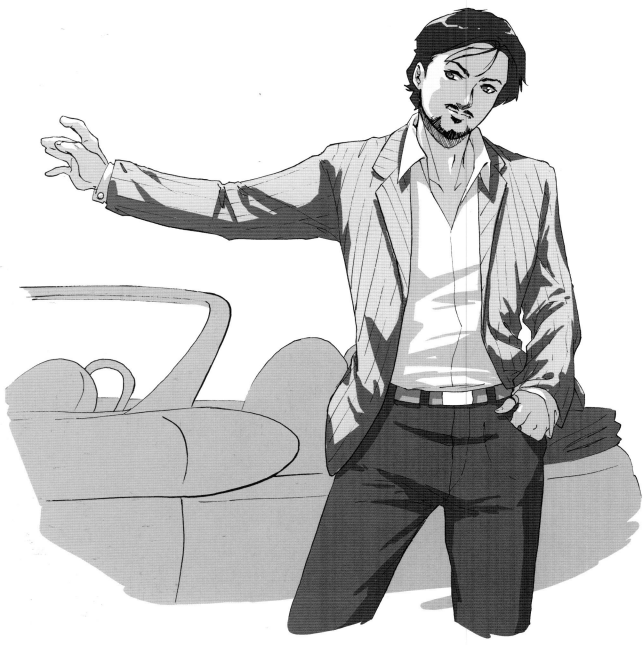

The predominant color in this image is gray, which is associated with independence, self sufficiency and self control. All of these are character traits of our protagonist. The white shirt gives him a more informal touch.

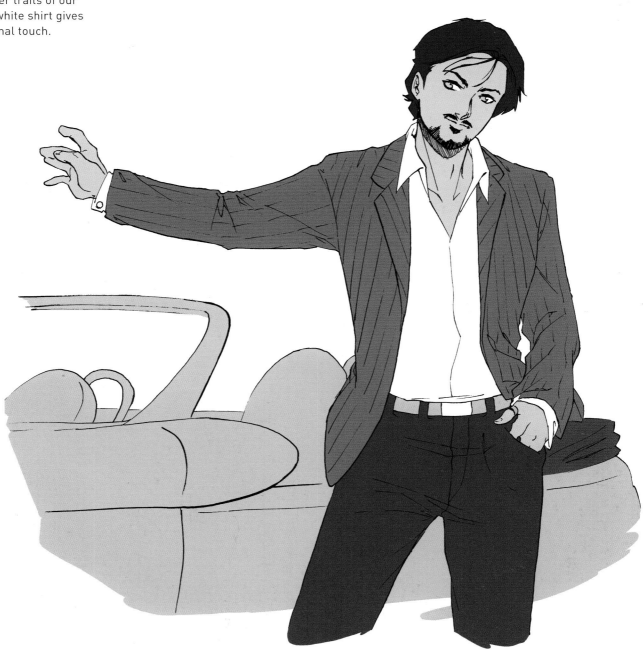

We use different gray tones
for the character. For the car,
a mix of blended grays, slightly
contrasting, and whites where the
light is reflected on the metal, are
used to represent the car's body.

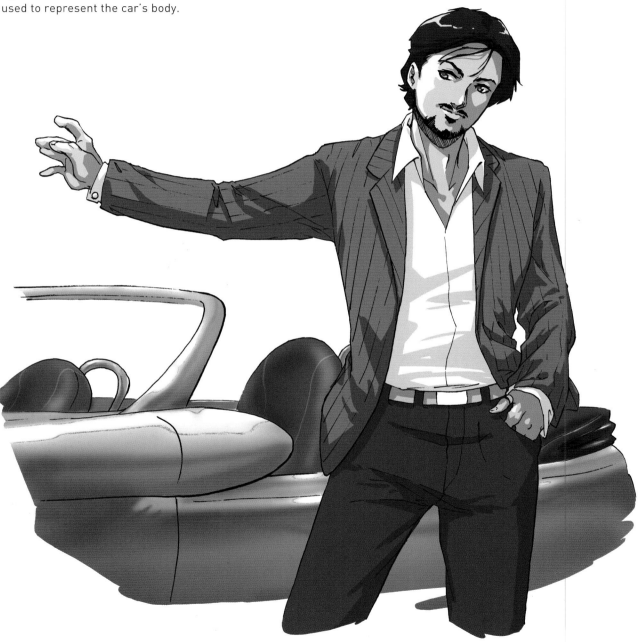

To provide the car with more realism, we add highlights and contrast the grays to achieve a metallic effect. We use a third lighter tone to increase the intensity of lighting over the character and the volume on his clothes.

GRANDFATHER

Old people are wise in manga. Time has given them experi-
ence, which after years has resulted in good judgment and an
important dose of patience. The fragile figure of an old person
is also often used as counterpoint to the typical young hero,
irresponsible and impetuous, like a villain perhaps, since he
could have accumulated years of misfortune, deception,
resentment, and hate. Consequently, he gives much to play
with, and becomes a good incentive for any story. We have
opted to show an innocent old man sitting peacefully on a
bench next to his version of super-deformed, which shows his
mischievous side.

1. Shape

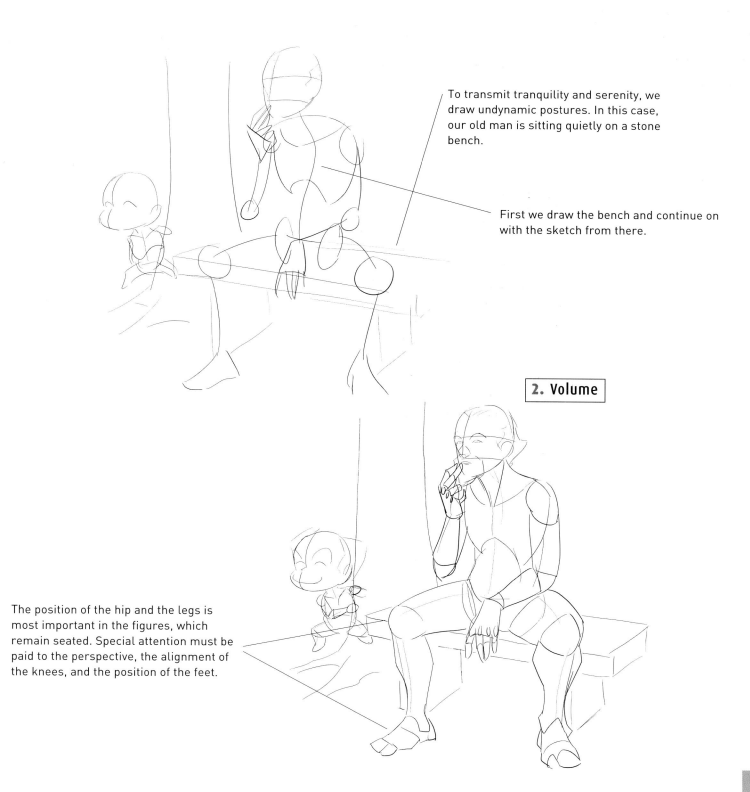

To transmit tranquility and serenity, we draw undynamic postures. In this case, our old man is sitting quietly on a stone bench.

First we draw the bench and continue on with the sketch from there.

2. Volume

The position of the hip and the legs is most important in the figures, which remain seated. Special attention must be paid to the perspective, the alignment of the knees, and the position of the feet.

The key points to draw an old man
are the curve in his back and the
pronounced wrinkles. We reduce
the size of the eyes and increase
the volume of the nose and the ears.

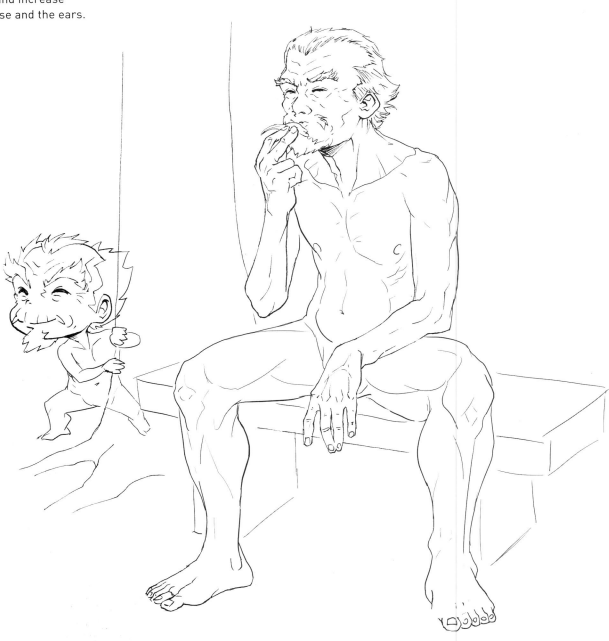

To give the character a touch of age, we can opt for traditional or out-of-style clothes; if not, we can use old worn-out vestments, depending on the personality we want the old man to adopt.

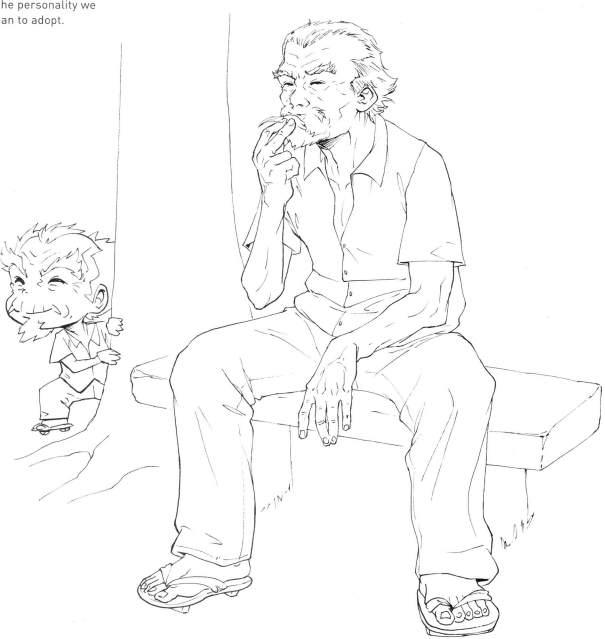

Once again, we use lighting to define the materials and the textures. The shadows applied softly on the clothes transmit fluidity and lightness to the fabric. For the clothes to look matte, we add very little contrast.

Source of light

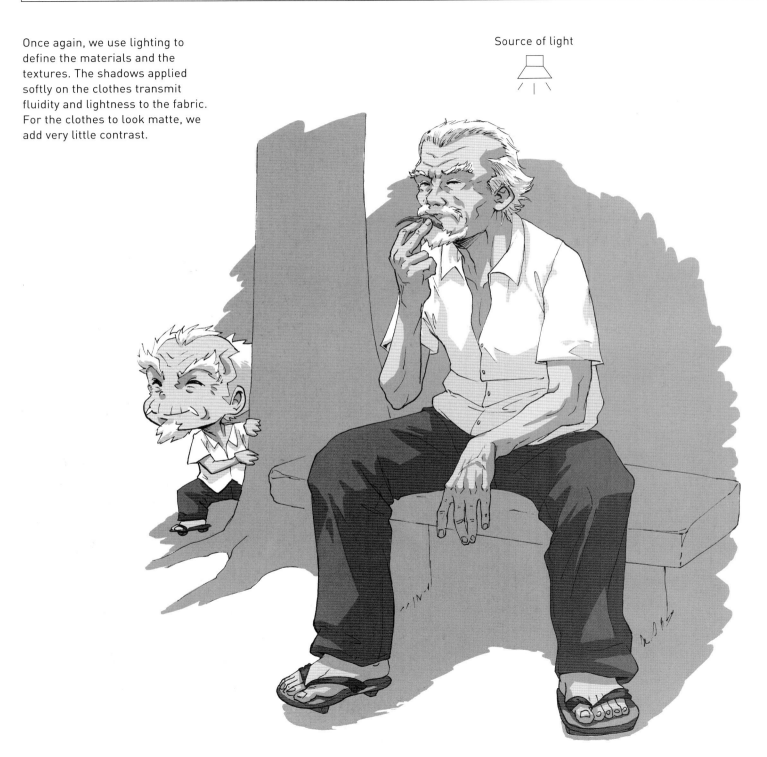

Old people usually have light or very pale skin, but in spite of this, we opt for a healthier skin tone to provide the illustration with a summery air. We choose a warm green for the background vegetation.

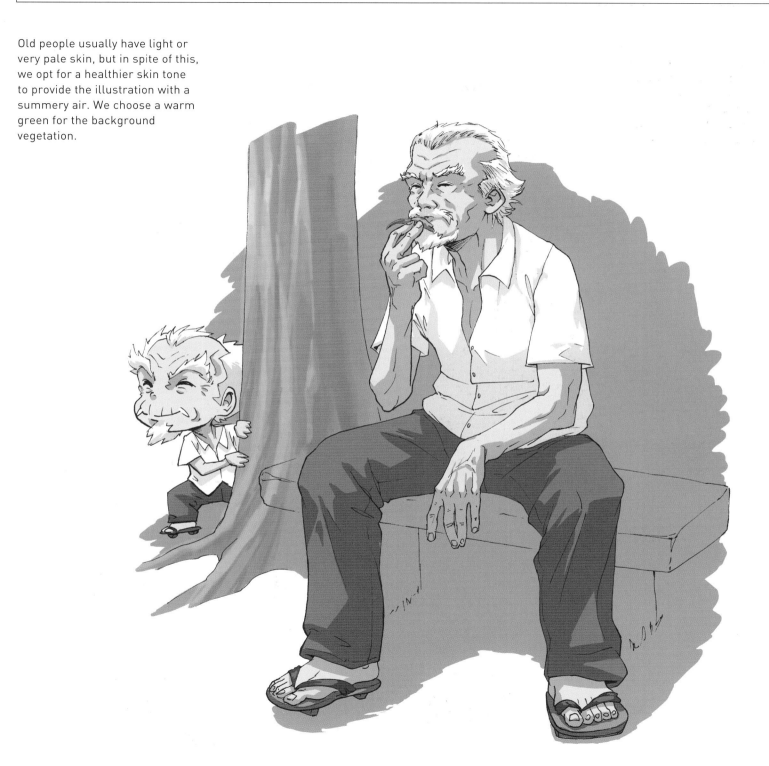

Using different tonalities of green and brown, we give form to the plants in the background and to the torso. Also, we draw the stone bench and we add vertical lines to provide the trousers with an old-fashioned touch.

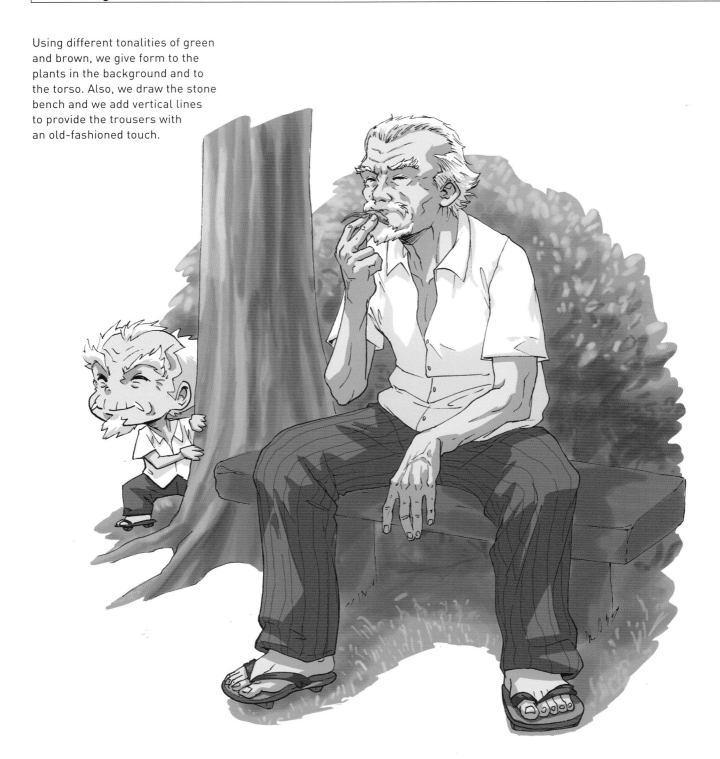

The tones of the clothes are simple and sober. To finalize, we draw the shadow of our character and that of the bench projected on the ground, which helps reinforce the depth in the drawing.

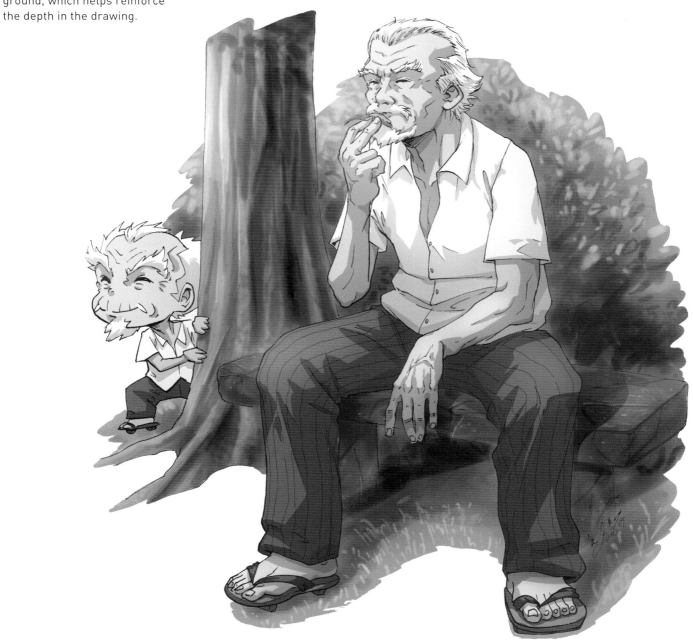

FASHION

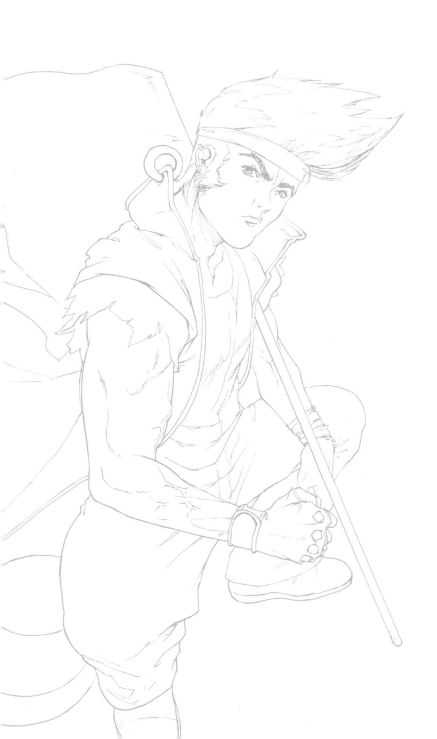

OTAKU

In the West the word *otaku* is used to define those people passionate about manga. However, in Japanese, *otaku* is a person who dedicates all his time and money to his pastime. They are introverted people who live uniquely for a special interest, such as manga, anime, video games or cosplay. In Japanese, it is a derogatory term. Among all *otaku*, the better known are the *akibakei*. This name is from the Tokyo neighborhood of Akihabara, where many specialized stores run by *otaku* obsessed with the anime and the video games are located.

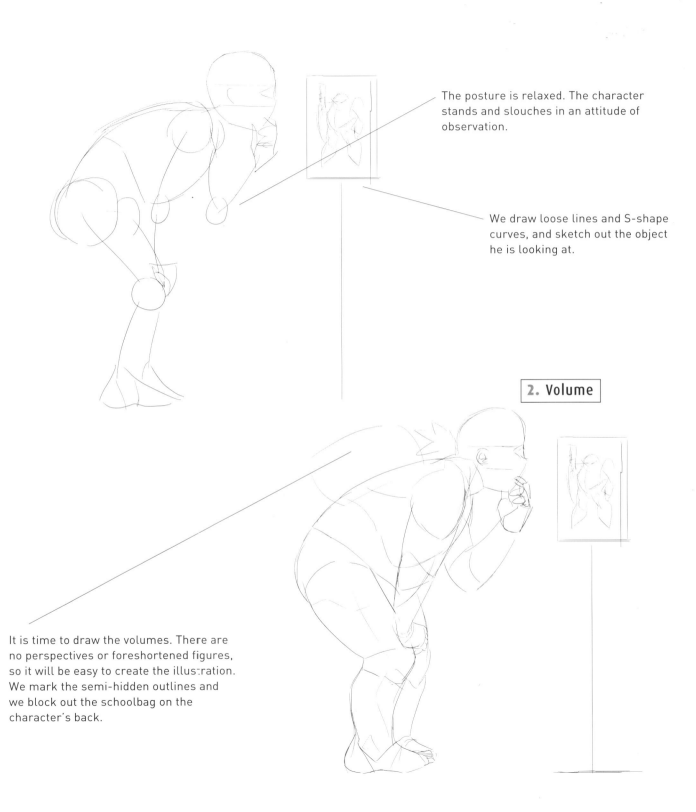

1. Shape

The posture is relaxed. The character stands and slouches in an attitude of observation.

We draw loose lines and S-shape curves, and sketch out the object he is looking at.

2. Volume

It is time to draw the volumes. There are no perspectives or foreshortened figures, so it will be easy to create the illustration. We mark the semi-hidden outlines and we block out the schoolbag on the character's back.

The body of the *otaku* is not athletic. It is not a subculture much connected to sports and physical activity, so we opt for a natural body, voluminous and round. His expression is rather childlike.

His clothes are simple and comfortable, indicating little interest in fashion. The backpack allows him to carry his new acquisitions. When drawing him observing a replica of a *mecha*, we further develop the *otaku*.

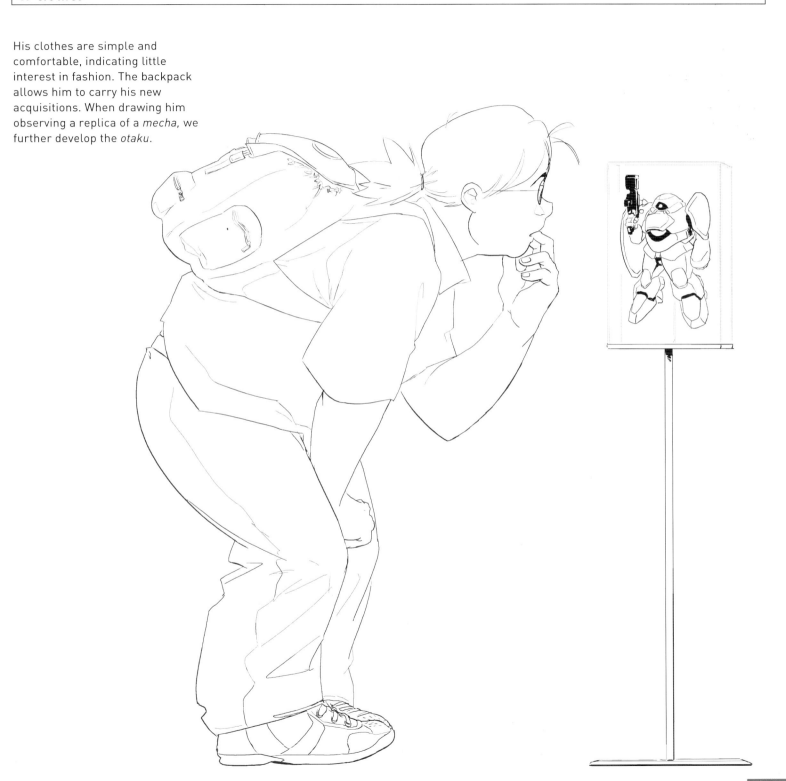

Source of light

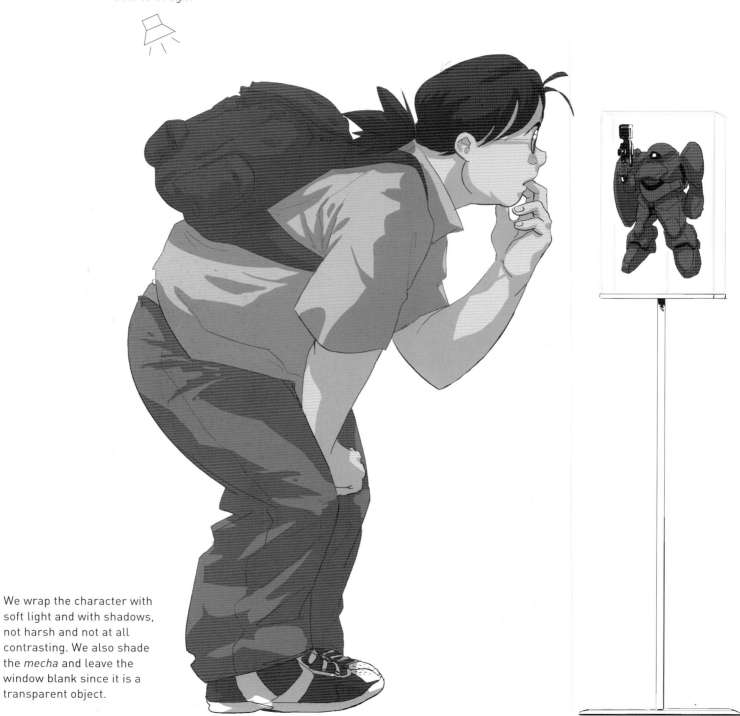

We wrap the character with soft light and with shadows, not harsh and not at all contrasting. We also shade the *mecha* and leave the window blank since it is a transparent object.

The colors of the clothes are not bright but rather subdued, not at all modern. To achieve the effect of the transparency of the window, we use a light blue for the glass and paint the line with a darker blue.

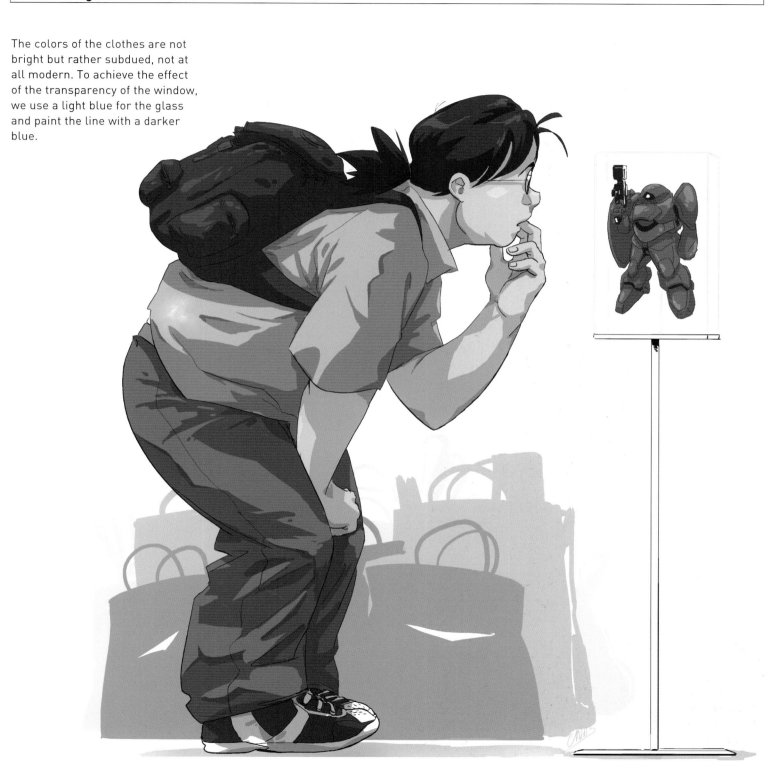

VISUAL KEI

Visual kei refers to a movement of marked aesthetic personality. The origins go back to the late eighties and early nineties. From a musical point of view, the references go from rock to heavy metal and punk. Contrary to the conservative aesthetic in classical Japan, he flees from it and searches for something more radical and extreme, somewhere between sinister and extremely attractive. It is not surprising to find very ambiguous and androgynous examples of *visual kei*, young men who adopt an image similar to that of a woman. Groups such as *Dir en Grey* are an example of this type.

1. Shape

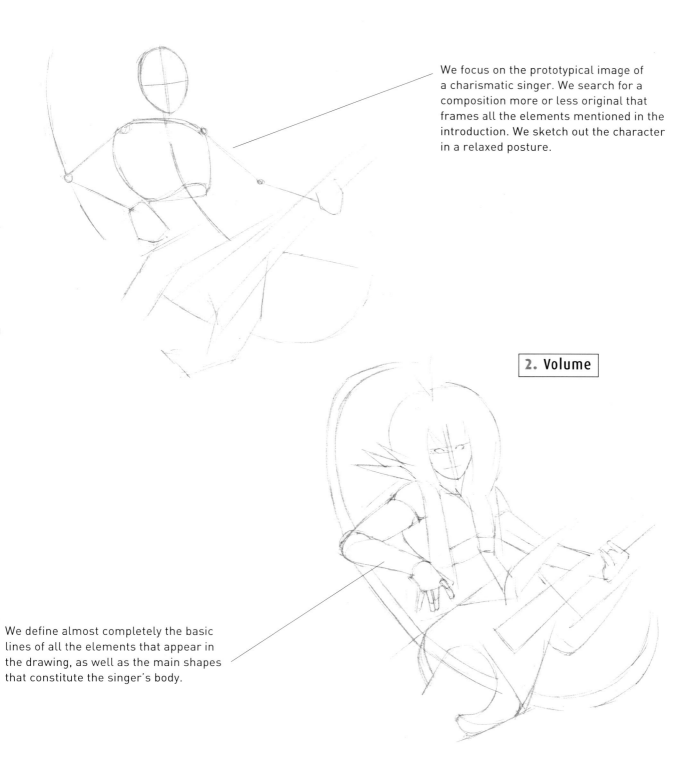

We focus on the prototypical image of a charismatic singer. We search for a composition more or less original that frames all the elements mentioned in the introduction. We sketch out the character in a relaxed posture.

2. Volume

We define almost completely the basic lines of all the elements that appear in the drawing, as well as the main shapes that constitute the singer's body.

In spite of the fact that we will give the character an androgynous aspect once we start rendering the image, his build is the standard of any young man in his late teens. His face, although masculine, has fine traits. His hands are very expressive.

This is perhaps the most relevant element of this illustration and includes everything from his hairstyle to *visual kei's* characteristic guitar. We add rings, feathers and piercings. We also define the chain that frames the illustration.

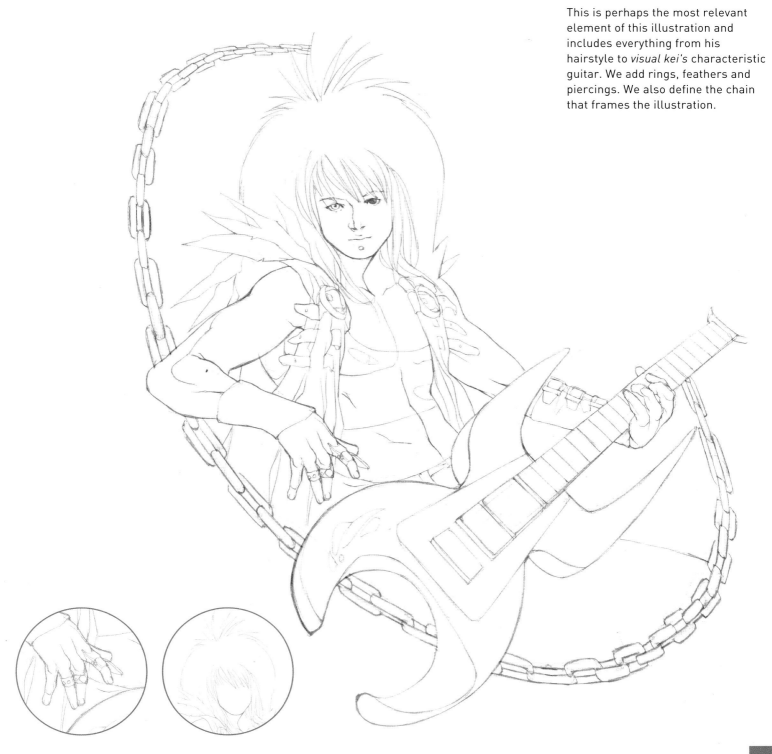

Source of light

Source of light

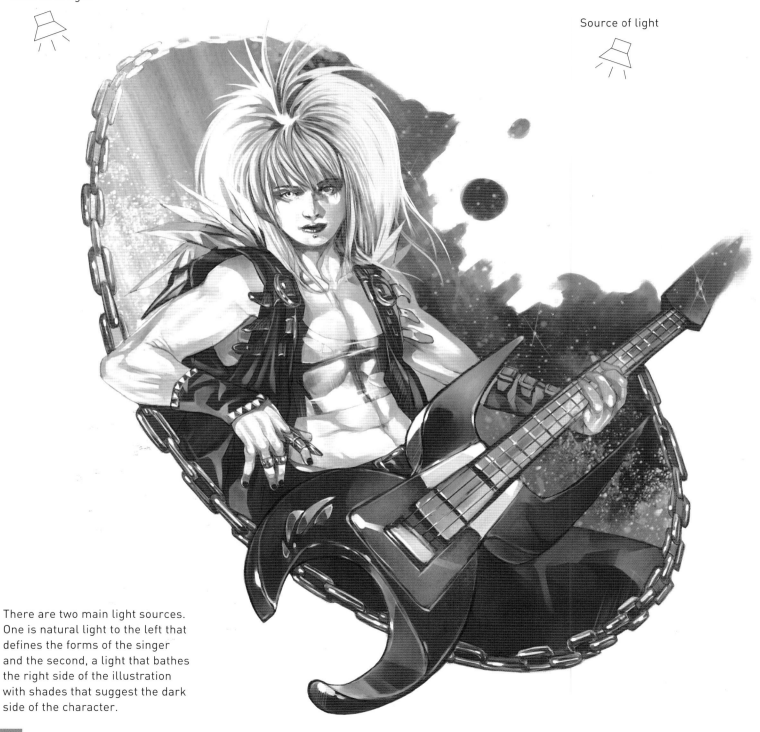

There are two main light sources. One is natural light to the left that defines the forms of the singer and the second, a light that bathes the right side of the illustration with shades that suggest the dark side of the character.

We opt for an almost monochromatic palette, with pale tones for the skin and dark colors for the clothes and the guitar. To show this contrast we use a fading effect that goes from warm colors associated with fire to blue purples.

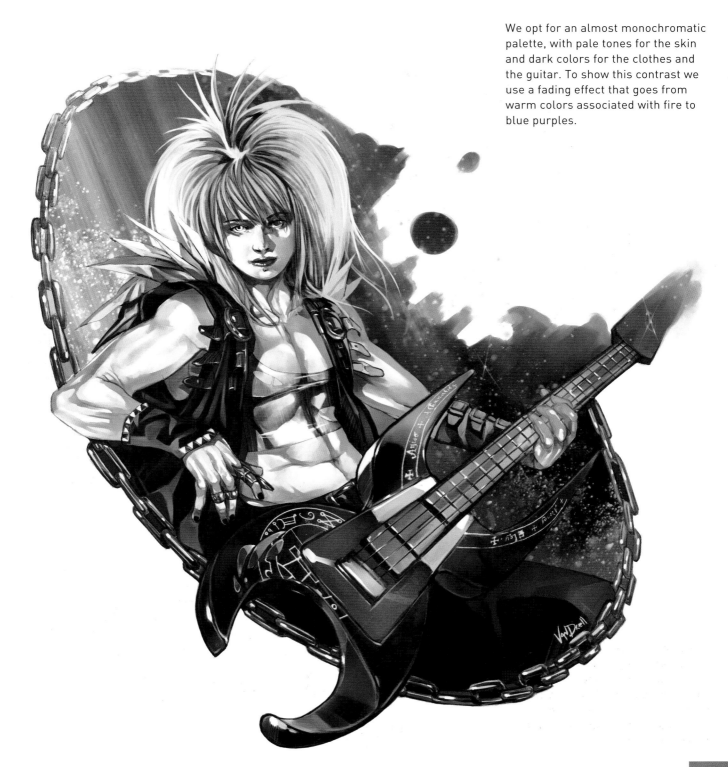

BOSOZOKU

The *bosozoku* are one of the most feared urban tribes in Japan, together with the *yakuza*. They are illegal motorized gangs feared even by the police. They usually wear *gakuran* (Japanese school uniforms) combined with American style and trend accessories, but always retain the retro and nostalgic touch that characterize them. In Japan there are various rock music groups, such as Kishidan, who try to emulate the typical stereotypes of this kind of music. They also appear in manga with violent content, which are often censored in some countries.

1. Shape

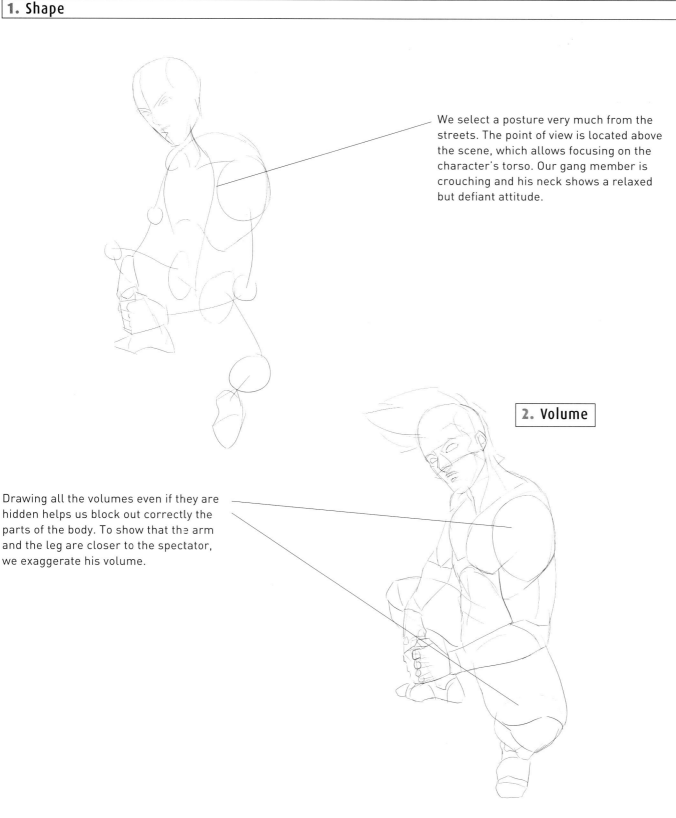

We select a posture very much from the streets. The point of view is located above the scene, which allows focusing on the character's torso. Our gang member is crouching and his neck shows a relaxed but defiant attitude.

2. Volume

Drawing all the volumes even if they are hidden helps us block out correctly the parts of the body. To show that the arm and the leg are closer to the spectator, we exaggerate his volume.

We draw masculine features and oriental traits. We personalize our character with a defiant expression in his eyes, which will be the central element that gives the character what we are looking for in our illustration.

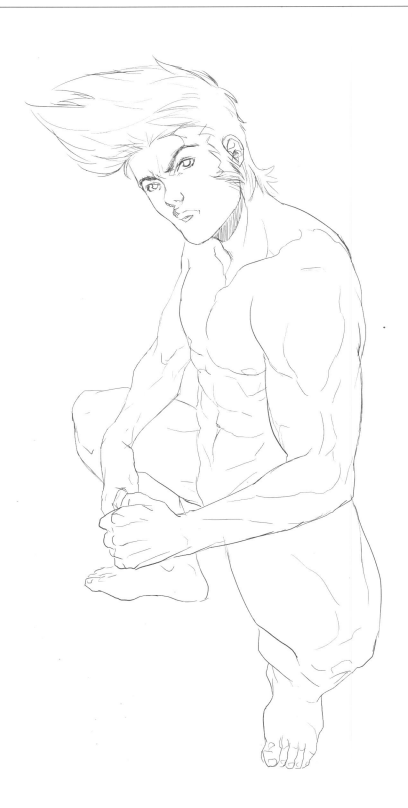

We give a nostalgic touch to the character, drawing a band around his head and a wristband as a nod to the eighties aesthetics. We also add an earring, ripped sleeves, and one single glove on the hand of the arm that the character maintains in tension.

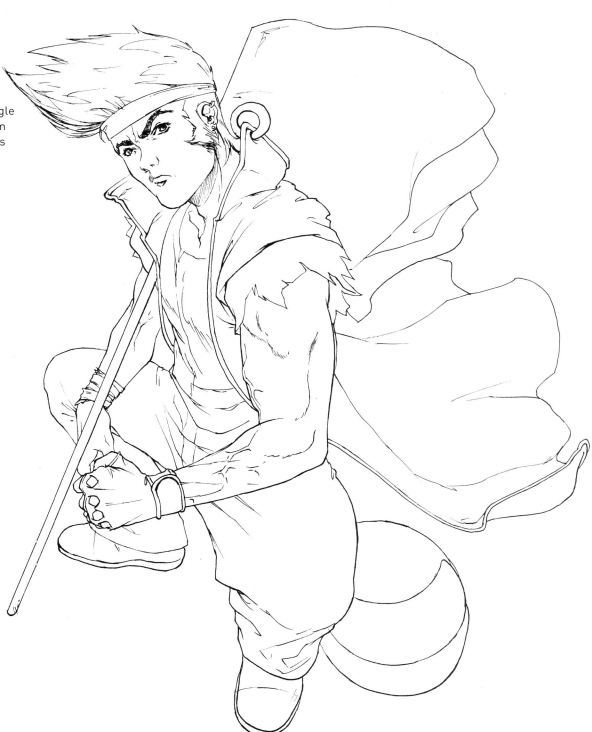

Since we are not applying highlights to the hair, we make sure it does not look natural, healthy, and taken care of, but rather hair damaged by the dye and the hairstyles common among this type of person.

Source of light

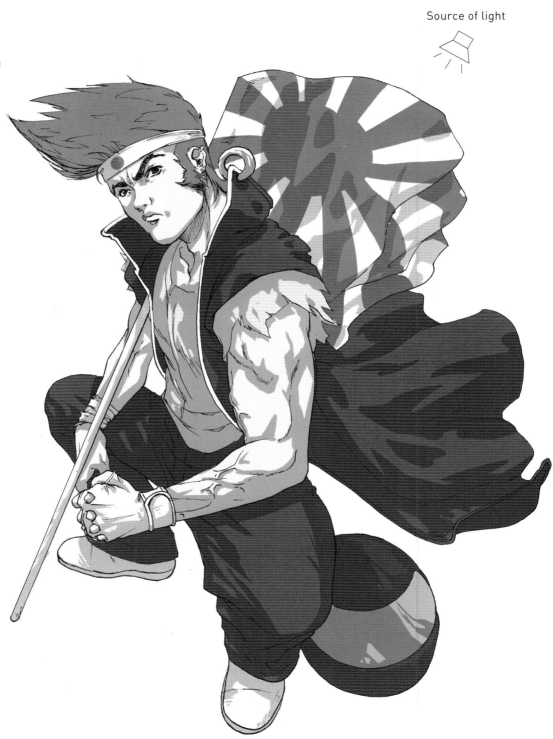

By picking a color in the brown range for the T-shirt, we achieve an effect of worn fabric. So that the character has a more aggressive touch, we draw the hair in a red color with some green-colored ends.

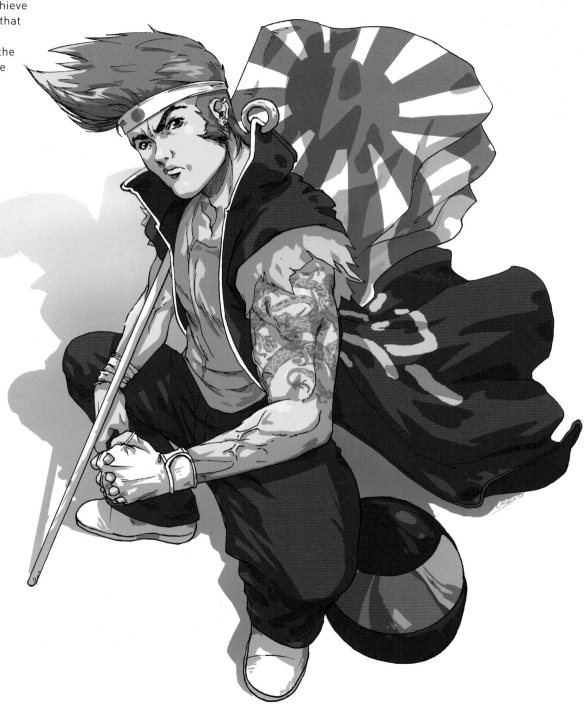

SURFER

There is evidence that surfing has existed for more than 500 years, in the Polynesian Islands. Surfers generally wear brightly colored clothes with Hawaiian prints. In Manga, the surfer stereotype has been as popular as in western pop culture, and has become synonymous with attractive and adventurous young men. The manga that are targeted at young adolescents are those that most often use this type of character for obvious reasons. We shall leave the *cool* aura and the surfer "attitude" behind, and we will develop an illustration that focuses on the athletic side of the character.

We block out the character in a position with a lot of movement. It is a dynamic posture, so the lines must be curved and loose to achieve a natural flow of the body on the surfboard.

2. Volume

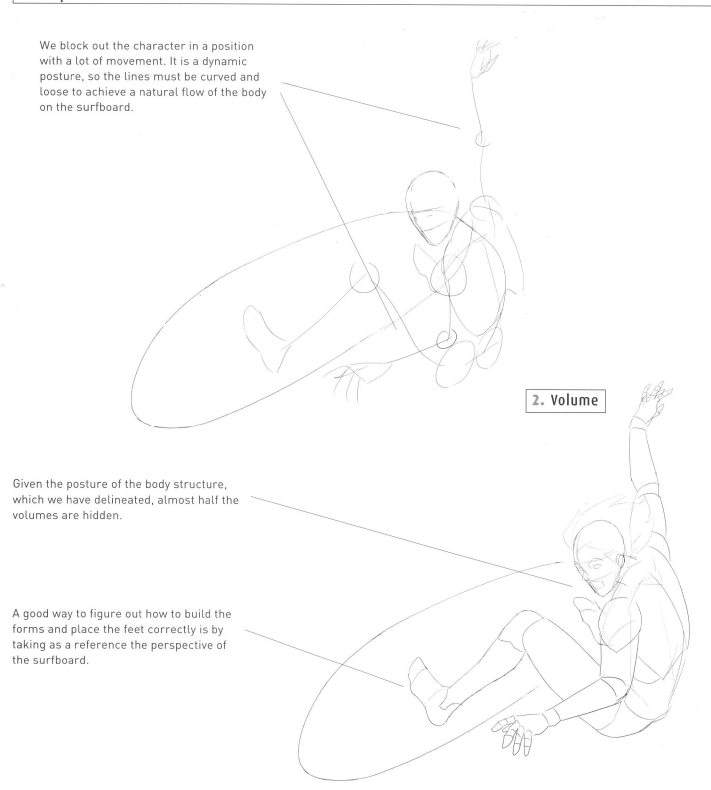

Given the posture of the body structure, which we have delineated, almost half the volumes are hidden.

A good way to figure out how to build the forms and place the feet correctly is by taking as a reference the perspective of the surfboard.

The bodies of the surfers are often quite voluminous and muscular. However, we opt for a young man with an athletic physique but fairly average build. We characterize him with the typical long hair waving in the wind.

Instead of dressing up the
character with a full neoprene
suit, we opt for a half body one.
For the lower part, we choose a
comfortable and baggy swimsuit
that goes halfway down his legs.
We also draw a wristband.

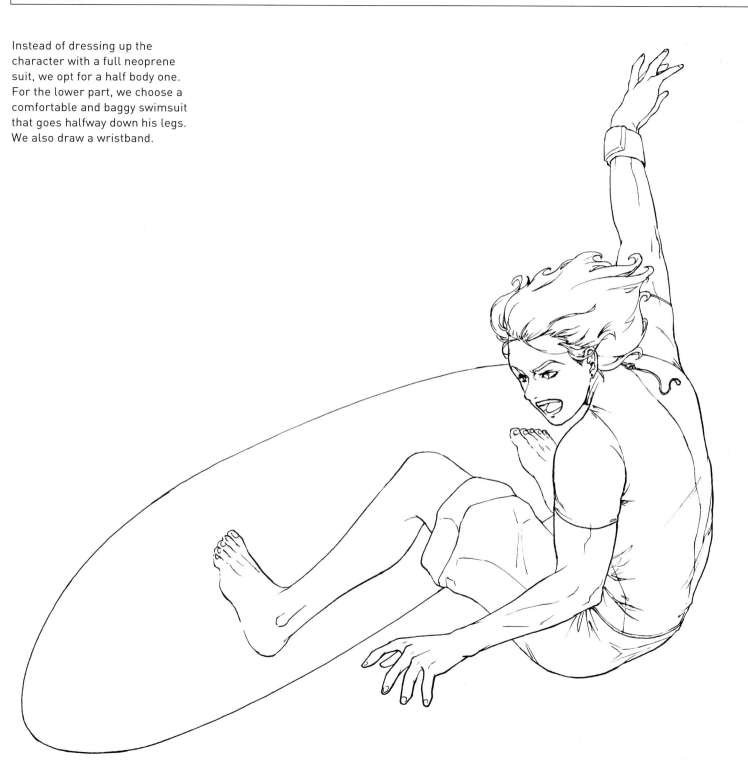

The shadow over the surfboard is the only element that gives volume to this object. In this illustration, the light comes from the left, so we shade the entire back of the character.

Source of light

We decorate the surfboard, the neoprene garment, and the swimsuit with tribal and marine motifs. Colors must be very bright and contrasting. We apply highlights on the hair and on the skin due to the sun's light reflection.

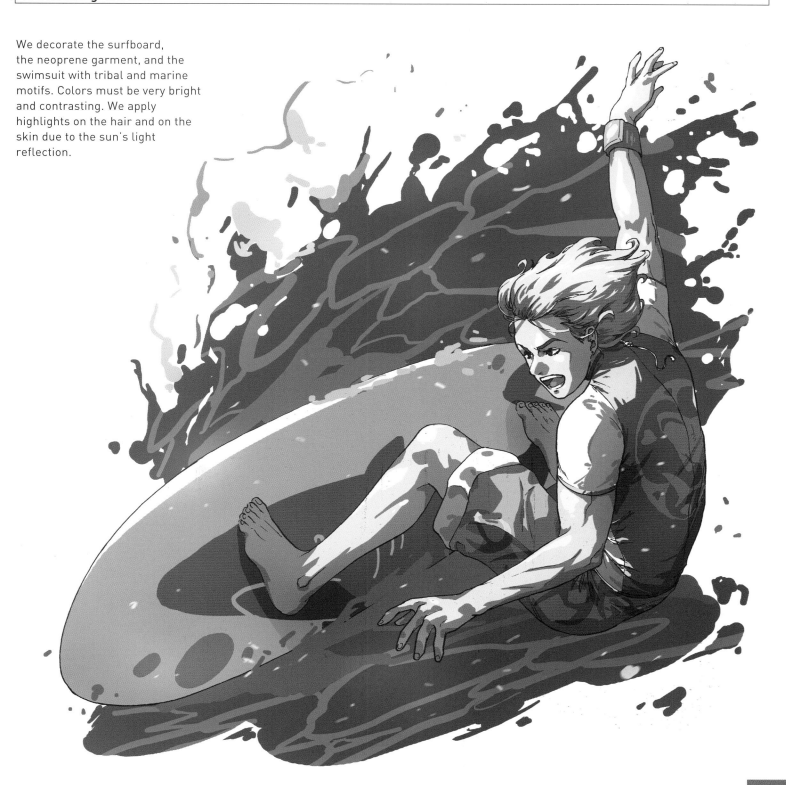

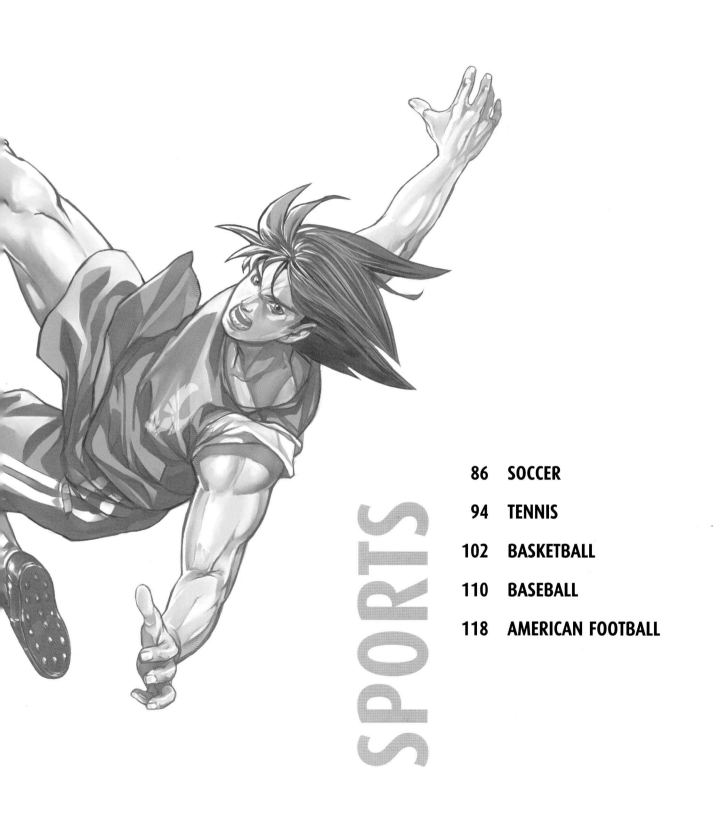

SPORTS

SOCCER

Soccer is the most popular sport in Europe, and its popularity is increasing every day throughout the rest of the world. Generally in manga the main character is the team captain, a key player. This character is not only an exceptional soccer player, but also a natural born leader with charisma. Similar to other sports adapted to manga, in soccer the "super hits" take on a dramatic importance. In this genre an antagonistic character generating a rivalry is also essential. The clearest soccer themed manga is *Captain Tsubasa*.

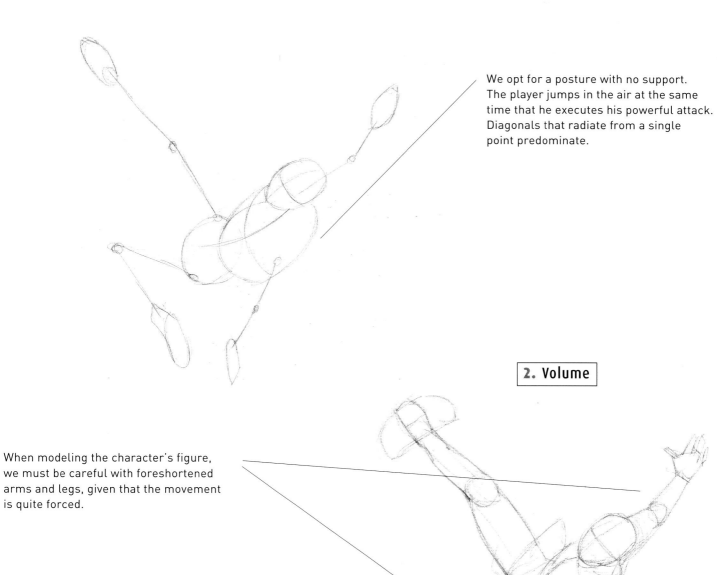

We opt for a posture with no support.
The player jumps in the air at the same
time that he executes his powerful attack.
Diagonals that radiate from a single
point predominate.

2. Volume

When modeling the character's figure,
we must be careful with foreshortened
arms and legs, given that the movement
is quite forced.

The constitution is muscular but his body is stylized. We focus on the muscles in the legs, which are his tools of the trade. His expression is harsh and aggressive.

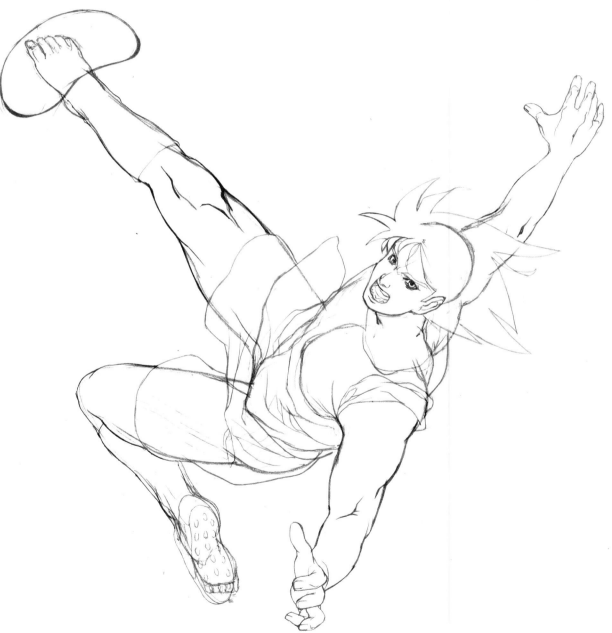

We take as reference the official outfit of a team. It can be complemented with an emblem such as the captain's armband. And don't forget the knee socks, very characteristic of the soccer player's uniform.

The light comes from the upper part of the illustration since the soccer ball is the center of attention. We imagine that the ball is a lantern that casts its light over the character and so we know where to place the lights.

Source of light

We work with two main tones: pink for the skin and light gray for the uniform, which will actually become highlights when we apply the shadows. Also, we hint at the shadows and the mid tones with a stiff brush.

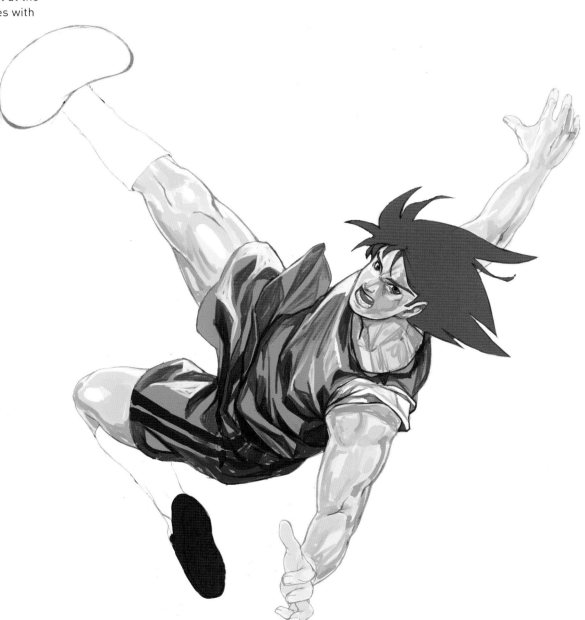

In this phase we complete the mid tones. We blur them and mix them to create the volumes. We include a few more shadows and some white highlights so the figure stands out from the paper.

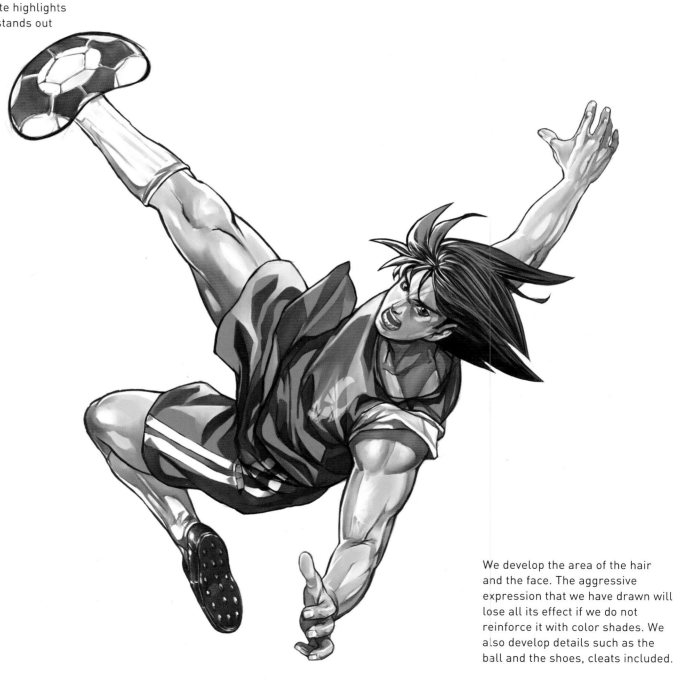

We develop the area of the hair and the face. The aggressive expression that we have drawn will lose all its effect if we do not reinforce it with color shades. We also develop details such as the ball and the shoes, cleats included.

We draw the flames that the ball emits like splashes done in India ink or digitally. These accentuate the feeling of movement. The aggressiveness of the illustration requires reds and blacks.

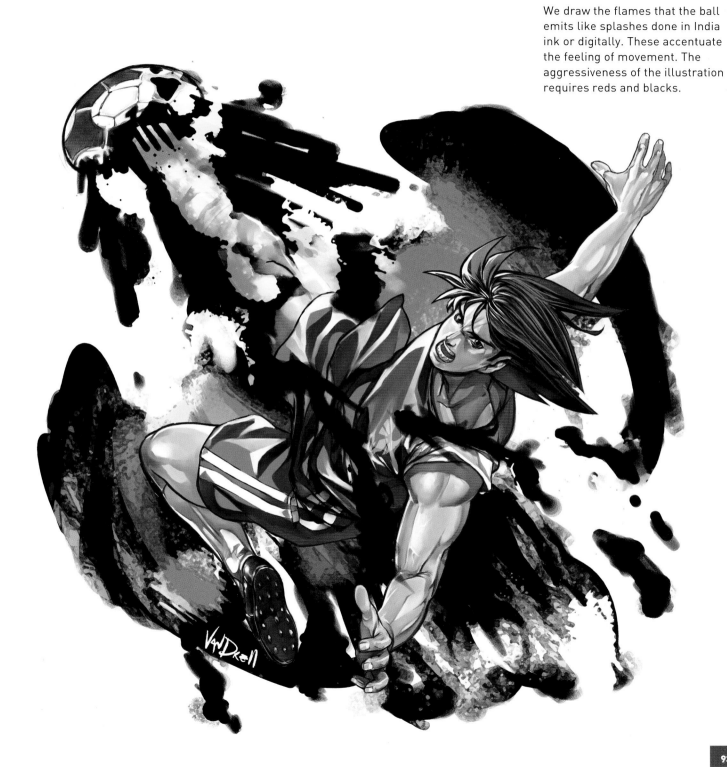

TENNIS

The tennis theme in manga is usually centered on the technical abilities and on the professional evolution of the main character rather than on his personality. When designing the attire, it will not be a problem. We shall concentrate on his bone structure which must be stylized and show good physical shape. We emphasize the upper body since it is the part that a tennis player exercises most. We also reinforce his spirit to exceed, showing how our character progressively reaches his objectives, planning new hits and practicing them often. The most popular manga in tennis is *Prince of Tennis*.

The posture of the character is very dynamic although his feet are immobile. We are guided by the two main diagonals: that of the shoulders and of the hips. We give the back's curve a light undulation.

2. Volume

We provide the figure with the framework on which we will later develop the anatomy. We give special attention to correctly drawing the head and we take into account the motion of the character, which is a little forced.

The tennis player is an adult,
not simply a stylized adolescent,
so his body mass is greater.
The upper body is muscular,
so we emphasize the muscles
in the arms. His legs are also
strong and robust.

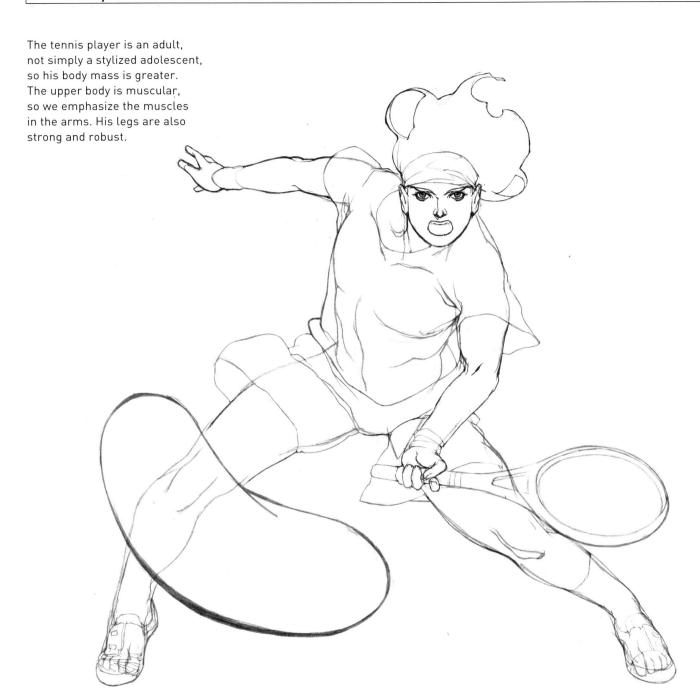

It is not necessary that the tennis player wear matching clothes. Some shorts and a large cotton T-shirt are enough. For the racket we use a real reference that we will later adapt to our own taste.

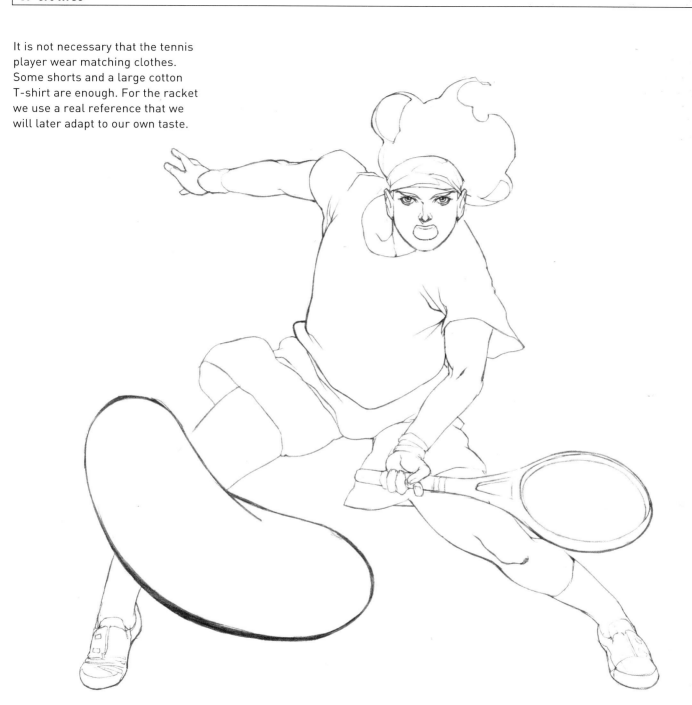

The light source is located in the ball, which we provide with an unusual characteristic: flames that give off an intense and warm light and that reinforce the power of the stroke. The ball "brightens up" the objects around it.

Source of light

We pick a color for the
character's skin and a range of
greens for the outfit. We render
the ball and the blazing effect.
The hair is also reddish to
contrast with the green as a
complementary color.

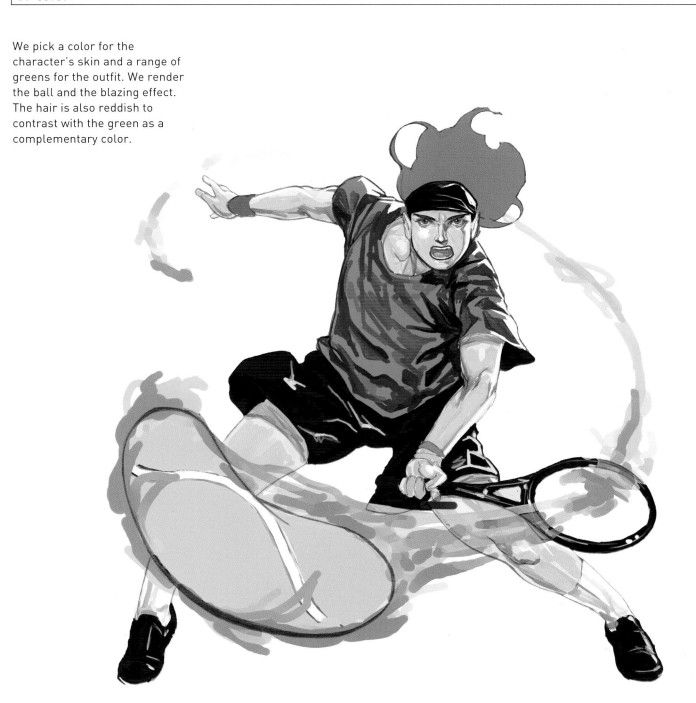

We develop the folds of the fabric. We use tones in the same chromatic range for the lights and shadows. We also add stronger lights and shadows on the face and limbs to reinforce the tension.

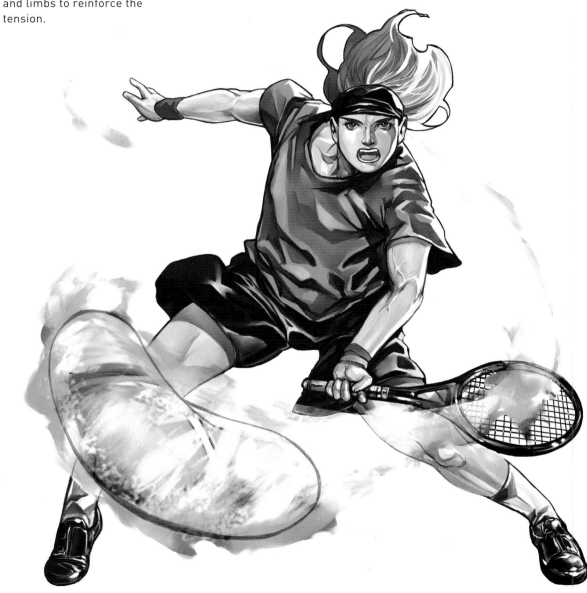

We combine green and red to provide the ball with strong visual impact. To achieve this, we intensify the color progressively: the further away, the blurrier, while the closer we get to the ball, the flames are more contrasting.

We define the lights, textures, and muscles and place the emblem of our team on the T-shirt. We finish up the effects on the ball and complete the illustration with a shadow on the ground where the tennis player stands.

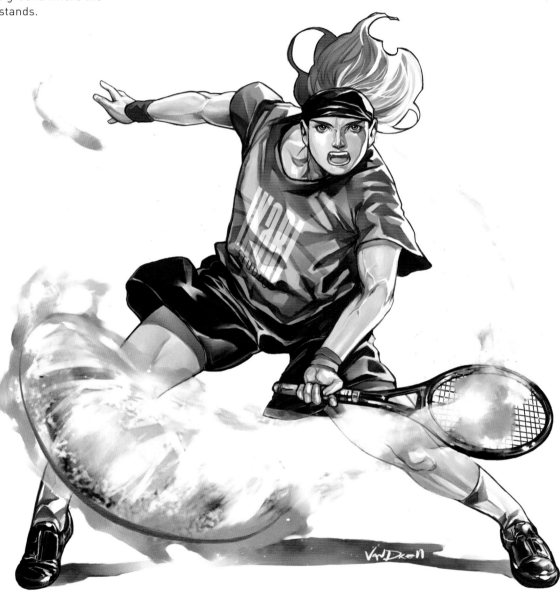

BASKETBALL

In a single basketball team we can find all types of players with different characters, tastes, and aspects, although all are united by their passion for this sport. Therefore, when drawing this character, we have an infinite range of possibilities. However, the character must be in great physical shape. He needs to be very tall and if possible, he should be attractive. We can opt for character prototypes when drawing, such as the gang member or the solitary guy. But it is recommended that his actions and attitude show a constant spirit of improvement and competition. *Slam Dunk* is the prototypical example in this type of manga.

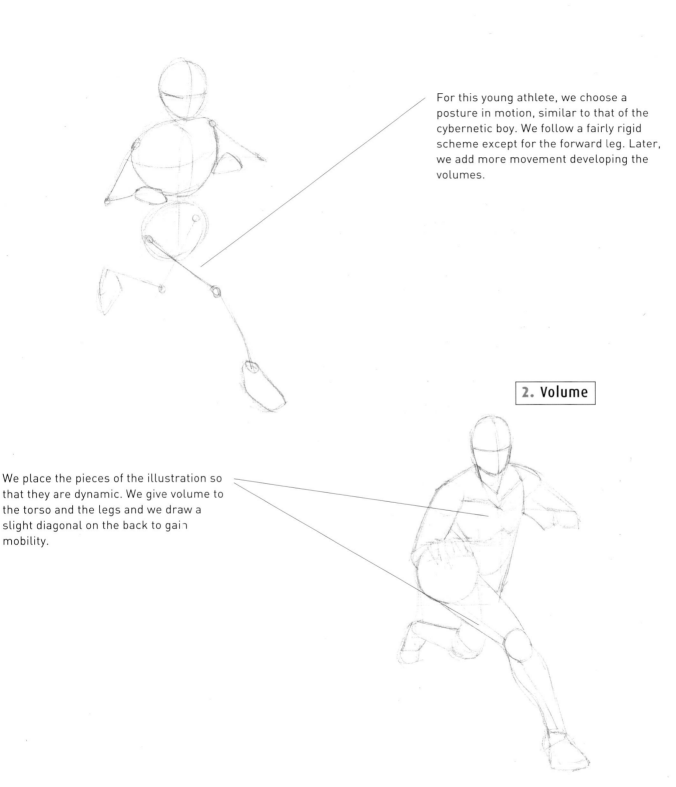

For this young athlete, we choose a posture in motion, similar to that of the cybernetic boy. We follow a fairly rigid scheme except for the forward leg. Later, we add more movement developing the volumes.

2. Volume

We place the pieces of the illustration so that they are dynamic. We give volume to the torso and the legs and we draw a slight diagonal on the back to gain mobility.

Although our character is an
athlete, we should not make
the mistake of drawing a very
developed body. His constitution
is very stylized. We especially
develop the muscles in the arms
and in the legs.

We find a real reference and we adapt it. We opt for a large tank top and shorts that we can decorate with stripes or with an emblem. Details can be added such as wristbands or a band around the head.

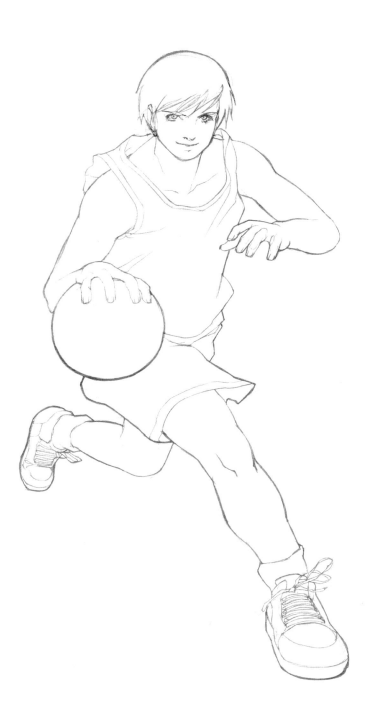

The main source of light comes from the right. It is a rather well-lit illustration, perhaps a little faint in areas that light does not penetrate, but quite warm.

Source of light

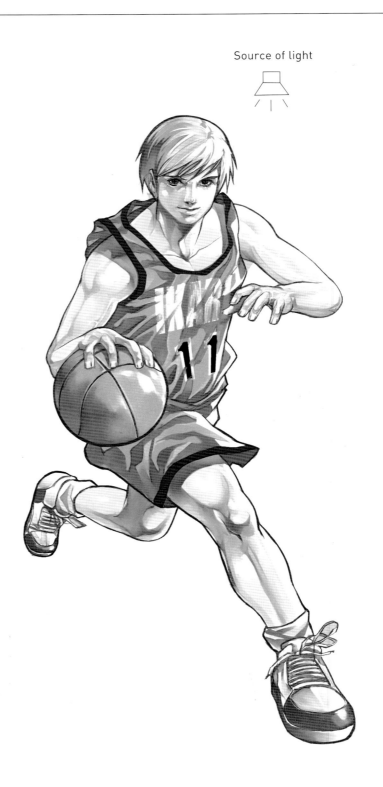

We use a range of warm and pastel colors. We draw a circle as the background in a flat pink color. On the T-shirt we apply brush strokes in a more saturated tone, which later will be wrinkles.

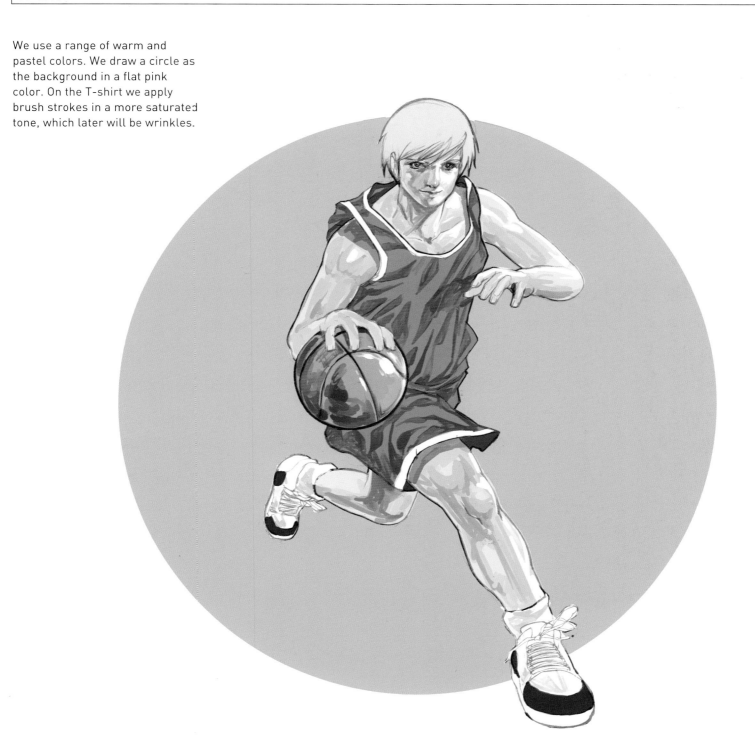

We define the mid tone blotches
that will eventually be volumes.
We blur them, then we finish with
darker colors. We turn the ball
that he holds in his hand into an
actual basketball. In a second
phase—following a logical order—
we define the character's hair and
face, and the drapes
of the fabric of the T-shirt
and the pants.

We finish up the muscles. We apply the shadows and the most contrasting and strong light to provide the muscles with greater realism and tension. We add an orange reflection of the basketball on the character's shorts.

BASEBALL

There are very few who manage to see their dream of becoming a professional baseball player come true. Many fail, but our character is not one of them. In the stories about baseball, the main character must be active and persistent, never drop the ball, and become the most efficient and fast in order to reach his glory. In this type of manga any age is good for the main character. It is important to emphasize how the player experiences an evolution and progresses. Baseball is one of the most followed sports in Japan. An example of this manga theme is *Major*.

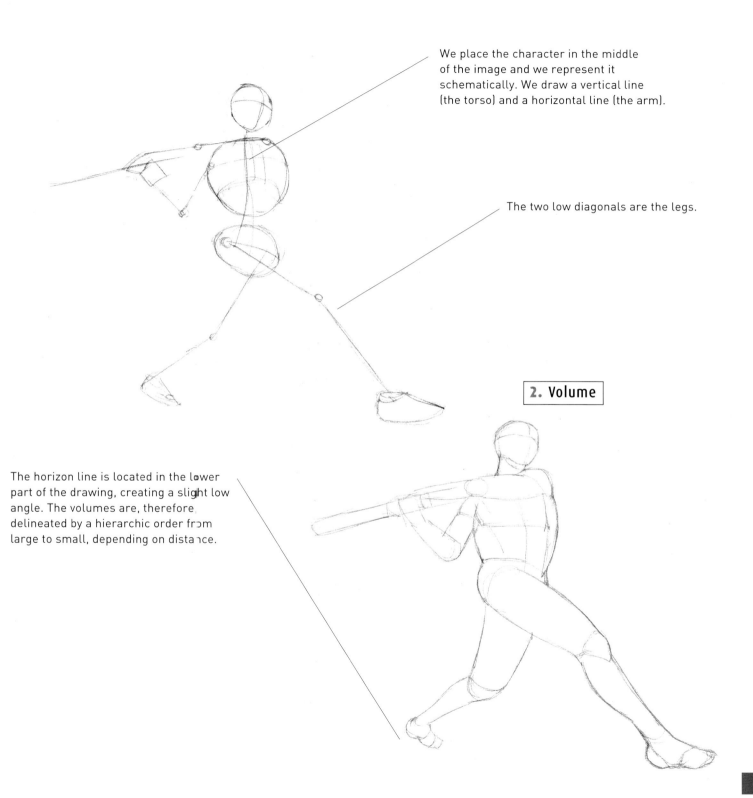

We place the character in the middle of the image and we represent it schematically. We draw a vertical line (the torso) and a horizontal line (the arm).

The two low diagonals are the legs.

2. Volume

The horizon line is located in the lower part of the drawing, creating a slight low angle. The volumes are, therefore, delineated by a hierarchic order from large to small, depending on distance.

The body of our athlete is that of an adult. Batters do not need to be very strong, so their anatomy is rather stylized. The muscles are mostly shown on the arms, and the legs are not too large.

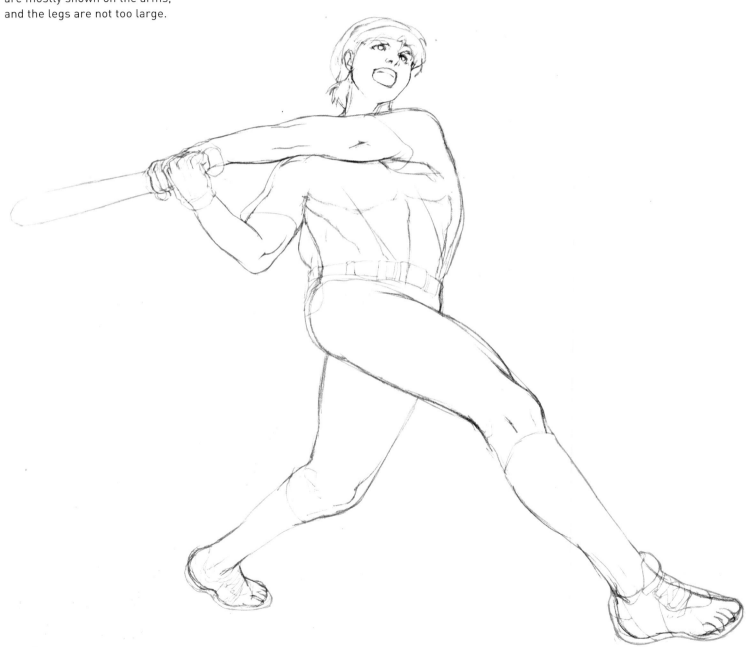

4. Clothes

The equipment is composed of tight pants, a T-shirt or short-sleeve shirt, socks, shoes, and a helmet. We use photographs as reference and "customize" them as we desire.

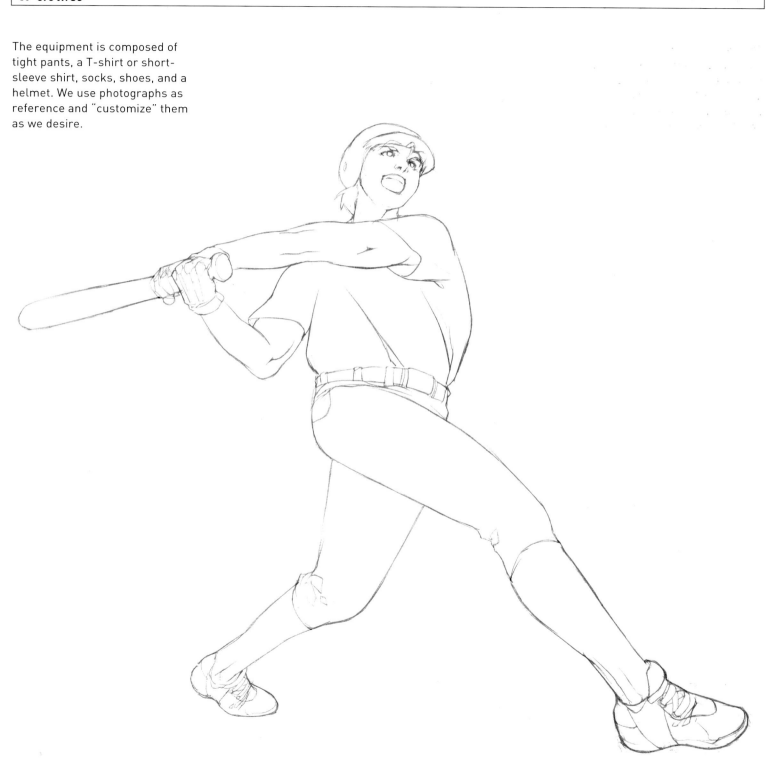

Source of light

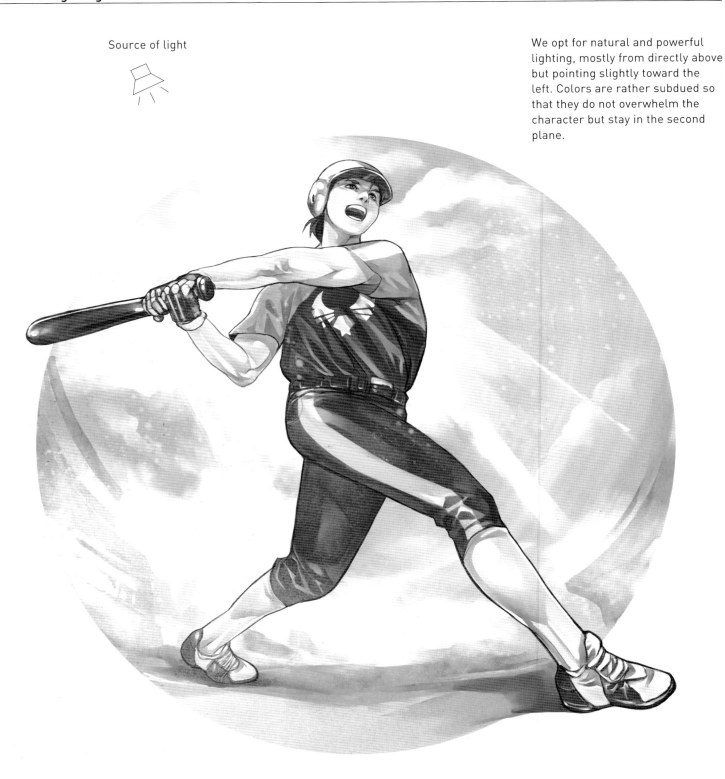

We opt for natural and powerful lighting, mostly from directly above but pointing slightly toward the left. Colors are rather subdued so that they do not overwhelm the character but stay in the second plane.

We chose a range of light colors for
the background, the uniform, and
the skin. We apply some purple
behind the character, which later
we will turn into stands. We mark
the folds in the clothes.

We draw the shadows, always on the right. We render the skin with bright colors and some darker ones to show the muscles. On the clothes, we pay attention to the wrinkles on the T-shirt, located mostly over the chest.

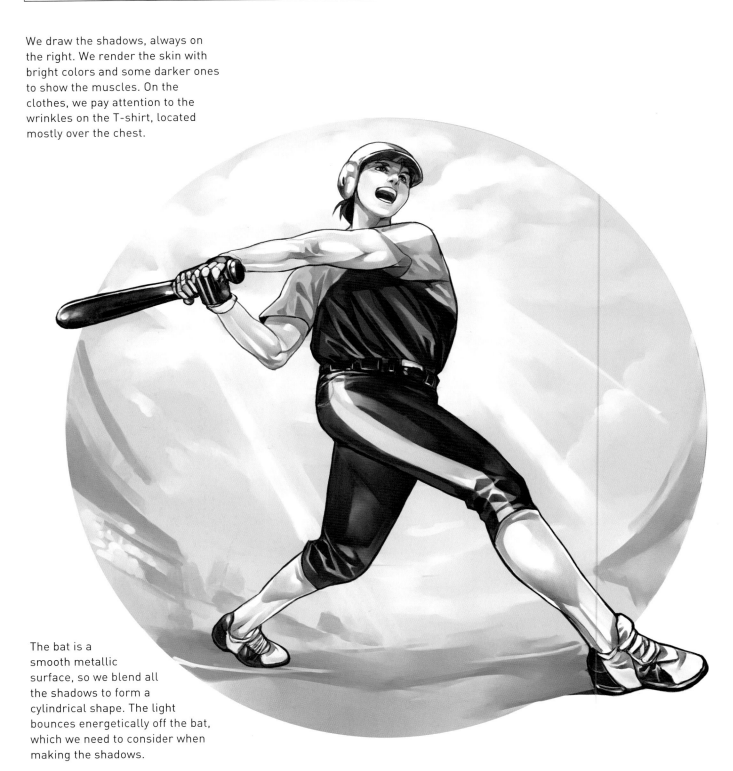

The bat is a smooth metallic surface, so we blend all the shadows to form a cylindrical shape. The light bounces energetically off the bat, which we need to consider when making the shadows.

Now it's time for the background. We blend the white spots to turn them into clouds. In the lower part we add yellow and orange details that will become the field and the stands.

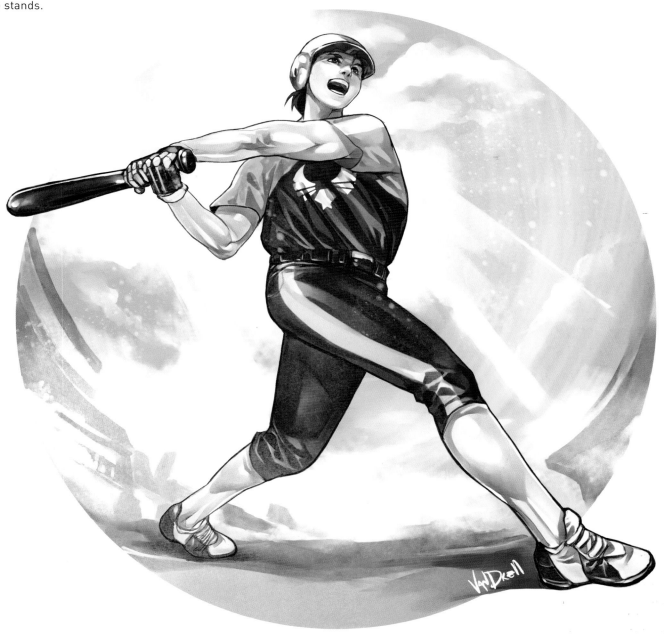

AMERICAN FOOTBALL

This is one of the most difficult sports, one in which every yard counts. Generally in football-themed manga the main characters are brawny professional athletes. Their presence must be impressive, but they also need to be agile and fast. This is a team game in which each player has a very specific assigned task. Depending on what position we pick, the player could be more aggressive (defense) or more skillful (quarterback). The most famous manga in Japan is *Eyeshield*, which tells the story of how a common young man, Sena, becomes the best player in high school thanks to his speed.

1. Shape

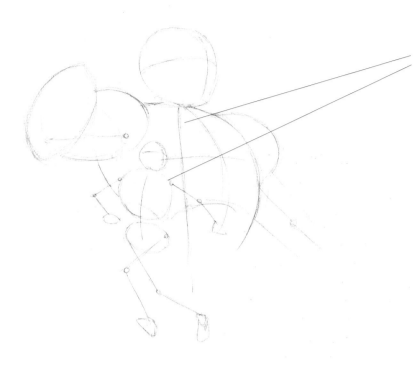

We draw a vertical line that will be the base to draw the character in the background. Also, we use it as guideline to plan the posture of the other silhouette, close to this line but a bit to the left.

2. Volume

Although it is usual to develop the figures in the foreground in detail, in this case, we do it the other way around.

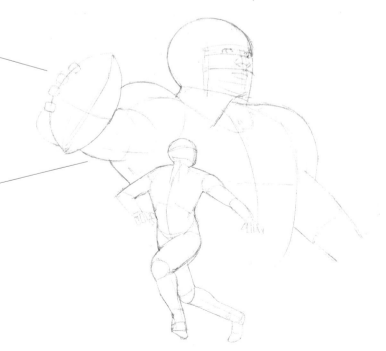

Pay attention to the foreshortened parts of the body: the hand that holds the ball for the large figure and the forward left knee for the small figure.

The defense in football is a large, muscular man. The chest and arms muscles are well developed and show a great deal of strength. Their legs are less heavy, but still muscular.

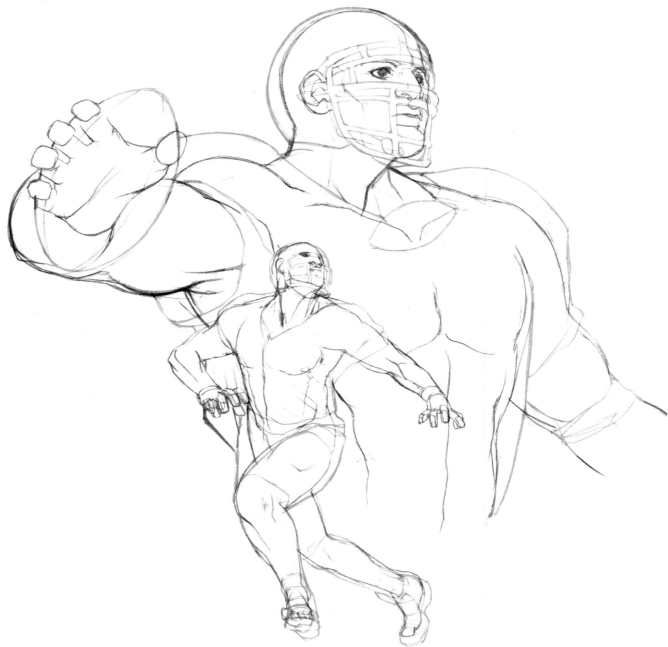

The football player's equipment consists of a very large short-sleeve T-shirt and tight shorts: very ergonomic. Among the accessories is a helmet, shoulder pads, knee pads, and elbow pads.

The games are often played at
night, so lighting over the players
comes from outdoor floodlights.
Therefore the scene depends on a
very powerful light, uniform and
artificial.

Source of light

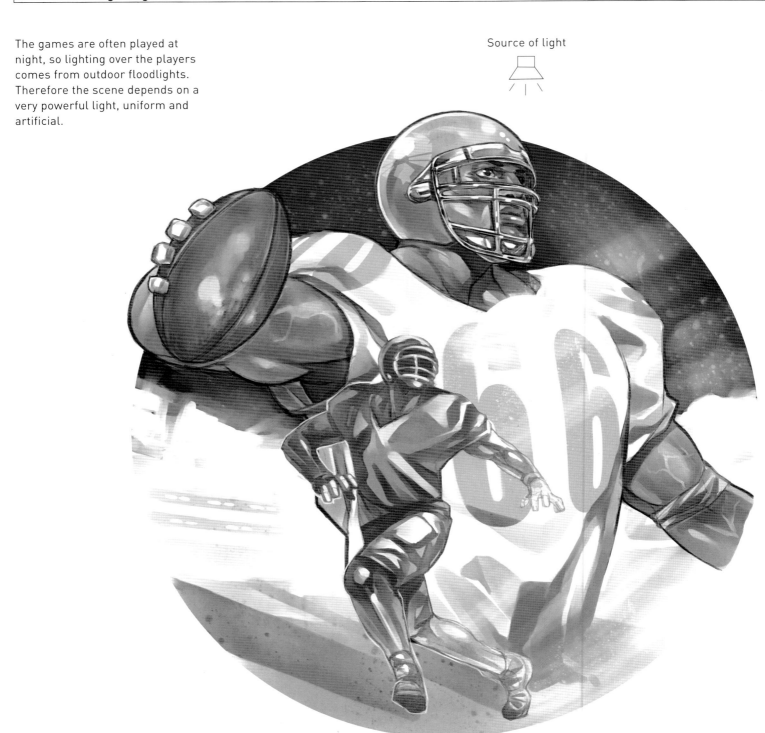

The base color is dark green. To emphasize the figure in the background, we use a brown tonality for the skin and white for the uniform. We leave the player's silhouette as a blotch of flat color.

We pay special attention to the main character, the one we previously started rendering. We develop his muscles and the lights. The expression is very important: using color, we emphasize the facial features and give him a tough air.

We go back to the player's silhouette to apply some highlights and shadows, although these are not final. We add detail to the blotches in the background to create the stadium where the game takes place.

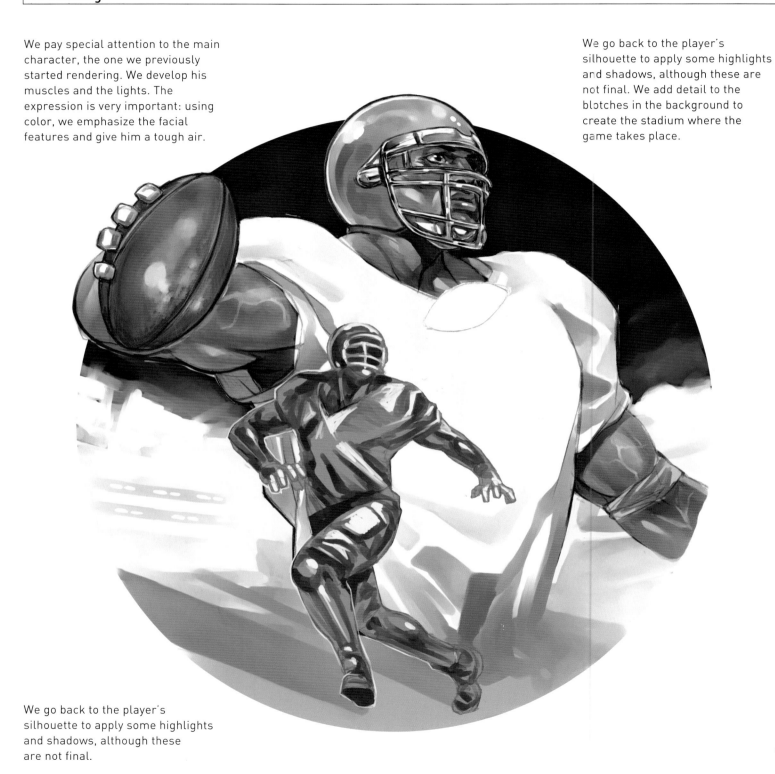

We go back to the player's silhouette to apply some highlights and shadows, although these are not final.

To finish we create a background with a star-filled sky. We draw the number on the player's T-shirt and delineate details such as shadows or the logo on the helmet. We finalize with a bright orange and white light.

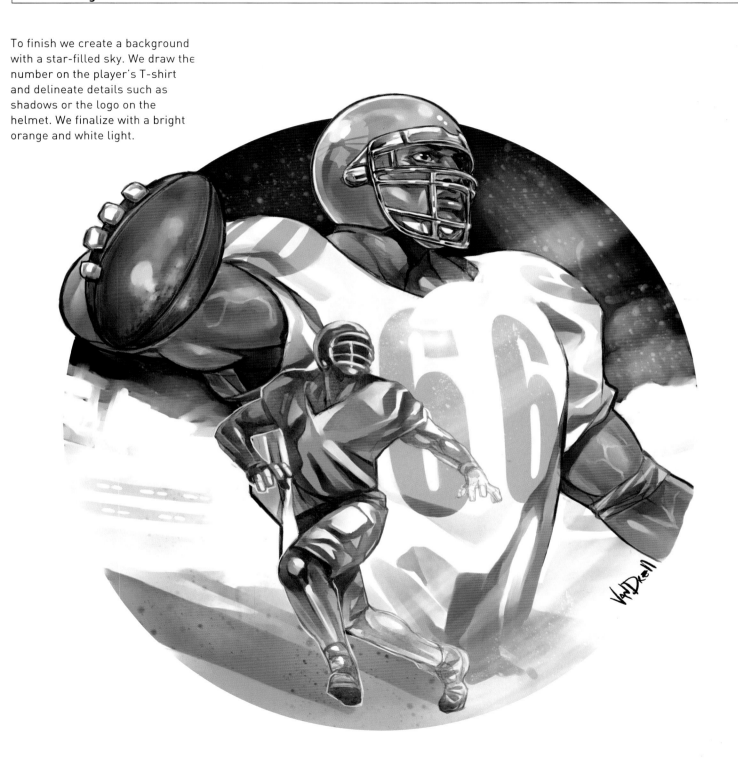

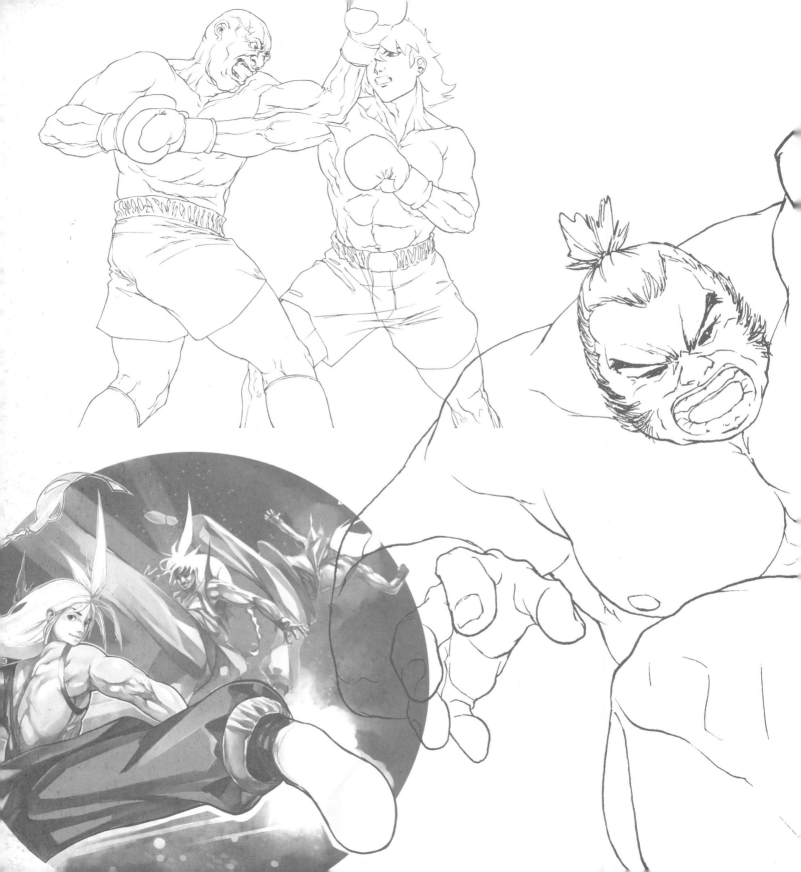

MARTIAL ARTS

KARATE

The karate expert is the athlete par excellence of the Japanese land. He is a skillful character, forceful and strong, but thoughtful and cautious. His is in good physical shape regardless of his size (the categories in karate go from heavyweight to featherweight) and shows serenity when time comes to use his infallible hits with a clean and incomparable technique. As far as his age, we can opt for the beginner who still has a long way to get to the top, or the expert who fights every day to stay in good form and reach new goals. *Karate Shoukoushi Kohinata Minoru* is the best example of this genre.

1. Shape

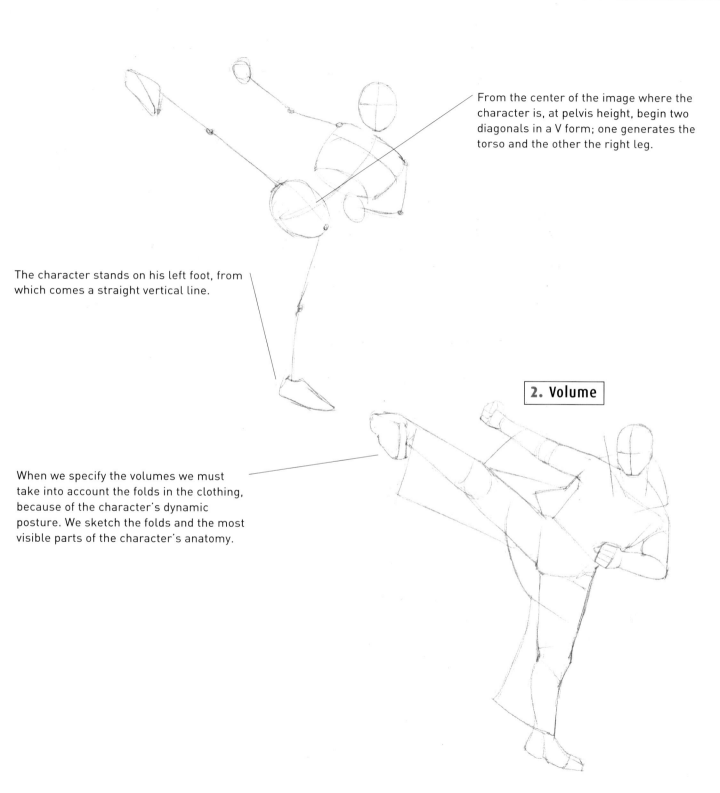

From the center of the image where the character is, at pelvis height, begin two diagonals in a V form; one generates the torso and the other the right leg.

The character stands on his left foot, from which comes a straight vertical line.

2. Volume

When we specify the volumes we must take into account the folds in the clothing, because of the character's dynamic posture. We sketch the folds and the most visible parts of the character's anatomy.

We use the karate expert prototype, which is a mature man with a trained physique, although not excessively so. His features are hard. We use polygonal shapes to give the impression that he is a tough man.

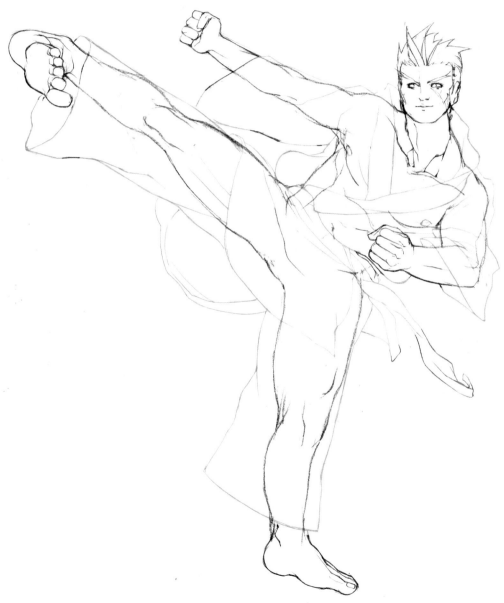

4. Clothes

The classical equipment of karate experts is the white kimono. The character can be modified and personalized in any manner, but we have opted to follow the tradition. The color of the belt marks the fighter's level of expertise.

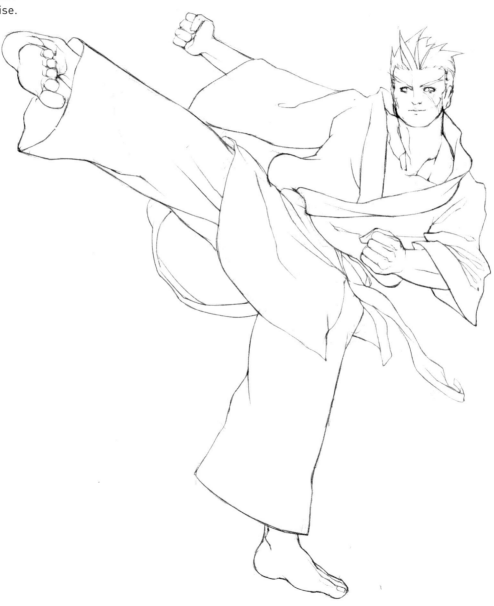

In the background we fake a sunset, which emphasizes the movement but does not have any lighting effect over the character. The light that envelops our karate expert is a direct light, very white, which blends with the kimono.

Source of light

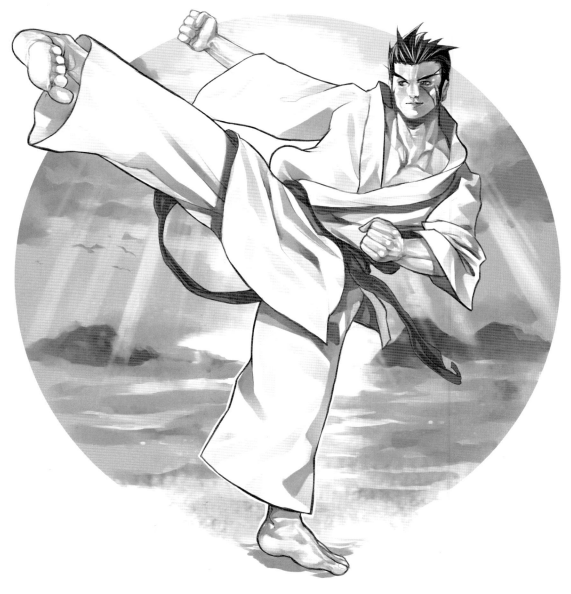

The tones of the background are orange and make up a warm range of shades. For the karate expert, we use the same tone for his skin and start working on the folds and wrinkles of the kimono.

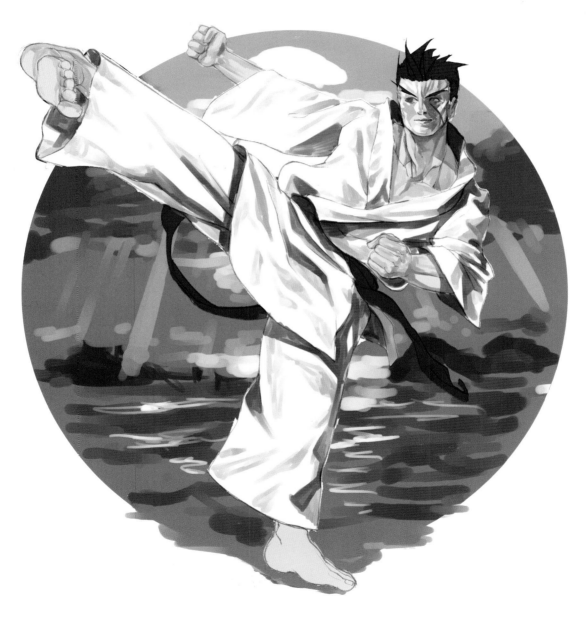

In the background of the image what before were simple blotches of red tones take form. We define the volumes of the character's clothes with grays. Blacks are used for the shadows and bright white for the most intense lights.

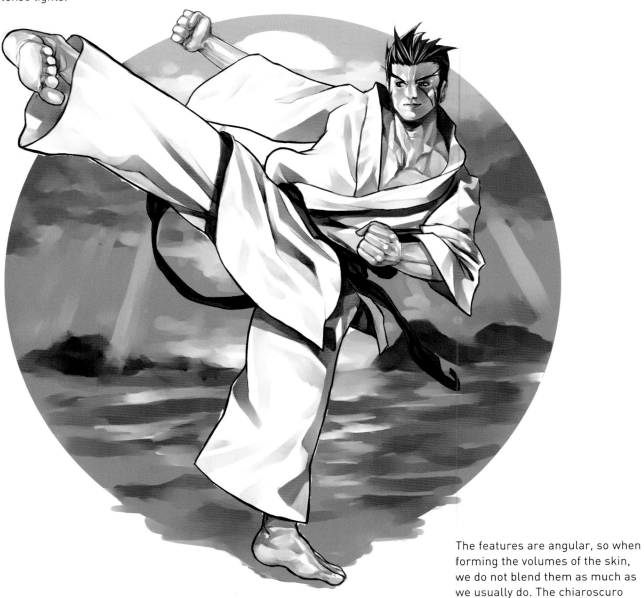

The features are angular, so when forming the volumes of the skin, we do not blend them as much as we usually do. The chiaroscuro elements are the strongest and result in marked polygonal forms.

8. Finishing Touches

We finish defining the sunset, including the textures in the sea and the details in the sky, such as the seagulls. For the character, we increase the contrast levels of color and emphasize the white lights.

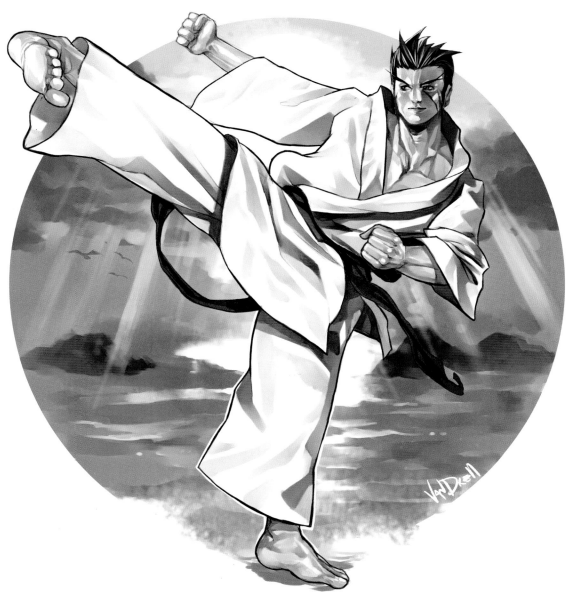

BOXING

One of the most successful genres is the sports manga. There are few sports that are not represented in some manga or anime. The authors usually focus on the most popular sports that have the most followers. In general, boxing is a genre in martial arts where two opponents fight using their fists. Based on the rules, different disciplines can be differentiated: English boxing or actual boxing, French boxing, Chinese boxing or *shaolin,* and kickboxing or Japanese boxing amongst others. Boxing is the subject of works such as the mythical *Hajime no Ippo.*

1. Shape

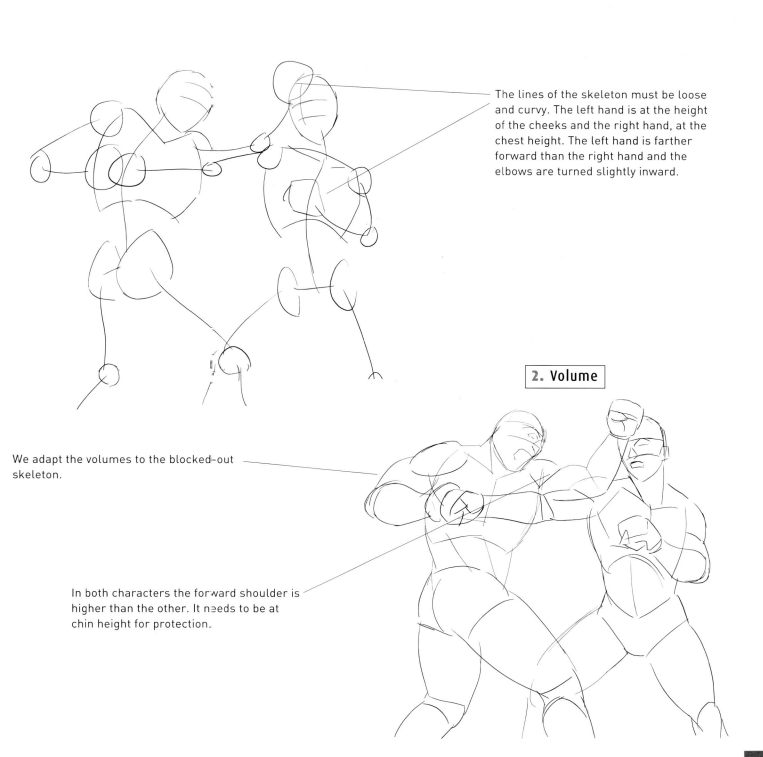

The lines of the skeleton must be loose and curvy. The left hand is at the height of the cheeks and the right hand, at the chest height. The left hand is farther forward than the right hand and the elbows are turned slightly inward.

2. Volume

We adapt the volumes to the blocked-out skeleton.

In both characters the forward shoulder is higher than the other. It needs to be at chin height for protection.

The boxers we draw are very strong, large, and robust. To do this we provide them with a wide bone structure and increase the size of the muscles to borderline hypertrophy.

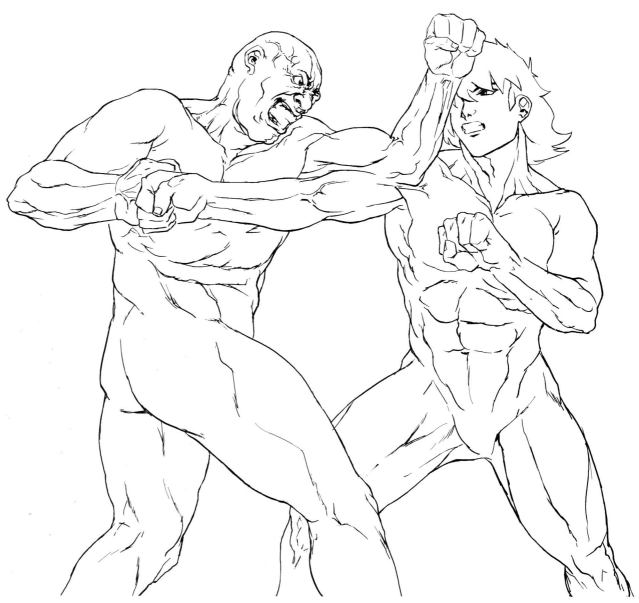

The shorts are baggy, so they are made to look loose by drawing forms that are bigger than the muscles. For the gloves, we used a closed fist as a base. We round off the shape and increase the size.

The light used in a ring is a strong overhead light which gives the scene some drama and creates contrast. The tones for the shorts and the hair are matte and we use less contrasting tones.

Source of light

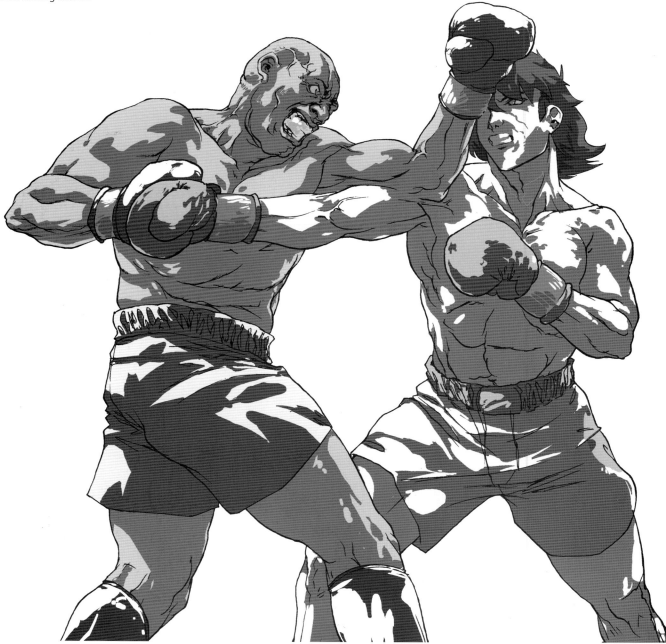

We differentiate the ethnicity of
our characters with skin color and
we choose the tone of the shorts
based on their flag and nationality
to quickly place the spectator in
the context of the fight.

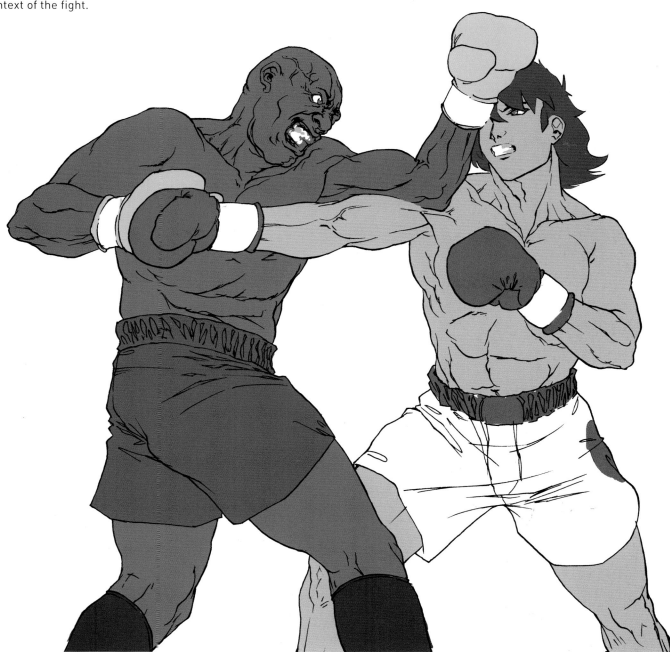

We add the base color to all the elements in the illustration and later, we unify the scene. We also apply the shadow tones based on overhead lighting. A good trick to reinforce the muscular and rough anatomy of the characters consists of adding different contrasting color tones for the shadows.

We apply the bright colors on the shiny surfaces, especially on the upper parts. The sweaty effect is achieved by applying white highlights to the skin. Finally, we add the tattoos.

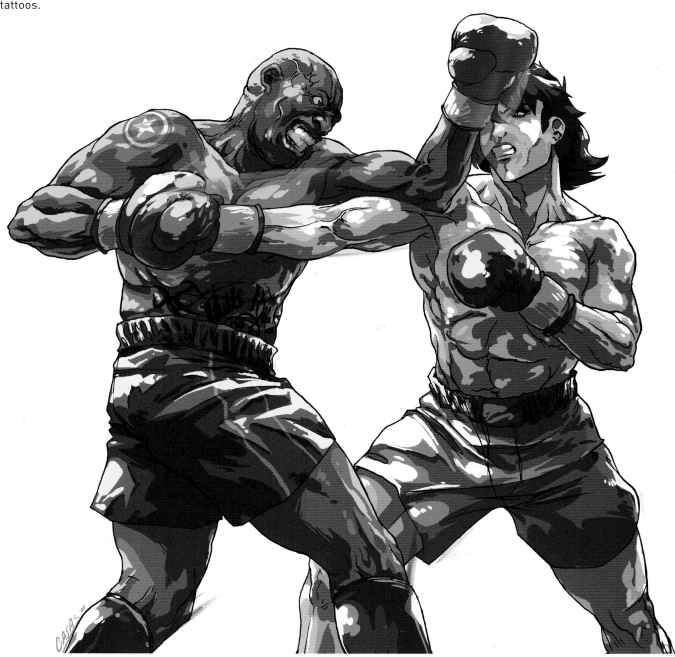

WRESTLING

Muscular and incredibly strong, this devoted wrestler usually hides under the most extravagant attire, as if he were a super hero. For this character we use the archetype of a very buff man and we add a costume to provide the character with personality. He is a wrestler who uses his strength, but he always has a strategy and, of course, a special move which is spectacular and capable of defeating the most fierce of opponents. In manga we find examples such as *Tiger Mask*, more realistic, or *Kinnikuman*, more surrealistic.

1. Shape

We draw a vertical line in the center that balances the image and a diagonal for the fighting scene. It is easier to draw this scene in two parts: one is the figure in the background, and second, the final strike.

2. Volume

Be careful with the foreshortened arms and face, both raised up.

To form the figures in the foreground we draw an L-shape guideline for the one who is attacking and a kind of hook for his opponent.

We must be careful to make the
character's muscles the same in
both representations, and to not
forget the legs since they need to
be thick enough to bear a lot of
weight.

4. Clothes

The character is quickly identified by his costume, which can be as imaginative and extravagant as we want, but needs to be comfortable. We complete this step with a mask and elbow pads.

We try to separate each plane. In the background of the image, the light comes from the zenith so as to accentuate the main character's satisfaction for his own victory. In the foreground, the light emerges from the bodies of the characters as an effect of the blow.

Source of light

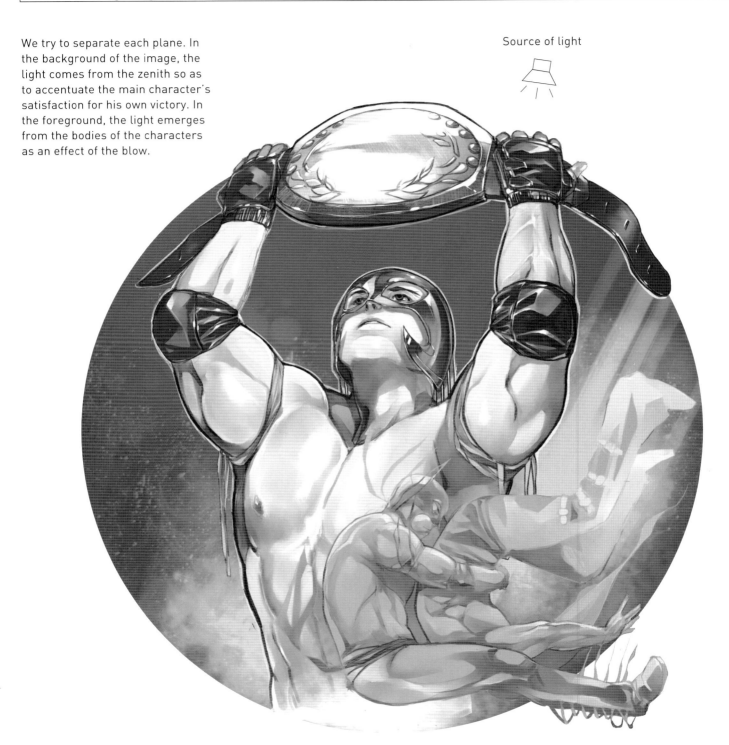

For the main character we choose
a range of earthy colors that does
not overwhelm the small figures.
Of these, we chose warmer and
more luminous colors. We also
add orange tones.

We combine brown with a rosy tone and we create the textures. On the right side, we substitute these textures with light rays using the same rosy tone to represent the trail of the movement when the characters fall.

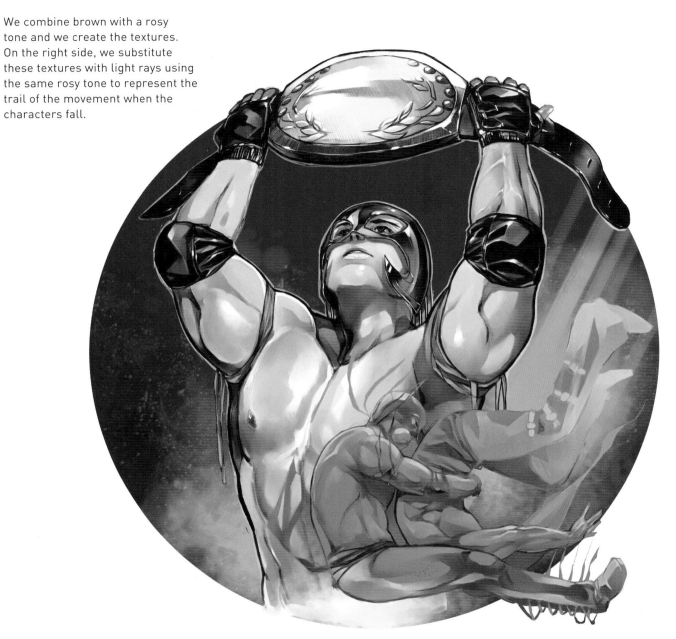

We define the muscles of the main character and blend the colors for the skin. Then, we incorporate brighter lights and develop the orange blotches so that they resemble highlights. We also refine the light effects.

We define the most intense highlights and develop details such as the shield on the belt or the veins on the arms. Also, we refine some areas of the attack's effect with greater intensity by adding splashes.

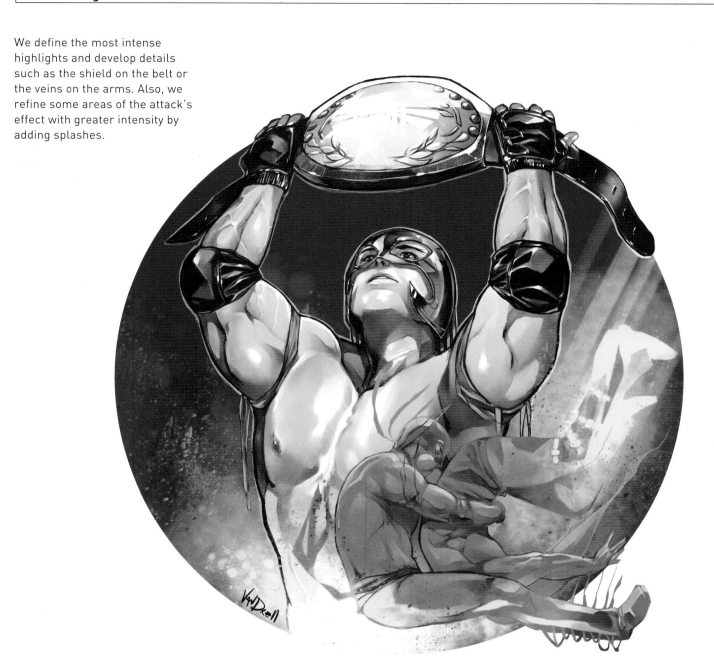

SUMO

Sumo is a traditional Japanese sport. It is a type of wrestling in which two opponents or *rikishi* try to force each other out of a circular while following the rules below:

- The first wrestler to step out of the circle is disqualified.
- The first wrestler to touch the ground with any part of his body other than his feet is disqualified.
- The wrestler who uses an illegal technique is disqualified.
- The wrestler who looses his loincloth, the *mawashi* is disqualified.

Because Sumo is a traditional Japanese sport it is almost omnipresent in wrestling mangas, just as much as other martial arts such as Karate or Judo, which are better known in western culture.

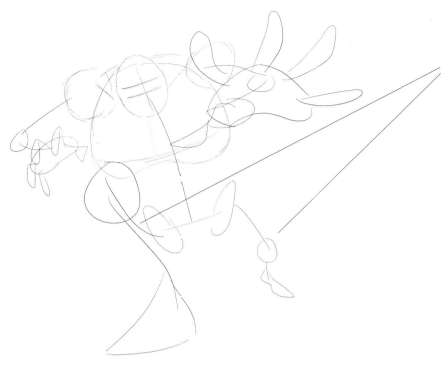

To achieve a dynamic drawing and a feeling of movement, we opt for exaggerated foreshortened figures and curvy lines. We use an imaginary line to simplify the perspective of the legs and the alignment of the feet.

2. Volume

We draw the wrestler in full-on attack. To make the foreshortened parts, we sketch the volumes starting with the parts farther from the spectator and finish with those that are closer. For the hands we use cylinders.

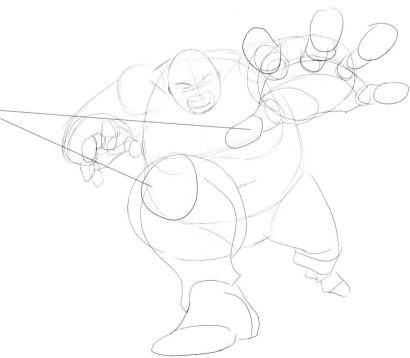

We start defining the drawing. We soften up the lines on the sketch to block out the anatomy correctly. We do not delineate the muscles excessively, but rather we suggest them.

To sketch the foreshortened parts we use fine lines for the areas in the background and thicker lines for those that are closer. We add the *mawashi* to our wrestler and we draw the traditional characteristic hairstyle of these athletes.

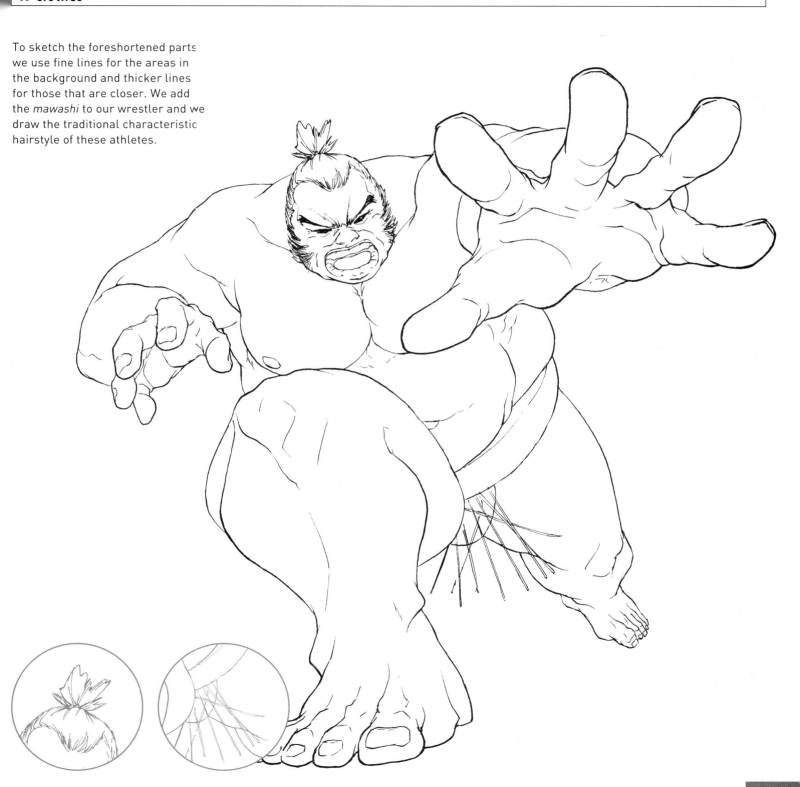

We opt for overhead lighting, which forces us to shade large parts of the wrestler's anatomy. To achieve this, we use blotches of very soft colors, barely marked in few areas.

Source of light

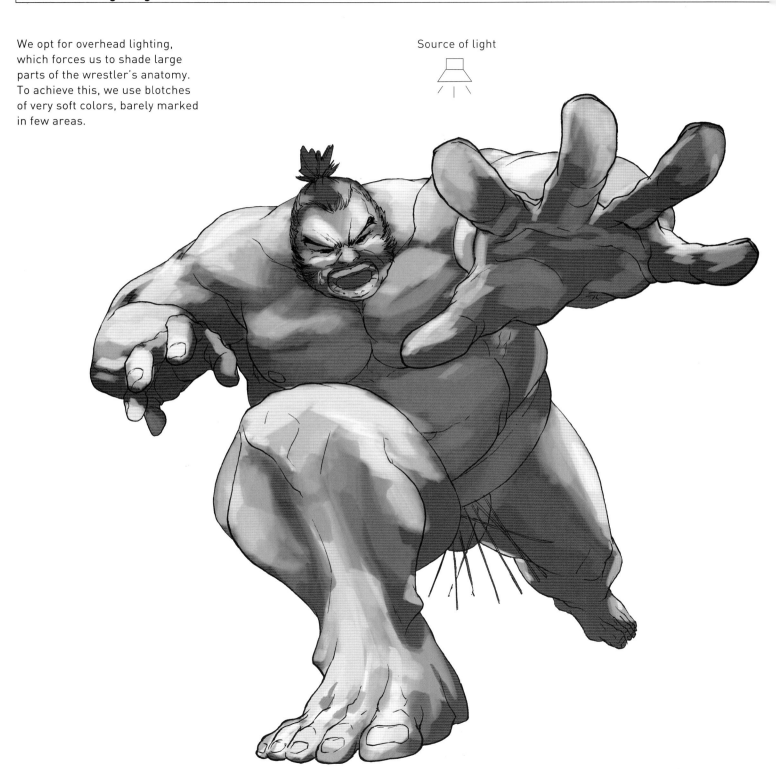

We use a matte dark color as a base and we brighten up the areas as we get to the more luminous sections. To provide the illustration with more color, we render the background.

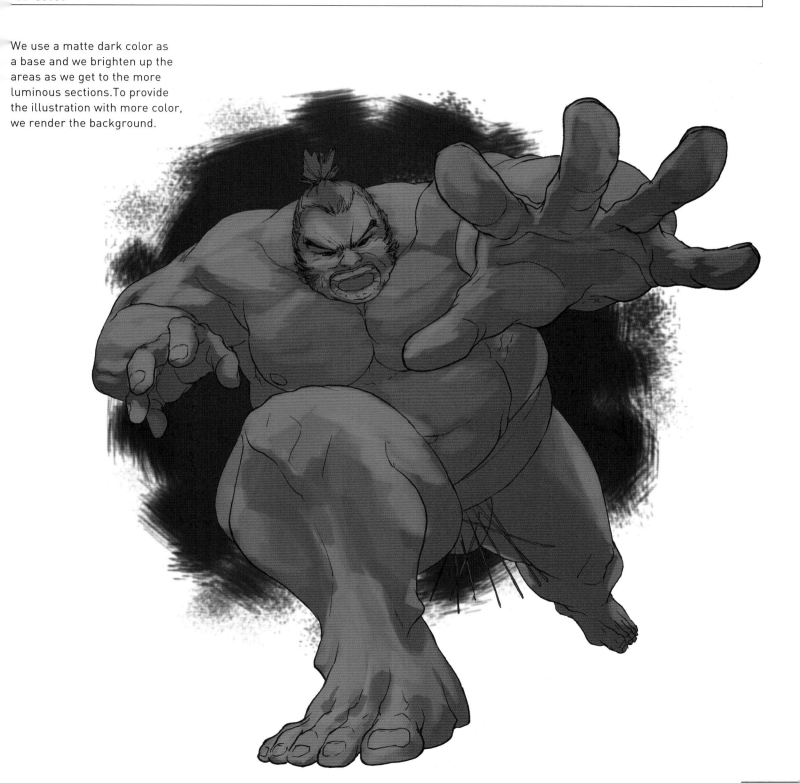

When modeling the shadows with color, it is important to delineate the shapes we have previously blocked out in the lighting step, where we have defined the character's volumes.

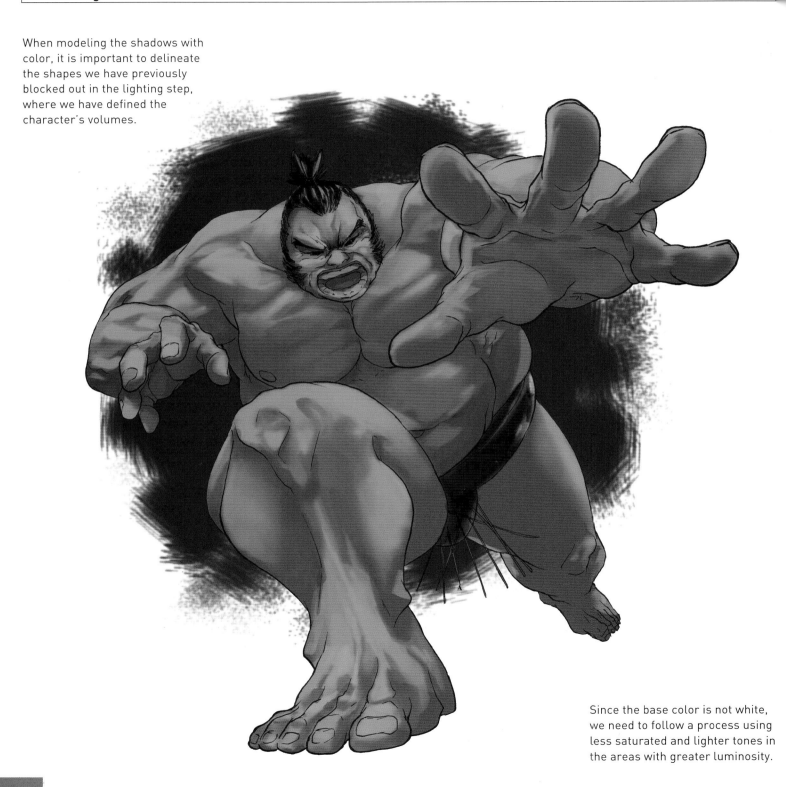

Since the base color is not white, we need to follow a process using less saturated and lighter tones in the areas with greater luminosity.

We apply small highlights on the skin and some sweat drops spread out in the air. All this, as well as his facial expression, reinforces the idea of exertion depicted in the character's movement.

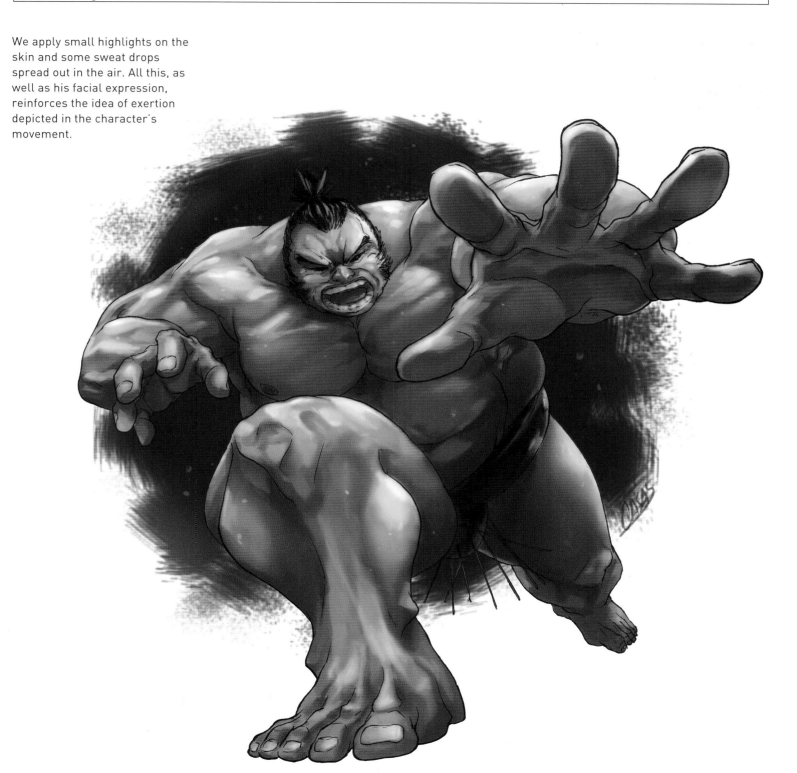

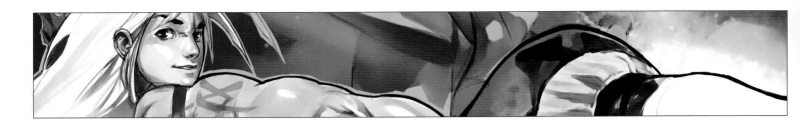

SUPER ATTACK

All the fighters have an ace up their sleeve: the ever-feared special and final attack, and all mangas that are about fighting and that are valued must count on a great deal of dramatic and striking special attacks. When creating them, we focus on movement. They must be realistic but extreme, based on powerful natural elements such as wind, fire, etc. There are a large number of mangas and anime that display attacks from the most comical to the most impressive and devastating. Some prototypical examples are *Dragon Ball*, video games such as *Street Fighter*, and *The King of Fighters*.

To represent movement, we clone the character. We place the clones in diagonal from small to large.

The composition forms an X. One diagonal is formed by the characters and the other by the leg that kicks.

2. Volume

We loosely define the volumes based on the proximity of the plane where the character stands. Later, we reinforce this effect with color as if we were to capture movement at slow motion.

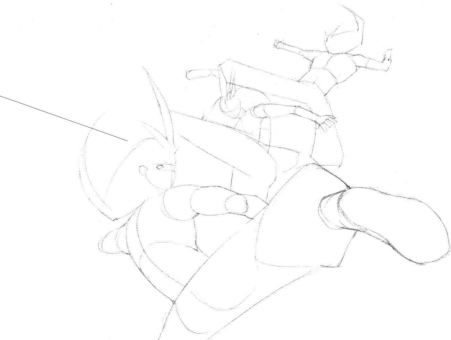

Our character is an adult but
still keeps some traits and the
typical constitution of an
adolescent. The fighter is thin,
but his muscles are well
developed, especially the
back, torso, and arms.

The fighters who practice martial arts usually wear some kind of light kimono that allows good mobility. Our character also has long hair and unusual bangs.

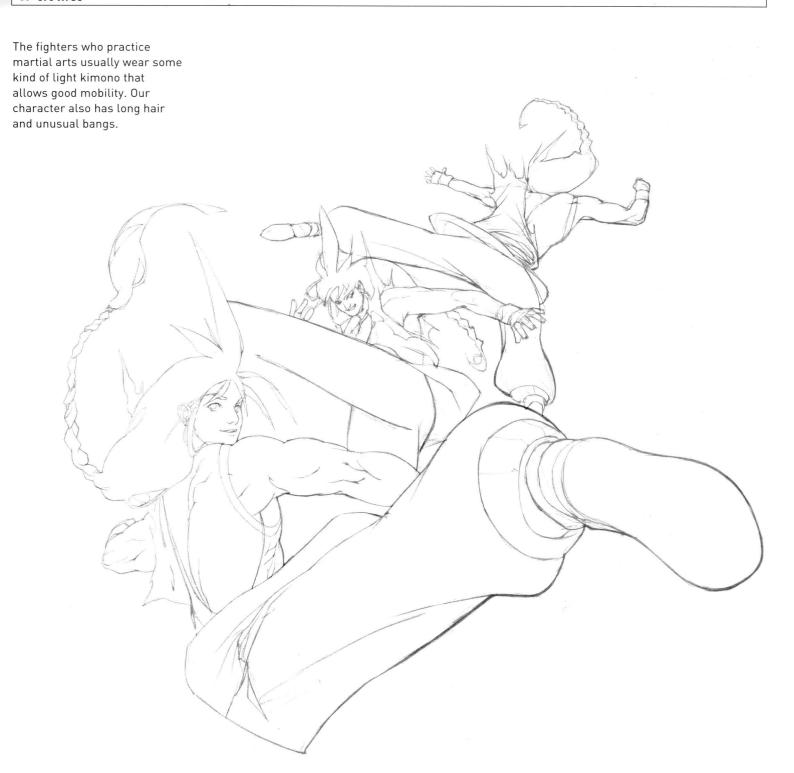

We pay attention to the light that
strikes the character in the
foreground. The light focuses on
two points: the foot that kicks
and the rest of the body. Both
planes that are left receive
lighting from the zenith.

Source of light

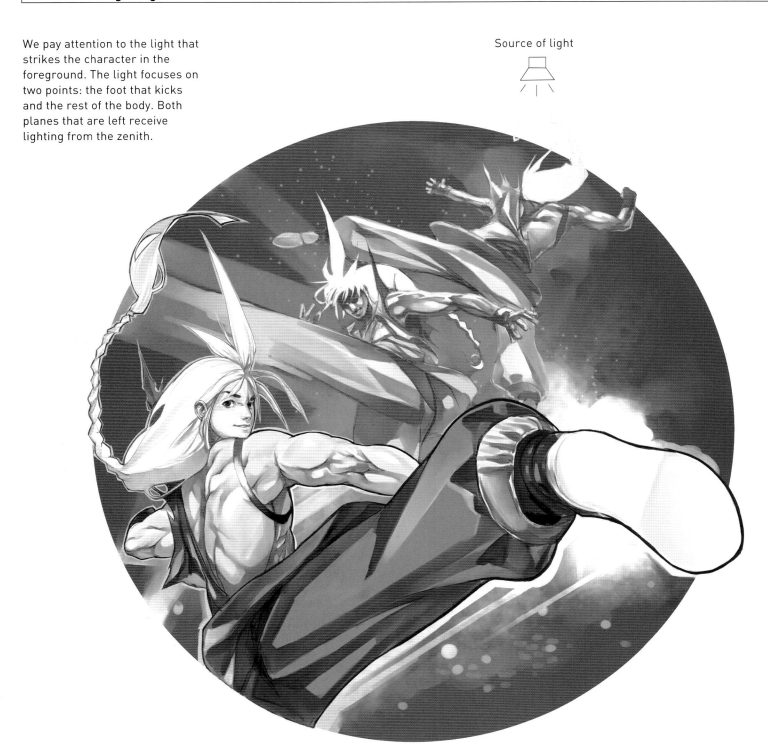

We divide the image. We choose a dark blue for the background, a luminous blue for the secondary figures, and navy blue for the outfit of the main character. We choose a light tone for his skin.

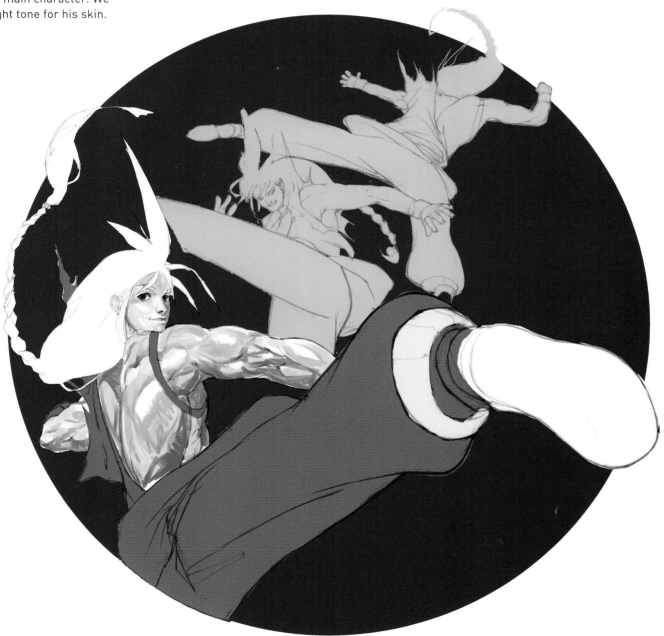

We apply texture to the
background and to the lights.
The characters that were earlier
simple bright blue blotches
start taking form. We define them
with darker tones and finish by
delineating them with shadows.

We add new light and shadows to the front character to define the muscles, clothes, and hair. We place intense lights—one above the bodies and in back and the other emerging from the kick. To finalize, we emphasize the light produced by the special attack.

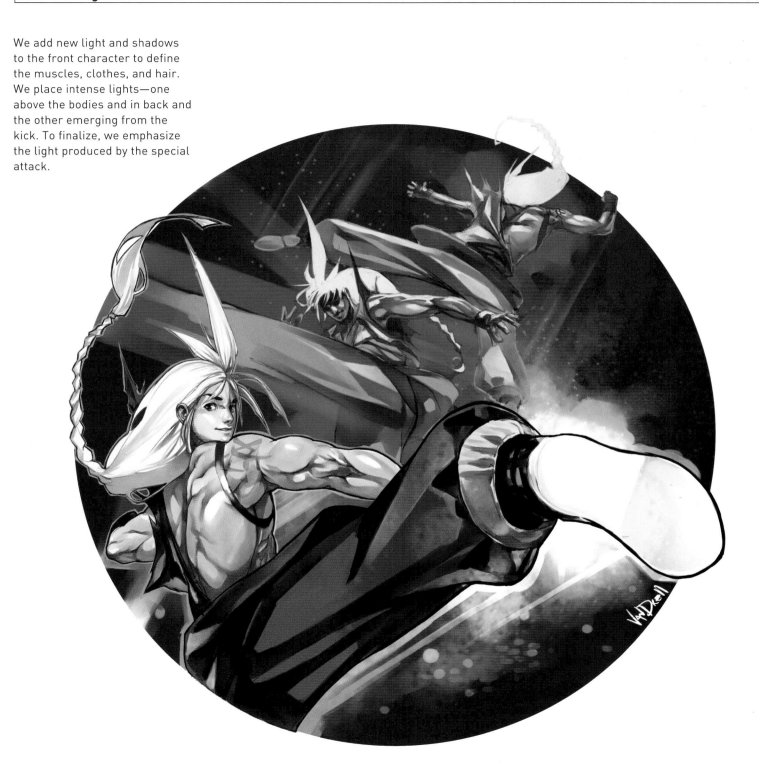

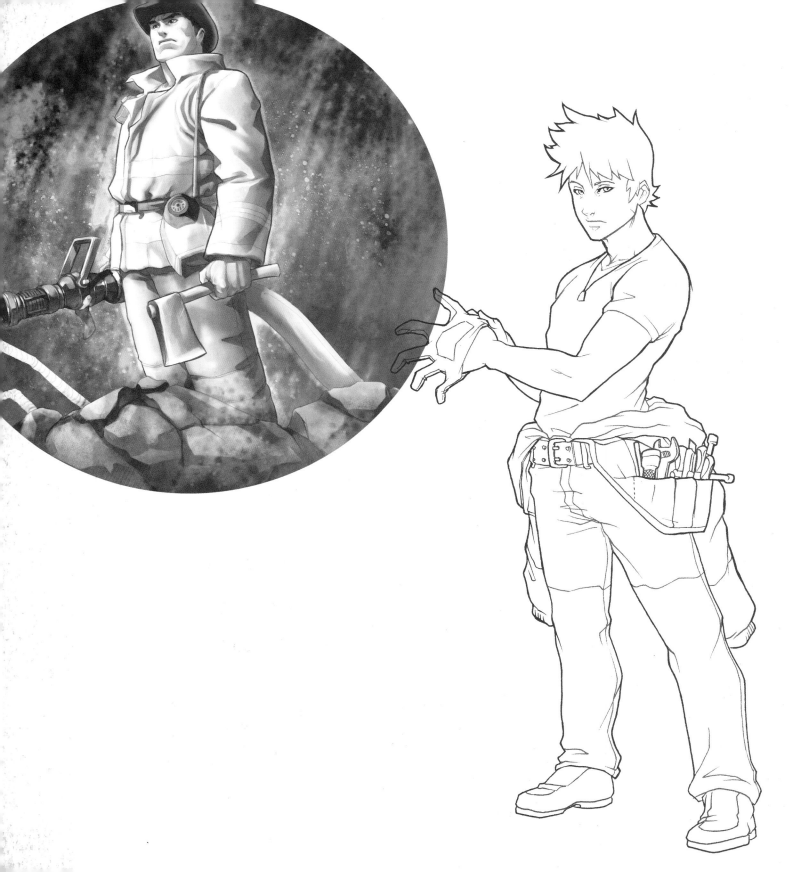

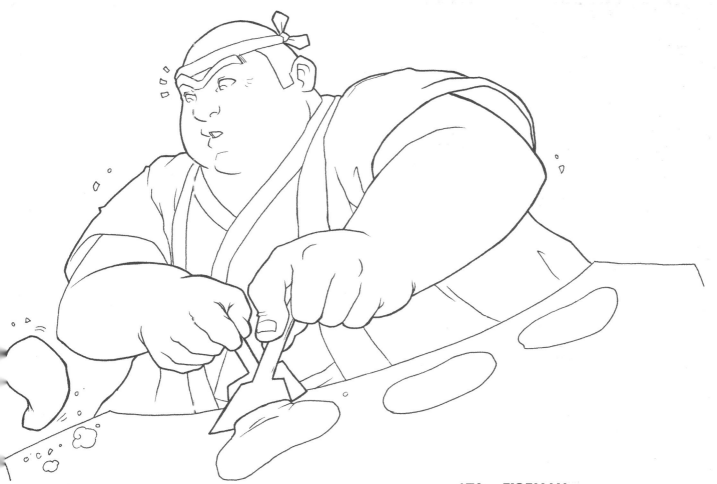

PROFESSIONS

FIREMAN

One of the most admired professions among children is that of a fireman. These anonymous heroes are charged with keeping us safe, even risking their own lives if required. Their routine consists of rescue missions, extinguishing fires, assisting the victims in a building collapse, and much more. In action manga the fireman is a character that often appears as secondary because of his connection with disasters. Nevertheless, an aspiring fireman, Daigo Asahina, rescued from a fire when he was a child, is the main character in *Firefighter! Me Gumi No Daigo* by Soda Masahito, a manga that is quite well known in Japan, published in 1995.

1. Shape

A low point of view helps us emphasize the figure of our fireman and provide him with a dignity inherent to his trade. To achieve this effect we draw a curve, not too pronounced, that starts in the back and extends down to the legs.

2. Volume

We exaggerate the size of the hand to strengthen this aspect of our character. It is a simple posture and an uncomplicated point of view, so we should not have much difficulty when blocking out the volumes.

To bring out the hand that strongly seizes the ax, we draw on the glove some creases that look like tendons, creating a feeling of tension which contrasts with the serenity of his face.

4. Clothes

We do not detail the accessories too much, so that the simple fireman's uniform does not lose visual impact. A couple of austere details are sufficient and allow the spectator to focus on what is truly important.

The light comes from a spotlight located high up that is probably artificial and is intended to illuminate the affected area. It strikes the character directly, provoking areas of intense shadow and others of high luminosity.

Source of light

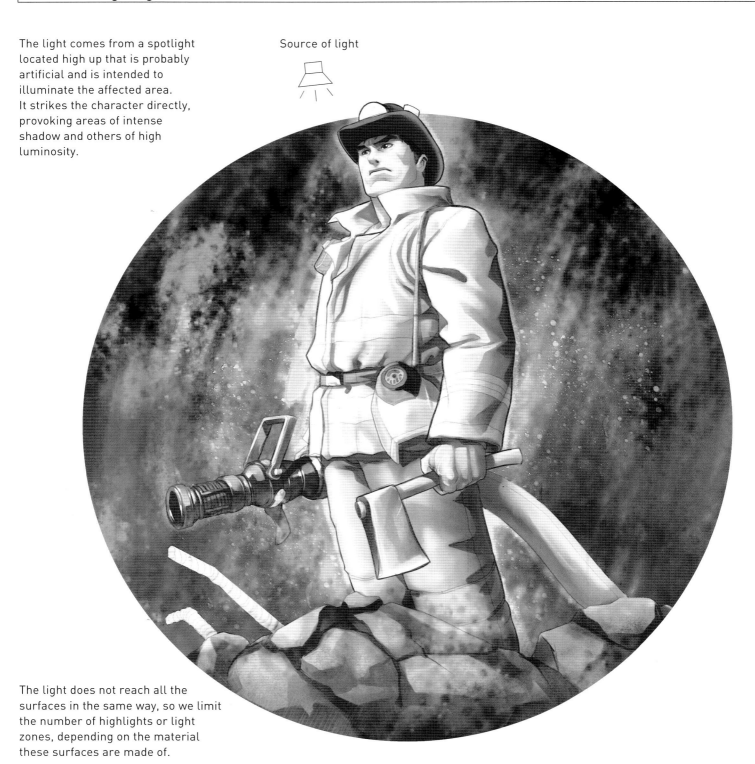

The light does not reach all the surfaces in the same way, so we limit the number of highlights or light zones, depending on the material these surfaces are made of.

Yellow and orange are indispensable in the scenes where there is a fire. It is important to know what the complementary colors are. In the case of orange, it is blue. In the background, we render an impressive wall in flames.

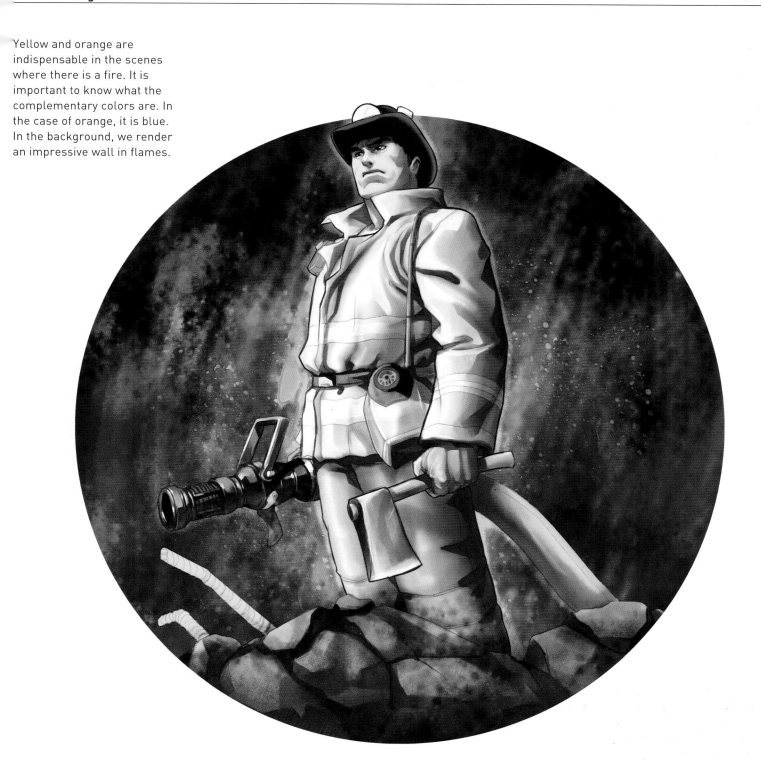

CHEF

The master of the stove can reach every heart, thanks to his delicious dishes. The cooks are constant and creative, and strive to continuously improve their trade with new delicacies offered to the most discerning palates. In manga, the chefs usually have a friendly personality and are somewhat competitive. If they are secondary characters, they are marked by their humor and tend to have conversations about the main characters. In Japan, food is generally good and healthy, and manga makes sure to represent this. An example of culinary manga is *Yakitate!! Japan*, which tells the story of how a young man strives to have his dream of becoming a master baker come true.

1. Shape

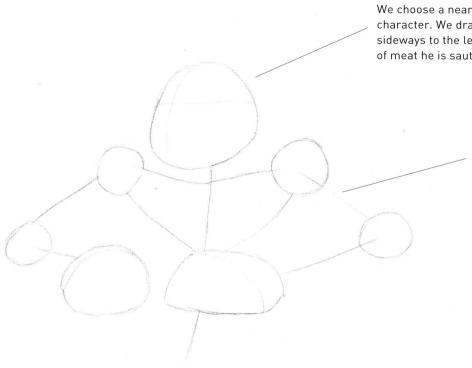

We choose a near plane to block out the character. We draw the cook turned sideways to the left, looking at a chunk of meat he is sautéing.

The position of his spinal column is straight. His arms are flipping a piece of meat over.

2. Volume

We define the basic forms of the body by means of circles and curves and we accentuate his excess weight. In this step, we sketch the contained surprise expression and we create a sense of direction by guiding the look towards the piece of meat.

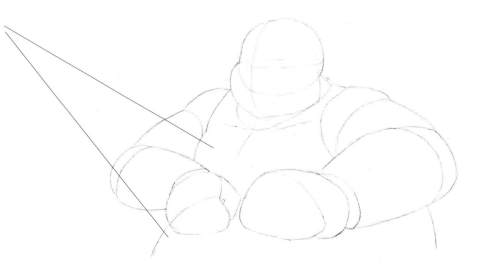

We reduce the proportion of the head while we make the cheeks look bigger. We draw big arms in a clumsy gesture. When defining the body, we give the belly more amplitude compared to the back.

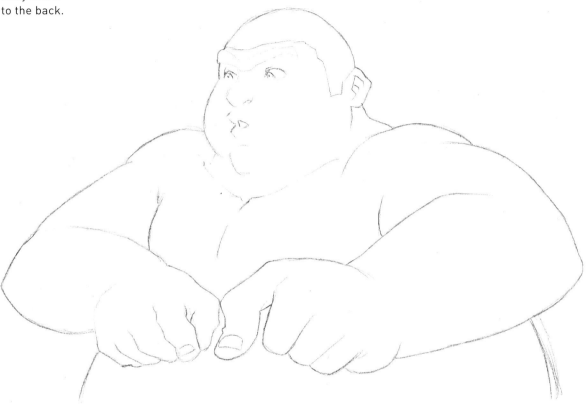

We draw a sweatband on his forehead. The blue smock protects his kimono from being stained. To accentuate his obesity, we draw loose clothes and in this way emphasize the feeling of volume.

We illuminate the illustration by means of a strong light from above, as if it comes from some fluorescent lights that are hanging from the ceiling of the kitchen where our cook works. Fluorescent light produces intense shadows in areas where light does not reach directly, and consequently, very luminous zones where the light hits directly.

Source of light

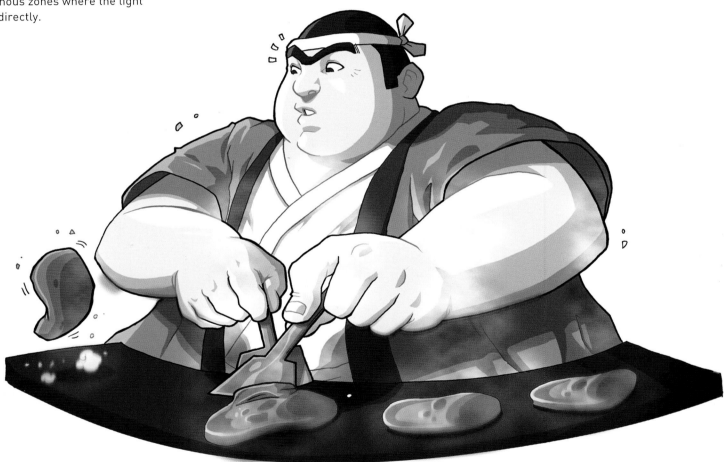

We work with a range of blues even though we use four colors: blue, white, black, and a salmon tone for the skin. We add the effect of steam that the stove gives off with a soft brush and diminish the opacity of this layer of color.

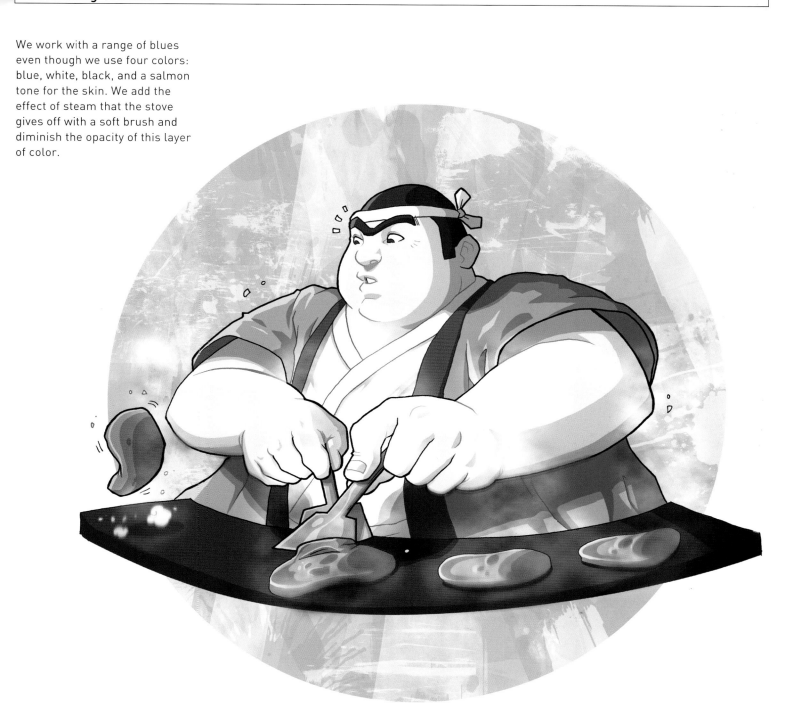

POLICEMAN

The police agent is a man of action, effective and perceptive. He is responsible for the citizen's security and he follows one unique religion: the law. He has a strong and dynamic personality. His presence must be imposing in order to ensure compliance with the law, but the character must also be incorruptible, as it is very easy to corrupt someone with this kind of power. For our character we have opted for an energetic type with a confident expression. We spare no effort in the details and we include most of the regulatory weapons to demonstrate that he is a good sheriff. As a reference in the manga world, we can find the 1985 work *Apple Seed* by Masamune Shirow.

1. Shape

We opt for a posture that reminds one of an equilateral triangle. To block it out, we draw a vertical line for the torso, from which branch out a diagonal for the right leg and an upside down L-shaped line for the other limb.

2. Volume

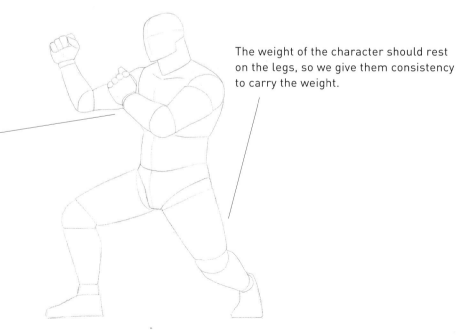

The weight of the character should rest on the legs, so we give them consistency to carry the weight.

We block out the torso. The bent arms should not be much trouble.

Our character is a man in good shape with well-developed muscles. His job is to suppress criminal activity. He must inspire fear in criminals. The facial features are rough and his expression is somewhat cunning.

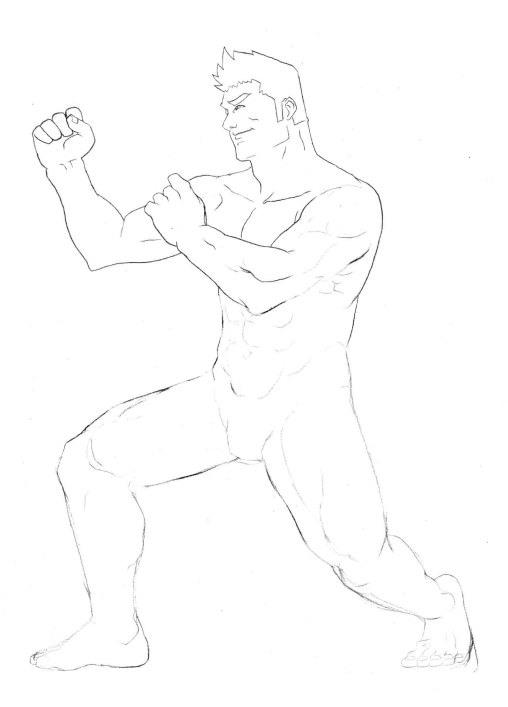

Unless they belong to a special department, police agents wear a blue uniform. If we need help we can always check the Internet and look for police uniforms. We should not forget details such as a billy club and a gun.

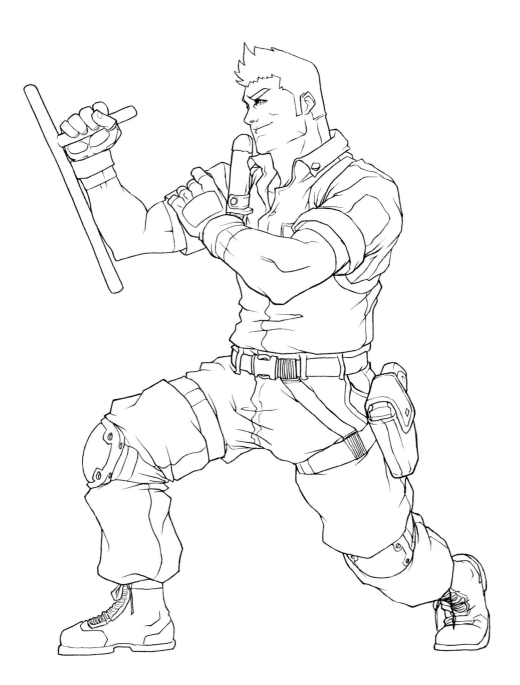

The light is reflected on the character's front, while he stands sideways facing the source. Therefore, all the shadows are to the right, except the one on the arm that holds the billy club.

Source of light

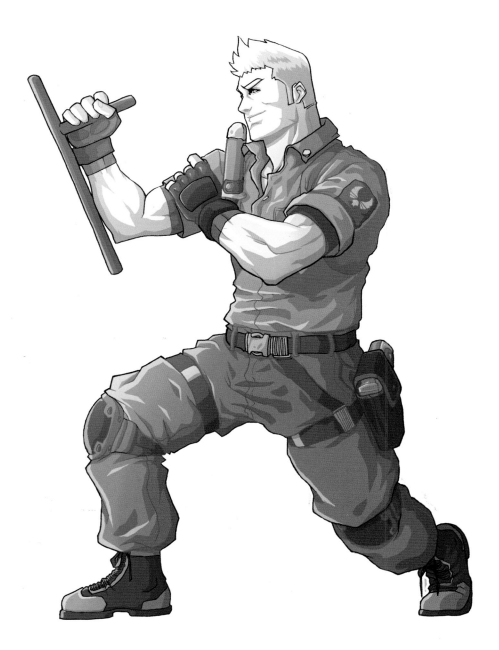

We choose a range of cool colors and we draw a flat base that serves as mid tone. We terminate the shadows with darker tones and the lights with brighter ones. Using brush strokes, we render the explosion in the background.

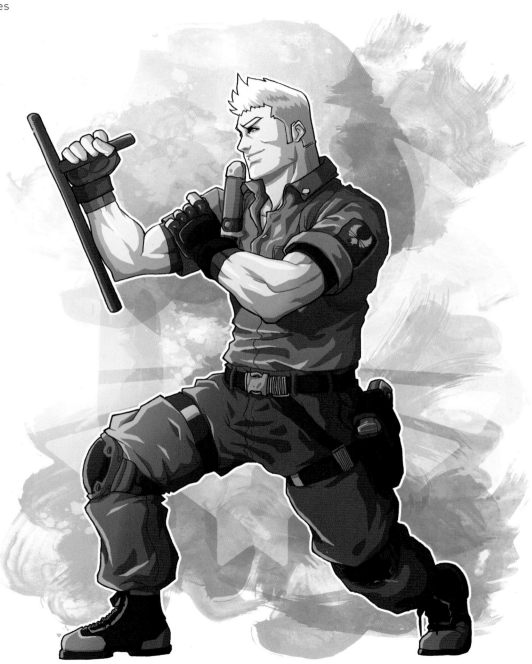

MERCENARY

"If life gives you the sword, do not waste your chance and hit her with your dagger." This is the mercenary's philosophy about life. In exchange for a large sum, he will serve any ideal or cause. Brutal and lethal, their lives are marked by necessity, by their physical and mental preparation, and by death. This type of character has influenced, directly or indirectly, innumerable manga titles, some of which stand out, such as the video game saga *Metal Gear*, created by Hideo Kojima for Konami. Another important title is the manga, *Black Lagoon* (2002) by Rei Hiroe, starring a group of mercenaries in the near future.

It is important that the line of the shoulders and the pelvis are parallel to the imaginary line at ground level to reinforce a feeling of stability.

It is also worth mentioning that the leg that supports all the character's weight should be aligned with the shoulders to form a 90 degree angle with the ground.

2. Volume

So that our mercenary seems an authentic muscle machine, it is important to define the visible parts of his body with barely curved lines, if not straight, to give the feeling of athletic development.

To emphasize the idea of
sturdiness we stylize the body
slightly, drawing square shapes,
which are more stable. The large
volumes and the outline of the
muscles suggest the physical
strength of the character.

The attire is composed of a knapsack, an oversized rifle, green camouflage pants, gloves, a vest with multiple pockets, tall boots, a sheathed gun, and the ID tags.

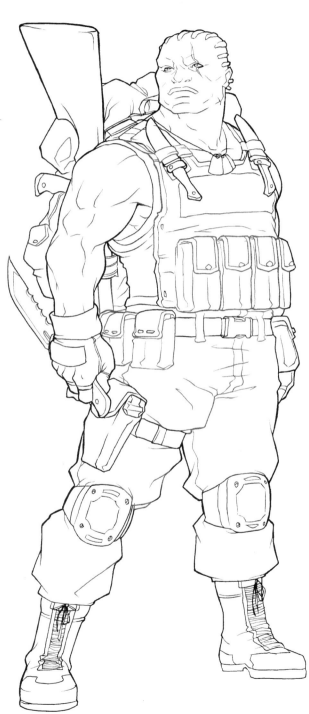

Light comes from the character's back and provokes very sharp shadows in the areas kept in the dark and on the light color surfaces. Be careful with the position and the volume of the character's accessories. For instance, the backpack covers the entire mercenary's back, projecting a sharp shadow to his side.

Source of light

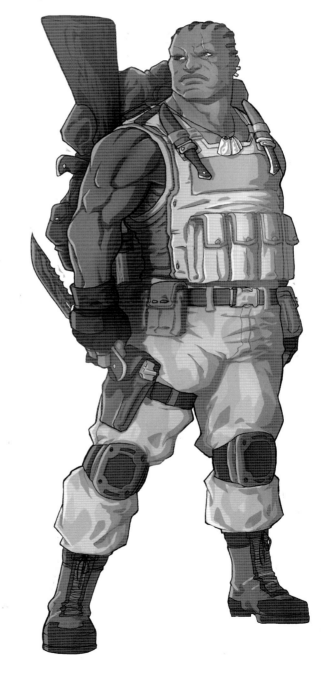

We eliminate the black outline of the areas in a twilight zone to create a misty effect that will allow us to discern the spatial depth of the elements. We add a white outline to bring out the figure in the background.

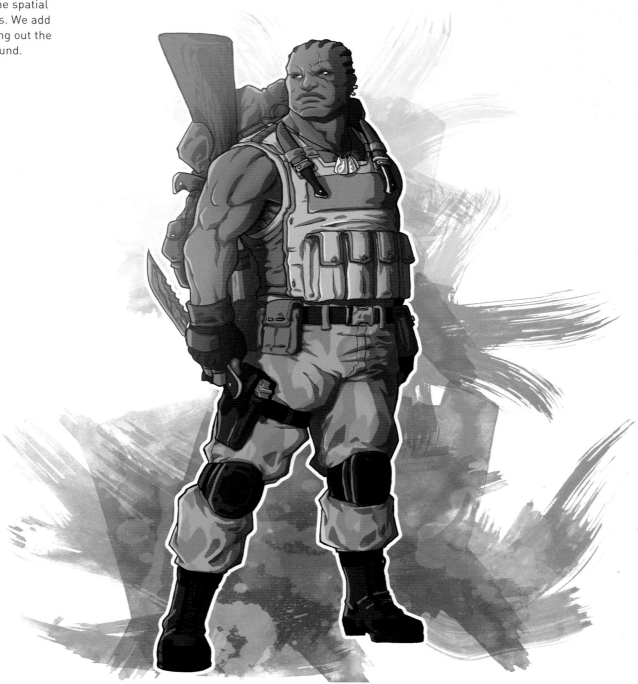

MECHANIC

There is no motor that our mechanic can't fix; in no time at all he can turn any old car into a sports car. There are two car mechanic types in manga: the crude and brutish middle-aged type who'd rather create problems than offer solutions, and, as in this case, the young man who needs to make a little extra money and who drives the girls wild. To give an example of this type of characters, we could look up any manga on *mecha* or on race cars, but we have chosen a humorous one, *Dub & Peter 1* by Akira Toriyamo, narrating in three chapters the crazy adventures of a car mechanic and his friend.

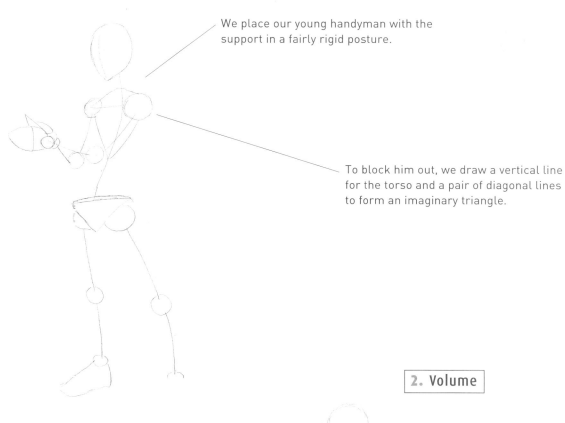

We place our young handyman with the support in a fairly rigid posture.

To block him out, we draw a vertical line for the torso and a pair of diagonal lines to form an imaginary triangle.

2. Volume

When giving the character some volume, we pay attention to his muscles and more specifically, to the upper part of his overalls hanging around his waist. We draw the hanging fabric so that it doesn't look as if it is floating in the air.

The body shape of our character is that of a young man in his early twenties, not too muscular but rather lean. His facial features are more of an adolescent than of an adult in his thirties or forties.

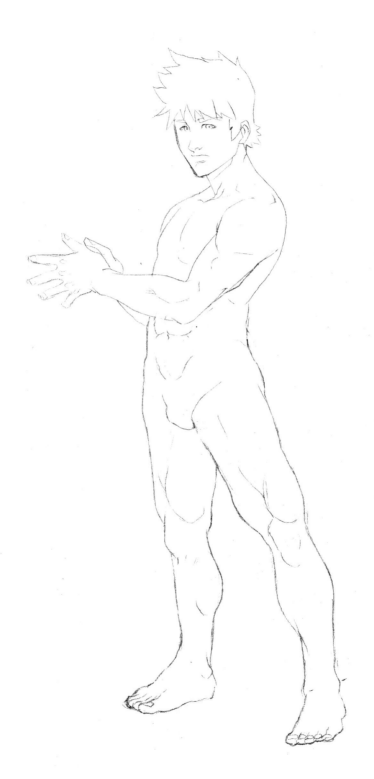

Our car mechanic wears the typical blue overalls and white T-shirt. To give him more charisma and a demeanor somewhere between a hard-working person and a slob, we undo his overalls as if we had just caught him in the middle of a job.

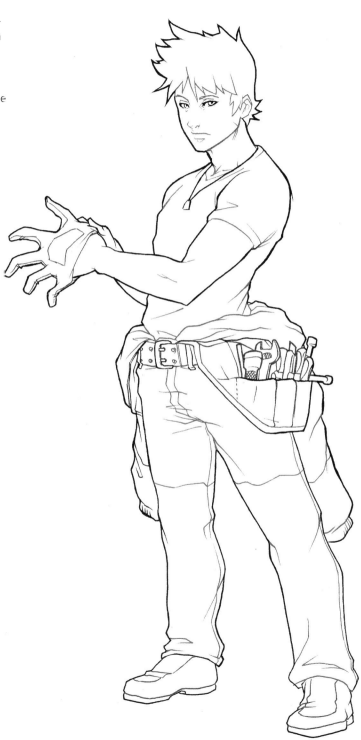

Almost all the light comes from the background, illuminating practically the entire scene. Most of our character receives light except for a small part on the right side and the shadows produced by the folds in the fabric.

Source of light

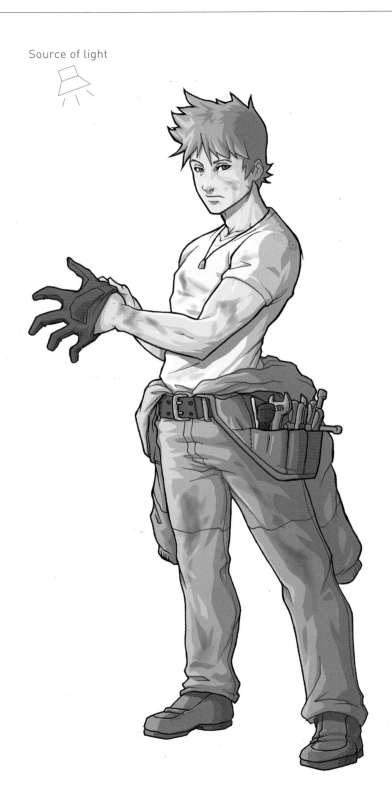

We use four tones: green, white, blue, and pink. We distribute them by zones and delineate the lights and the tones with similar colors. Some blurred black blotches represent oil stains.

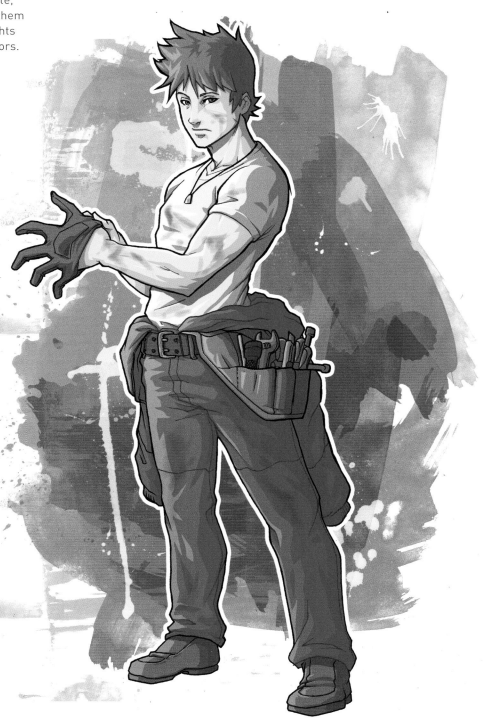

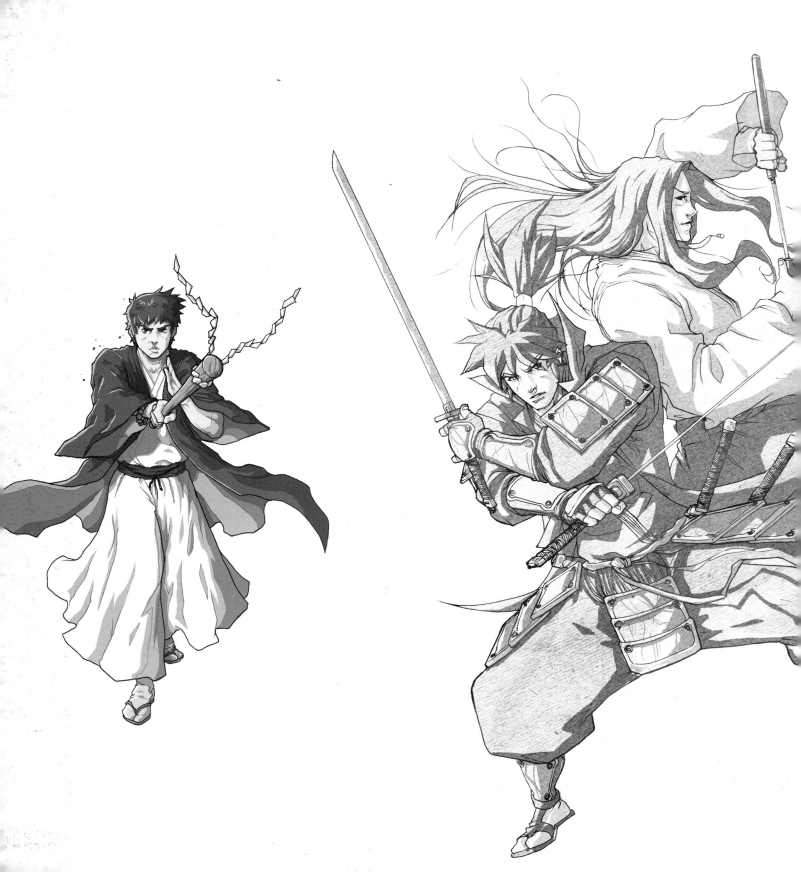

TRADITIONAL

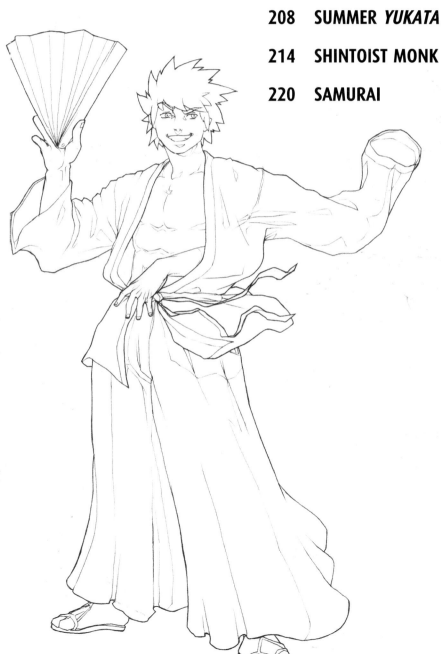

KIMONO

In this exercise, we are not going to talk about a particular character but about how to draw clothes on any of them. The kimono is a traditional Japanese garment. Nowadays, it has almost fallen into complete disuse, usually only being used at parties or commemorative events. In spite of this, and because it is such a characteristic garment in Japanese culture, in manga we find an endless number of characters who wear it. A good example is *Inu Yasha* by Rumiko Takahashi, a fantasy story that takes place halfway between the Japanese feudal era and modern times. In the story the majority of characters wear various types of kimonos.

1. Shape

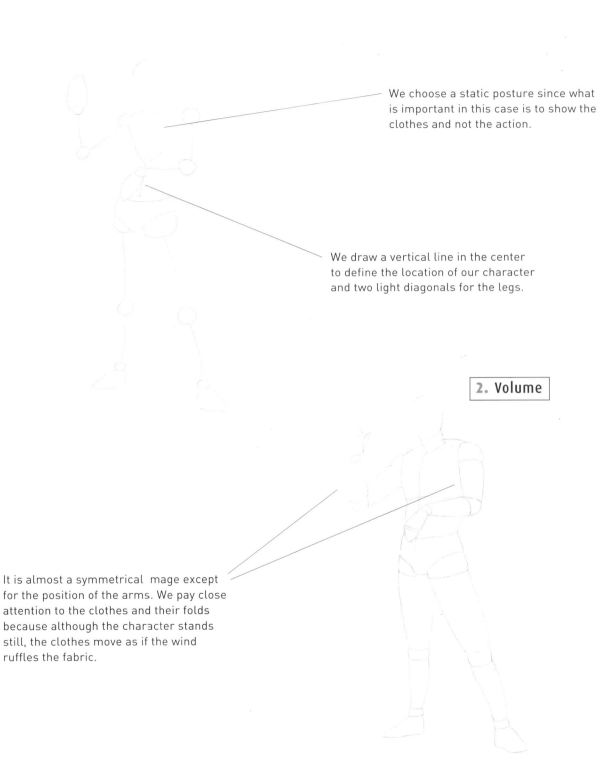

We choose a static posture since what is important in this case is to show the clothes and not the action.

We draw a vertical line in the center to define the location of our character and two light diagonals for the legs.

2. Volume

It is almost a symmetrical mage except for the position of the arms. We pay close attention to the clothes and their folds because although the character stands still, the clothes move as if the wind ruffles the fabric.

We have chosen a young blond with a cunning expression. So that the kimono fits him well, we opt for a stylized physique. In this way attention falls on the kimono, rather than on his body.

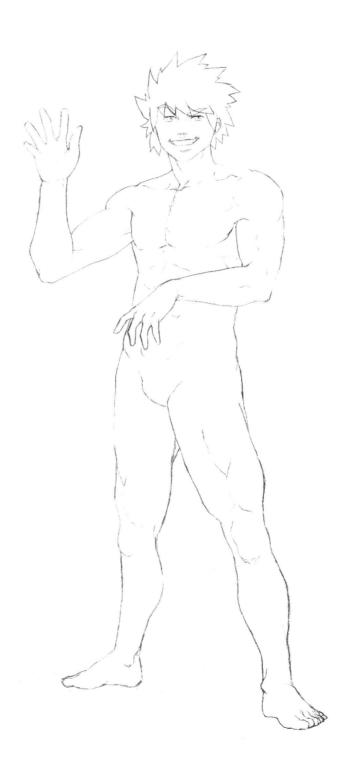

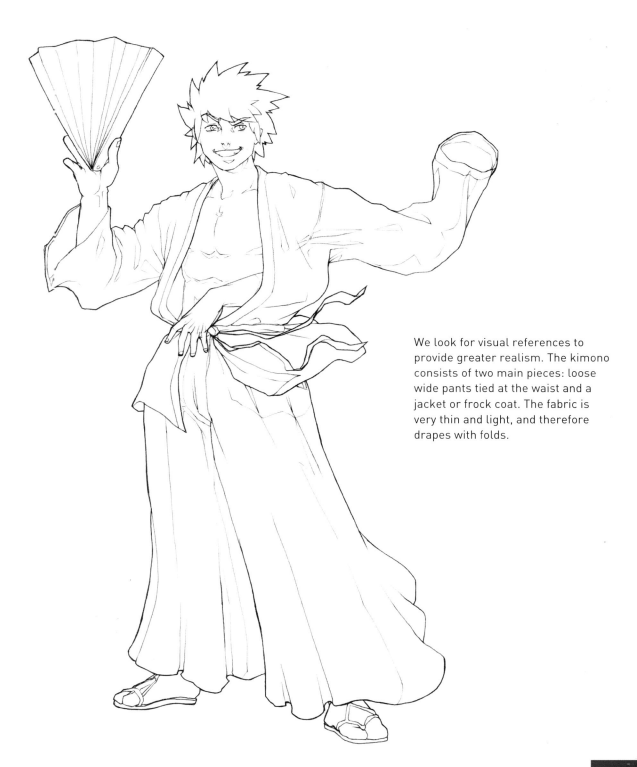

We look for visual references to provide greater realism. The kimono consists of two main pieces: loose wide pants tied at the waist and a jacket or frock coat. The fabric is very thin and light, and therefore drapes with folds.

Lighting is frontal and comes from the left. It is a powerful and artificial light that produces a strong contrast between the illuminated parts and the shadows, which are not so powerful due to their tonality.

Source of light

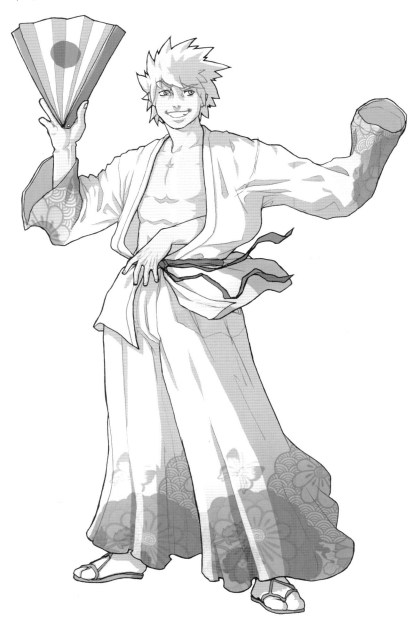

We opt for a luminous range in which pastel colors and whites predominate. For the boy's skin we choose a pink tonality. For the kimono we use white. We paint the shadows and patterns on the kimono blue.

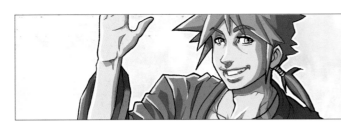

SUMMER *YUKATA*

The *yukata* is the garment of love *shojo* par excellence. Nothing like an extraordinary and comfortable *yukata* to enjoy spare time and Japanese traditional parties. One of the simplest and most efficient devices to set a story and contextualize a character is the use of this simple garment, since it is the perfect outfit to enjoy a day full of confusion that culminates in the beginning of a love affair. Who does not know *Ranma 1/2*, the fabulous title by Rumiko Takahashi published in 1987, and is not able to remember the protagonists' flirtations while always dressed in a *yukata*?

1. Shape

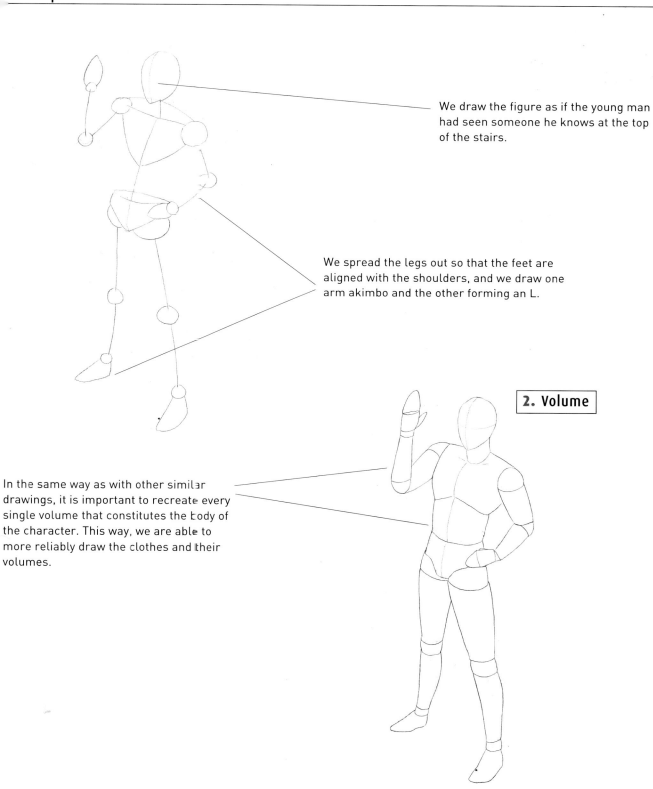

We draw the figure as if the young man had seen someone he knows at the top of the stairs.

We spread the legs out so that the feet are aligned with the shoulders, and we draw one arm akimbo and the other forming an L.

2. Volume

In the same way as with other similar drawings, it is important to recreate every single volume that constitutes the body of the character. This way, we are able to more reliably draw the clothes and their volumes.

We outline the body without many details since it is mostly hidden. We draw our character with a smile, arching eyebrows, open eyes, and a minuscule smile wrinkle by the mouth.

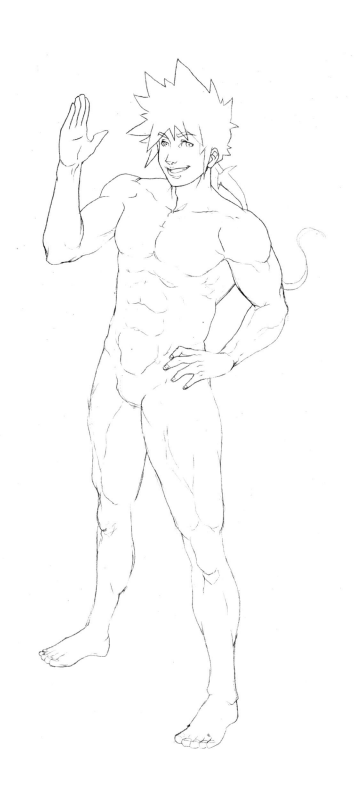

The *yukata* is a type of thin kimono. The attire is completed with a silk belt on top of which is a thin cord that keeps the garment closed. We complete the outfit with a small piece of jewelry around the neck.

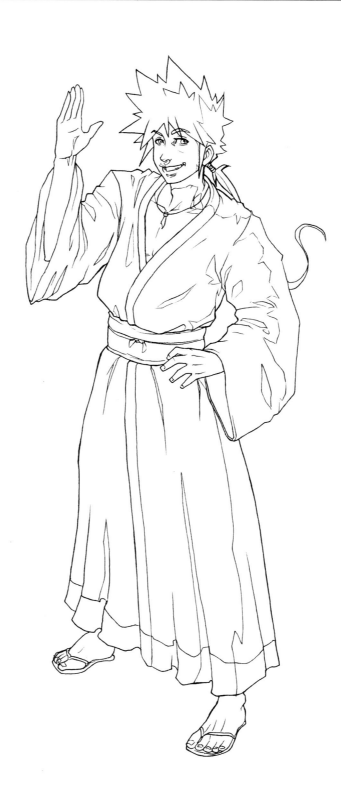

Source of light

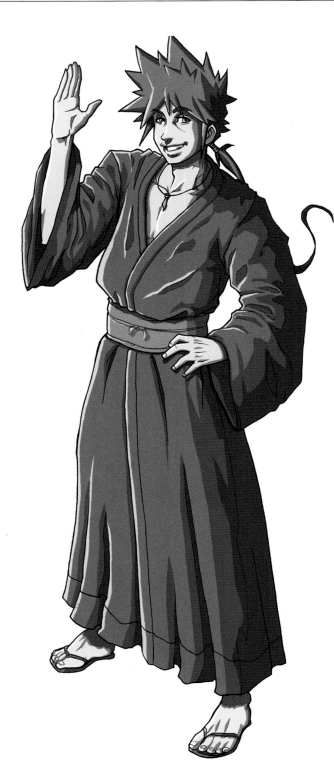

The light comes from a point located towards the left, perhaps some kind of artificial lighting that generates intense shadow zones and other, smaller, very luminous zones.

We use a range of cool colors as a base. We add an elaborate background using brush strokes of cool colors and different opacities to provide our illustration with harmony and a refreshing touch.

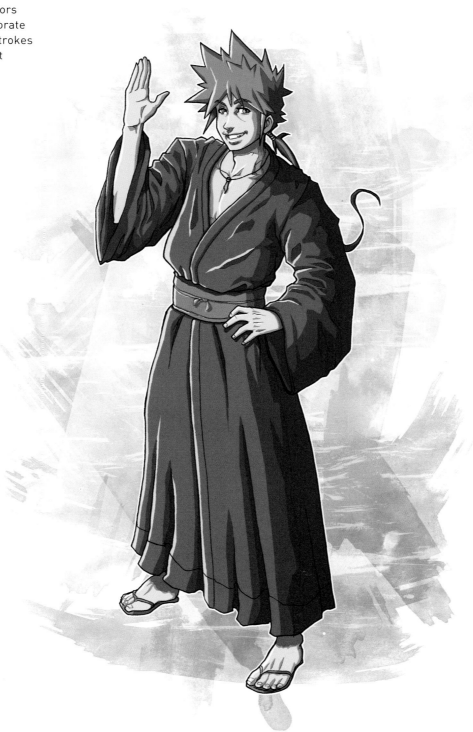

SHINTOIST MONK

This character is one of the most frequently used in novels and in paranormal themes in manga. The monk, in perfect equilibrium of body and mind, is always siding with justice and benevolence; he is knowledgeable about all sorts of dark arts, alchemy and white arts; he fights against the demons, sorcerers, and unjust criminals; and he is just as infallible with his fists as with his prayers. Among the titles that stand out the most is the animation movie *Doomed Megalopolis*, a version of the epic novels by Hiroshi Aramata, in which a sorcerer who is resentful of Tokyo intends to destroy the Japanese capital by means of spells.

We place the elements in the space. We pay attention to the foot in the background which is further back and reduced by effect of the perspective. Our intention is to create a contained gesture, not exaggerated but firm.

2. Volume

We draw the volumes, taking as a reference the arm that holds the stick. We work with simple geometric forms.

We finish up the rest of the body, taking into account the bent knees and shoulders.

The arm that holds the stick is
foreshortened and difficult to draw,
so it is recommended that some
visual reference is established. The
character has a stylized aspect that
is not particularly threatening and
helps us understand the nature of
the monk.

In this illustration, the character stands still, so it is the clothes that suggest most of the action of the scene. The ends of the tunics and the rags around the stick point out and emphasize the tension of spiritual combat.

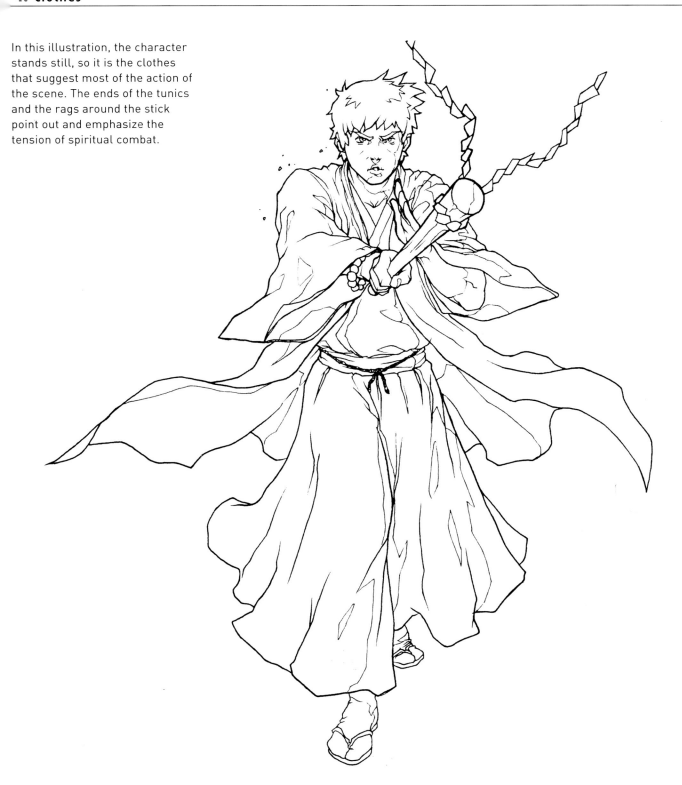

The light is very bright, so we reinforce the contrasts between shadows and lights. The kimono is made of a material with a light tonality so it reflects light more intensely than the tunic which is dark and dull.

Source of light

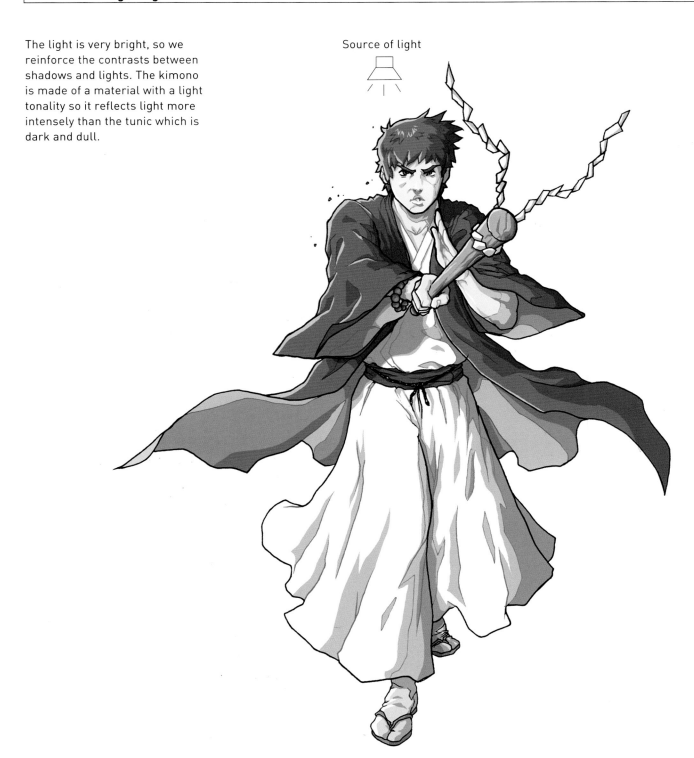

It is important to finish up the volumes of the anatomy before starting with the clothes. To provide the illustration with a more impressive effect, we mark the outline of some shadows. To round off, we add a background with blotches.

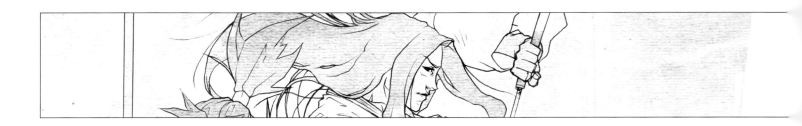

SAMURAI

The samurai, who are much more a part of the Japanese mythology than of its history, were the elite of the now vanished Japanese military which preceded the Meiji era. Skillful in the disciplines of the bow and the sword, and erudite, they served their master until death. Their life philosophy and their heroic deeds have made them the subjects of innumerable novels, manga, and movies. Standing out among them all are the *ronin* samurais who, once they lost their master, followed their own destiny, wandering, protecting the weak and selling themselves as hired assassins to the highest bidder. In this genre the names that stand out are *Usagi Yojimbo* and the mythical *Lone wolf & Cub*.

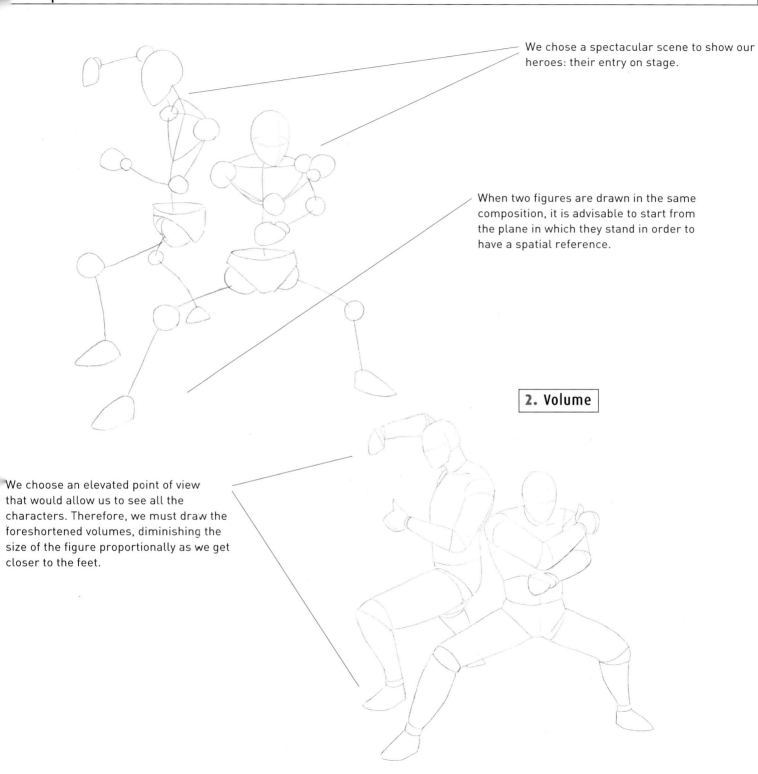

We chose a spectacular scene to show our heroes: their entry on stage.

When two figures are drawn in the same composition, it is advisable to start from the plane in which they stand in order to have a spatial reference.

2. Volume

We choose an elevated point of view that would allow us to see all the characters. Therefore, we must draw the foreshortened volumes, diminishing the size of the figure proportionally as we get closer to the feet.

The bodies of the warriors are strong and agile. Their posture is rigid and tight and their legs are spread out. We draw an expression of determination on their faces. Experienced in combat and focused on their encounter, they know they cannot lose.

The samurai to the left wears armor. He stands far enough away that there is no need to work much on the details. However, we bring out the rivets. The warrior to the right uses only a *katana*.

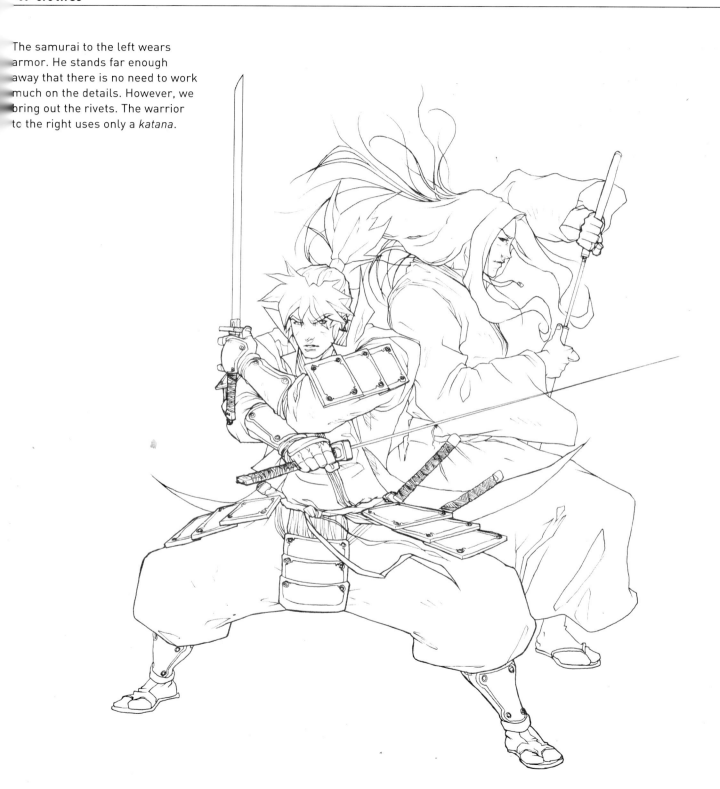

We choose a light source placed overhead and we define the shadows without overdoing them. When drawing bodies close together we add shadows that are cast due to their proximity. This trick reinforces the feeling that they both occupy the same space.

Source of light

In this illustration, color has a symbolic meaning. The clothes and armor of the samurai to the left have red tones, looking aggressive. White, instead, is related to knowledge and restraint. We add a rough paper texture with a soiled and worn-out tone that will help the image to look old.

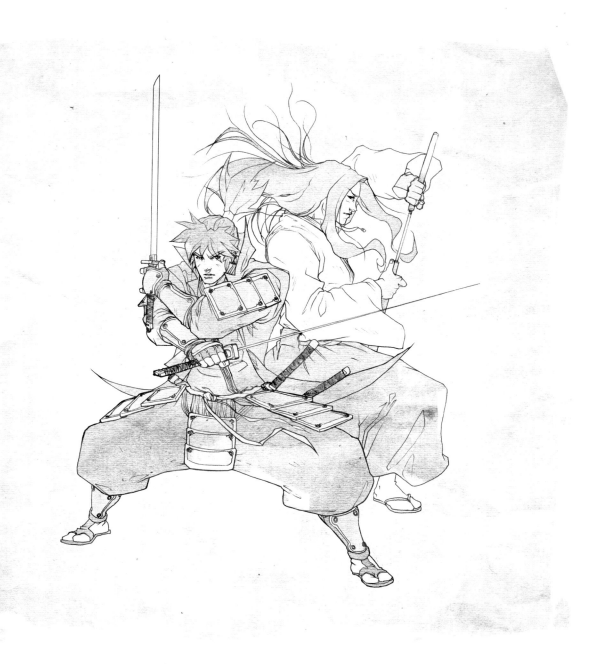

It is important to learn how to
render the characters in a way
that not only differentiates them,
but also provides
them with personality.
We start with the
base colors of every
surface and then
apply the darker
tones for the
shadows.

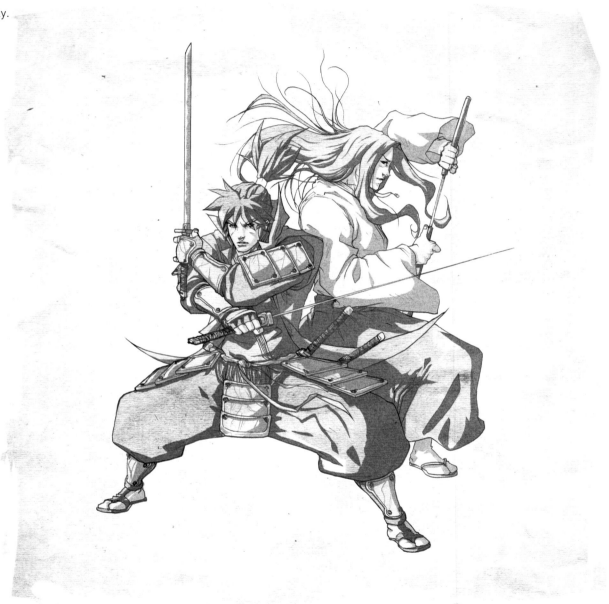

We add one more shadow tone
and another one, more luminous,
for the base. Finally, we draw
some random blotches
and Japanese calligraphy
that will act in the
background, providing
the image with
dynamism and the
characters with drama.

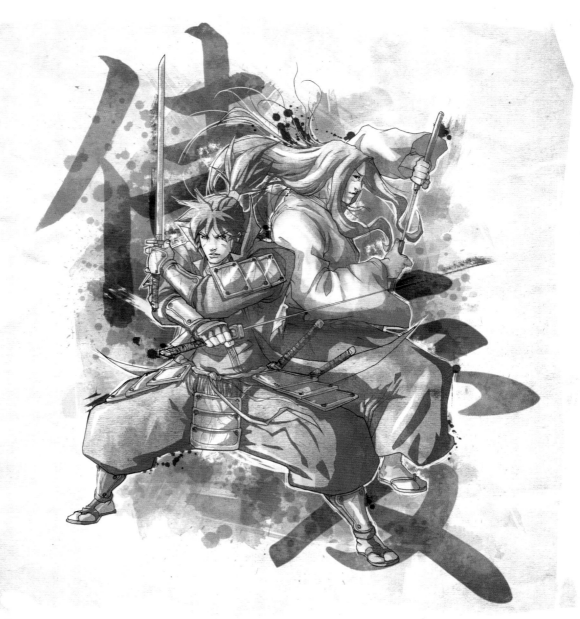

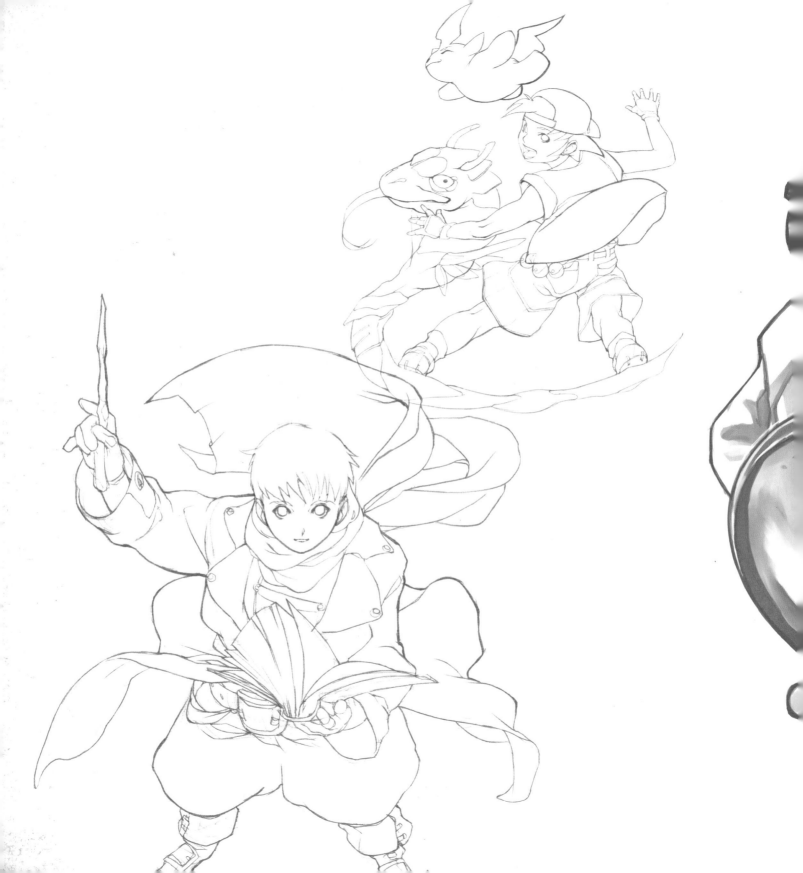

CHILD HEROES

CYBERNETIC BOY

We might suggest that this character is the modern and futuristic version of Pinocchio. It is usually about a boy created artificially with the objective of helping humanity. They are nice and innocent heroes, but very powerful and sufficiently energetic to confront evil face to face. We provide our character with some kind of mark that distinguishes him from any other normal boy. In the world of manga, the idea of cybernetic boy has been explored considerably. Some examples are *Astroboy* from Osamu Tezuka or more recently, *Megaman*, which started with video games and then expanded into manga and anime.

1. Shape

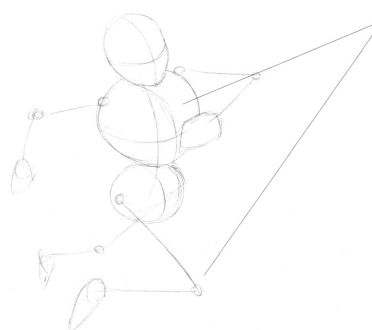

For this vigorous and anxious character, we have chosen a posture of movement. When drawing his structure, we must take into account an almost imperceptible arch in his torso and the position of his legs.

2. Volume

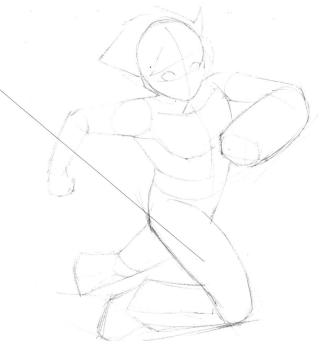

We must avoid stillness because the posture is a bit forced. Pay attention when roughing out the legs because the squat one in the foreground could cause some trouble and the one farther away may seem strange.

The boy's body is not fully developed and his head is proportionally bigger than that of an adult, but he is also a superhero, so his anatomy is a little more developed than that of a normal boy, especially his chest.

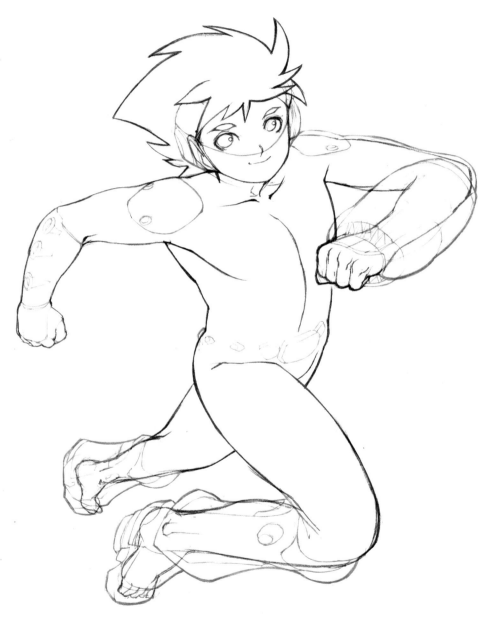

4. Clothes

The main characteristic of this character is a striking and extravagant uniform. Our cybernetic hero wears a tight costume in a bright color that allows good mobility and can be quickly identified.

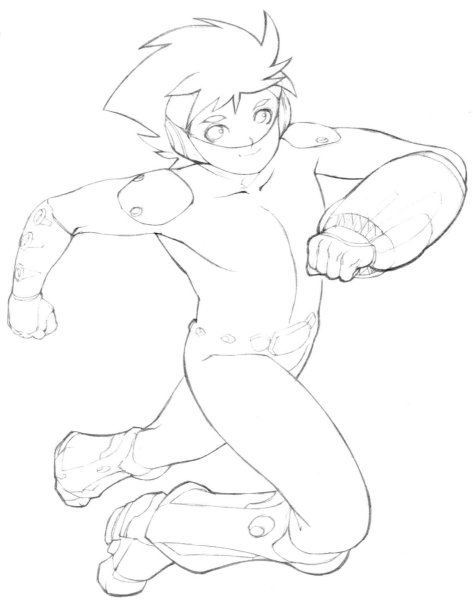

The light source is at the top right corner. The brightest highlights are to his right side. But do not be confused: the character is not completely in front of the light, in which case there would be much more shadow.

Source of light

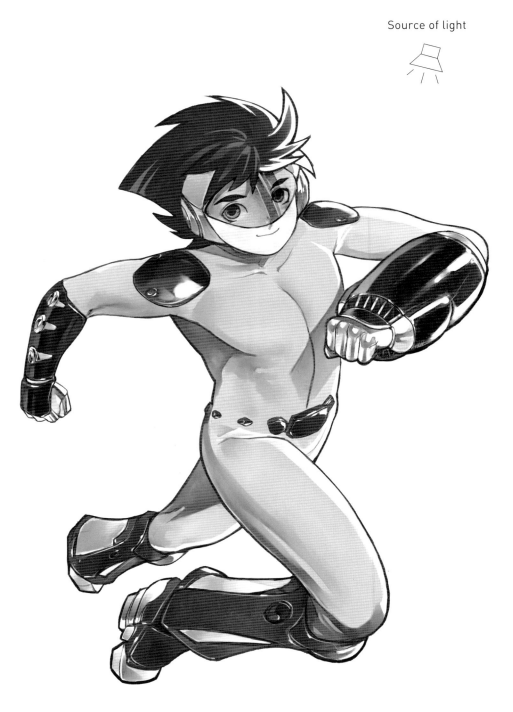

We opt for very bright, loud colors to emphasize his superhero status and provide him with mirth and vitality. We define the highlights on his lycra costume and on the gloves.

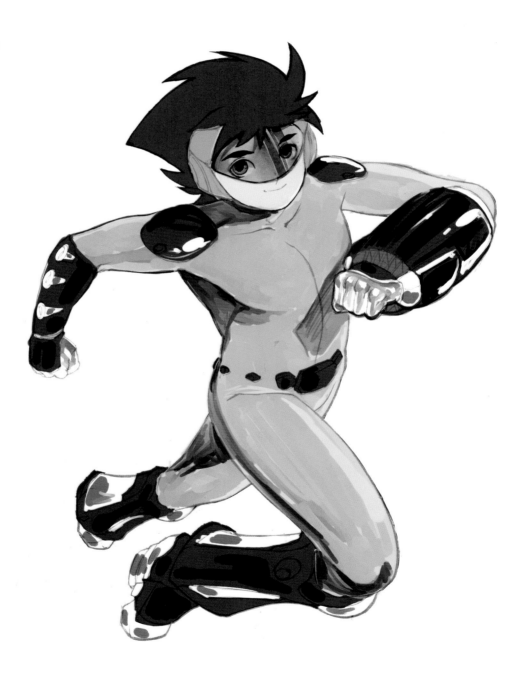

The most intense light outlines the right side of the figure. We draw these highlights and develop the color subtly, without over-stressing the contrasts, given that there is no source of direct light over the rest of the body.

We must not forget the volumes. The boy's costume is very tight and although he does not have big muscles, we need to "suggest" his anatomy to the spectator.

We place the insignia on his chest to complete the costume. Flames come out of his boots to indicate propulsion. We draw a light mark like a kinetic line behind his head to increase the motion effect.

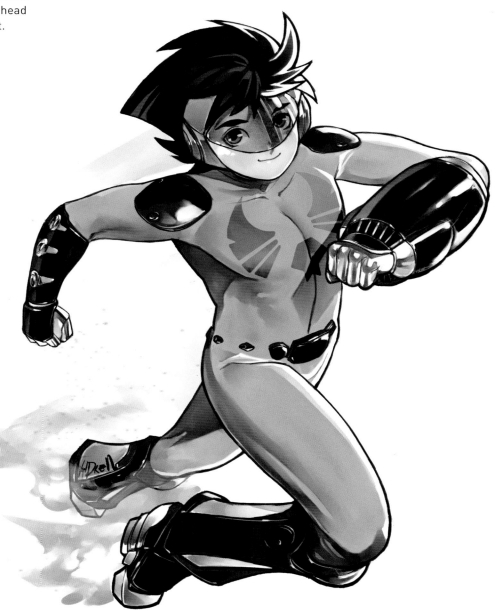

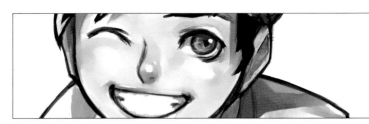

YOUNG DETECTIVE

There is no unsolved case when one of these brave, sharp little children comes onto the crime scene. Their logic is worthy of the wisest person. Generally, they have a harmless appearance, but their psychology is that of an adult. They are eloquent and charming, and keep a childlike grace. Very common in this type of manga is the typical nerdy child. We have opted for a more average-looking boy but with an outfit worthy of the Sherlock Holmes novels. Perhaps the clearest example of the type is *Detective Conan*, in which a young promising investigator is turned into a child.

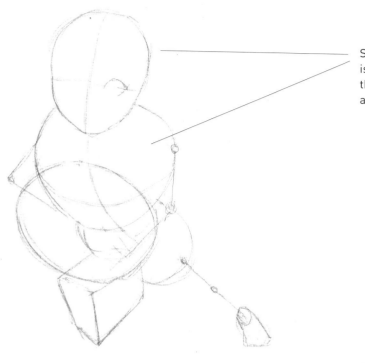

So that the overhead view of the character is correct, we fit him in a cube. Remember that the head and the torso will be larger and that the feet will barely be seen.

2. Volume

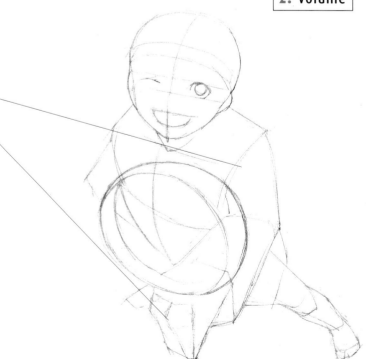

The arm is noticeably foreshortened. Also, the magnifying glass enlarges everything that can be seen through the lens. We draw the volumes according to this perspective and we pay special attention to the hand that holds the magnifying glass.

The shape is that of a child, with a body that is barely formed, a big head and no muscles. Children usually have proportionally larger eyes than adults and the physical traits are softer.

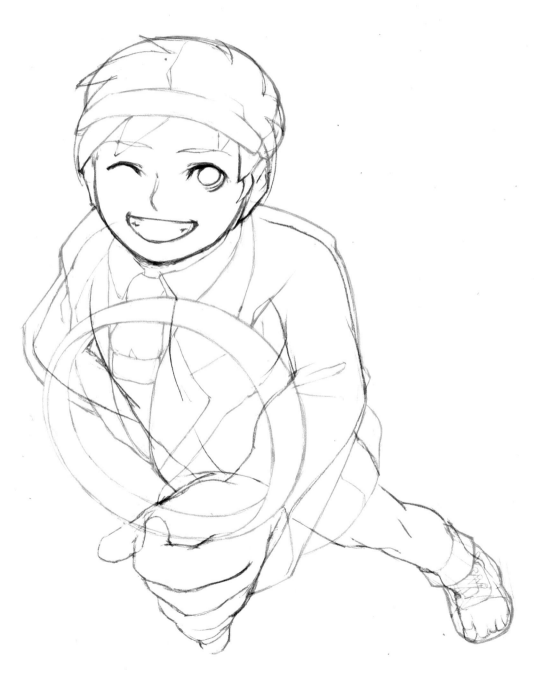

4. Clothes

We dress the character in the style of the first mystery novels from the end of the 19th century, providing him with a retro feeling. We choose short pants and a jacket a few sizes too large to emphasize his psychological and intellectual maturity.

Source of light

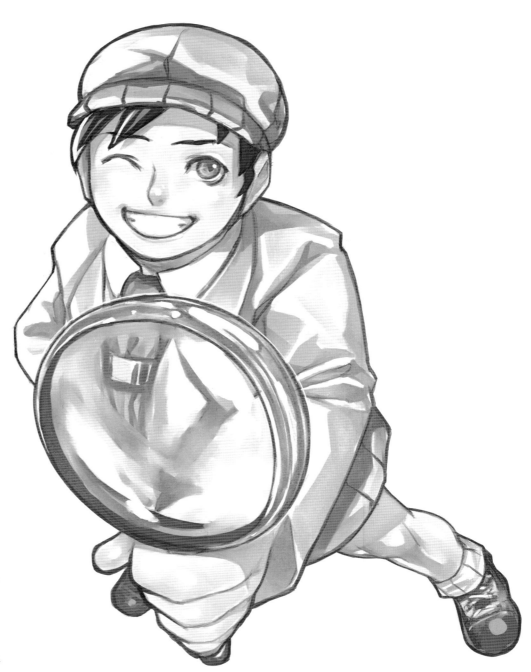

The light that comes from the upper left part of the image is white and artificial, similar to that in a photographic studio. It is a fairly luminous image, as much for the colors used as for the light intensity.

To provide our image with a retro air, we choose pastel and earthy colors. Three tones predominate: the skin tone, the yellow of the beret and the pants, and the pink of the rest of the accessories.

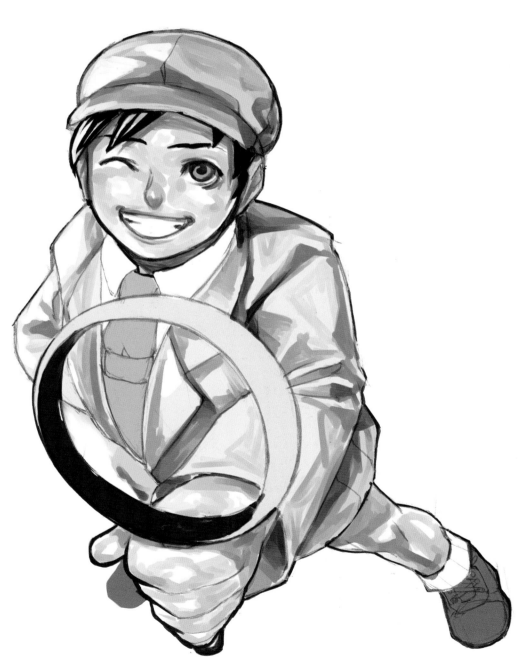

The illustration is quite luminous. We develop the skin by very softly accentuating the cheeks and the nose with some red, not to show shadows, but to indicate the health and youthfulness. The clothes are too big, so we draw a lot of drapes, even though it's a fairly thick fabric. We develop the beret with round and sinuous forms. The only shadow is the one cast by the raised arm.

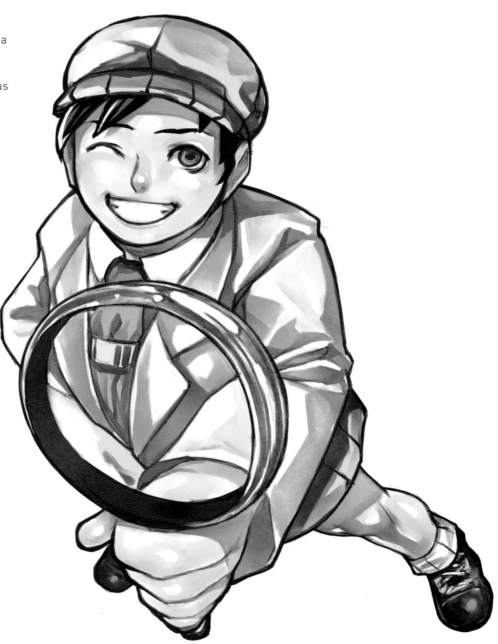

To finalize, we tone down the luminosity of the image so it does not seem so flashy and we add some highlights on the eyes and on the skin. We delineate the magnifying glass as the final touch, blurring what is seen through its lens.

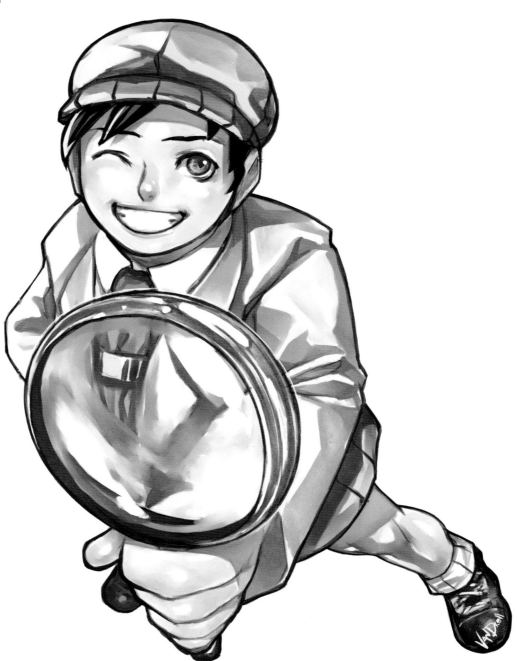

MAGICIAN

What child has not dreamed at times of making the peas disappear from his plate or of flying on a broomstick? The magician kid is capable of this and much more. His appearance is very conventional, which makes him go unnoticed amongst normal people. But when he wears his cape or grabs a magic wand, not even the most powerful dares to cross him. This character does not have a prototype, but he is usually smart and cunning. In manga, this role often falls to a female, as in *Card Captor Sakura*, but currently there is an increasing number of authors that include boy magicians, even if they have a secondary role.

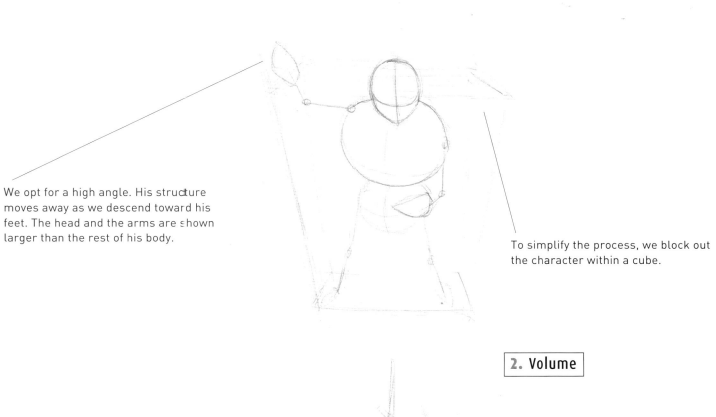

We opt for a high angle. His structure moves away as we descend toward his feet. The head and the arms are shown larger than the rest of his body.

To simplify the process, we block out the character within a cube.

2. Volume

We develop with greater detail the areas that are in the foreground. The lower part of the body has less importance. The lightness of his costume gives a feeling of motion, as if the character was in the center of a tornado.

The way his body is treated is similar to that of the cyber kid, although the magician is older, so his anatomy is much more stylized and less soft. We maintain the large proportion of the head.

Without his attire, the magician boy is nothing more than a child, so we design a cute outfit. His clothes are large and light. The movement of the coat and the scarf emphasize the feeling of "magic atmosphere."

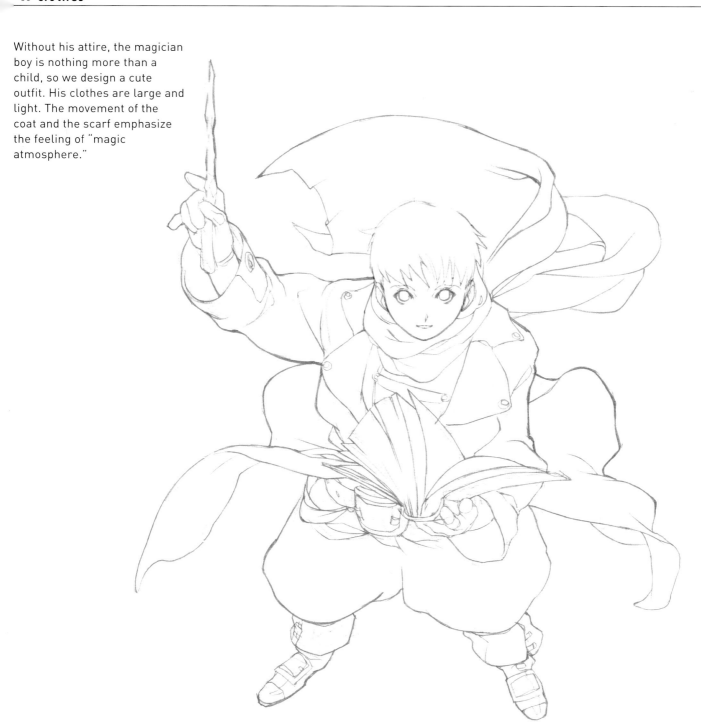

The most intense light comes from within the book because the boy is casting a spell and a luminous glow emerges from the pages. The lower part of the boy is kept in the shadow while the face and the arm holding the magic wand gleam.

Source of light

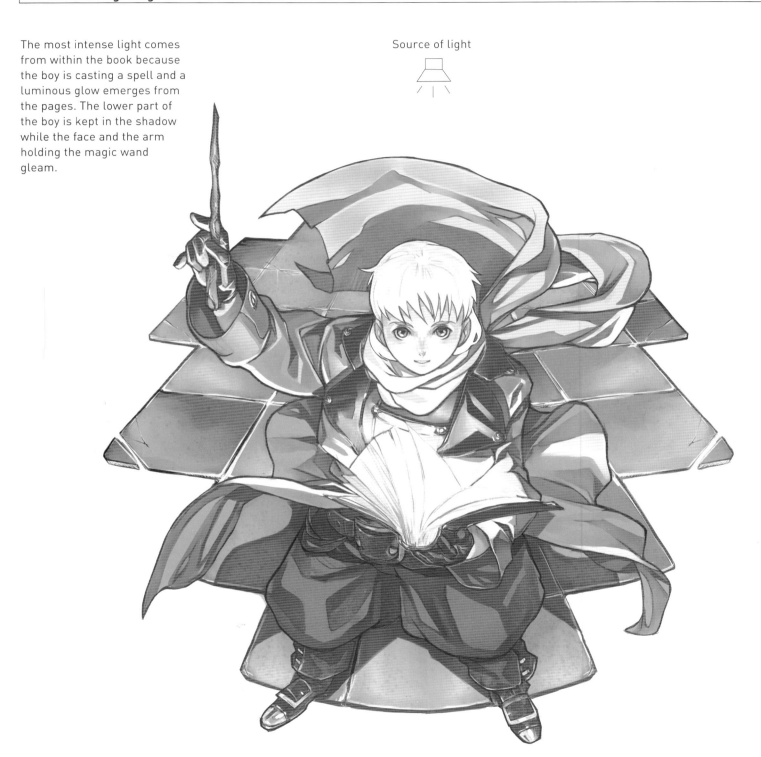

We have selected a range of cool colors that, combined with the light from the book, provide the illustration with a mystical atmosphere. A blotch of color on the paper indicates where the ground is.

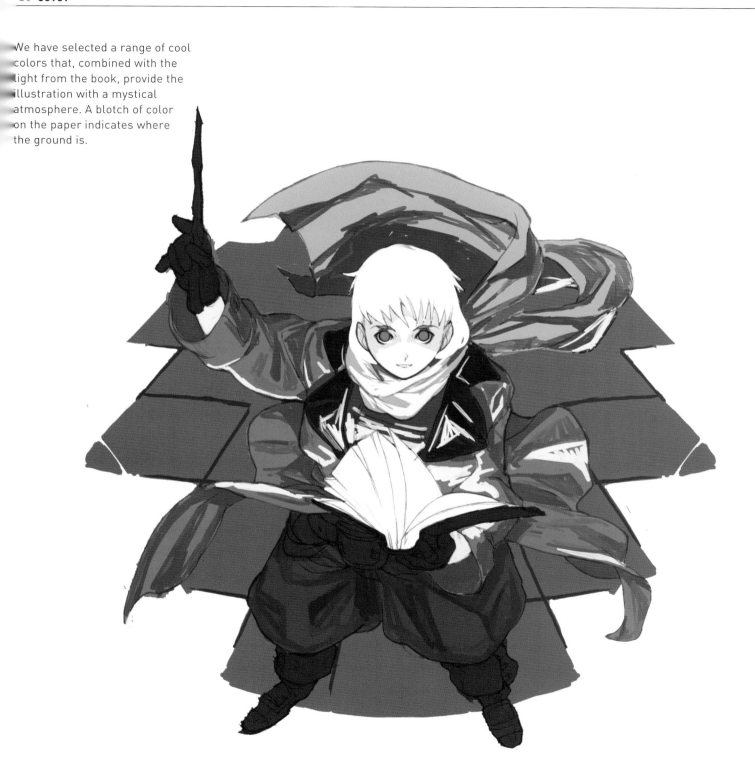

Once the color base is applied with flat shades, we start with the volume and the textures. We draw the wrinkles in the clothing to achieve greater volume. Also, we touch up the mid tones of the shadows and the lights.

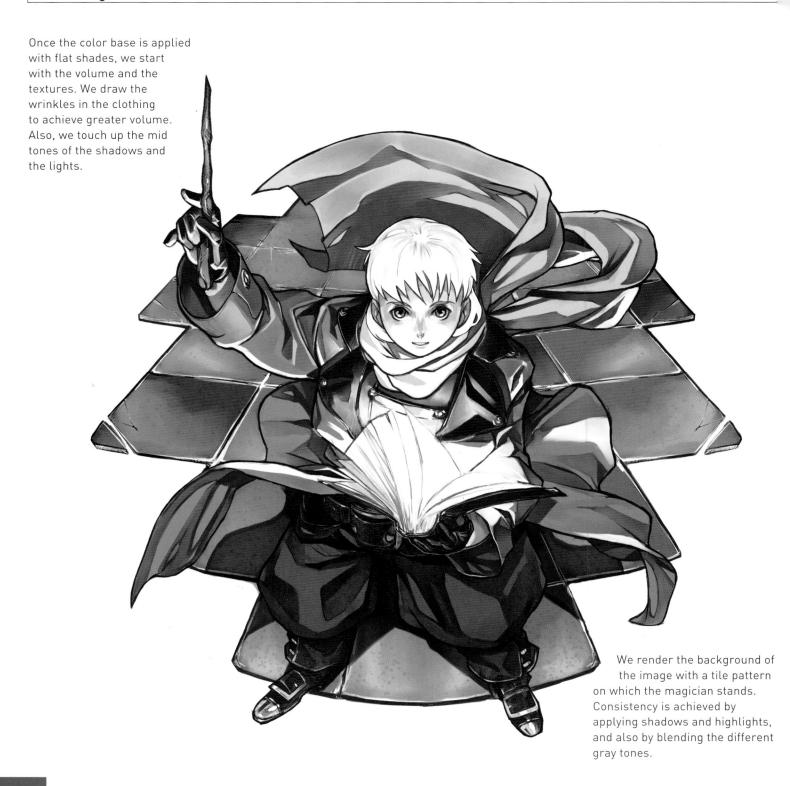

We render the background of the image with a tile pattern on which the magician stands. Consistency is achieved by applying shadows and highlights, and also by blending the different gray tones.

We put in the light that emerges from the book. We reinforce the tones of the colors in the drawing and add contrast where we want to visually accentuate. Be careful with the reflections on our young magician's face.

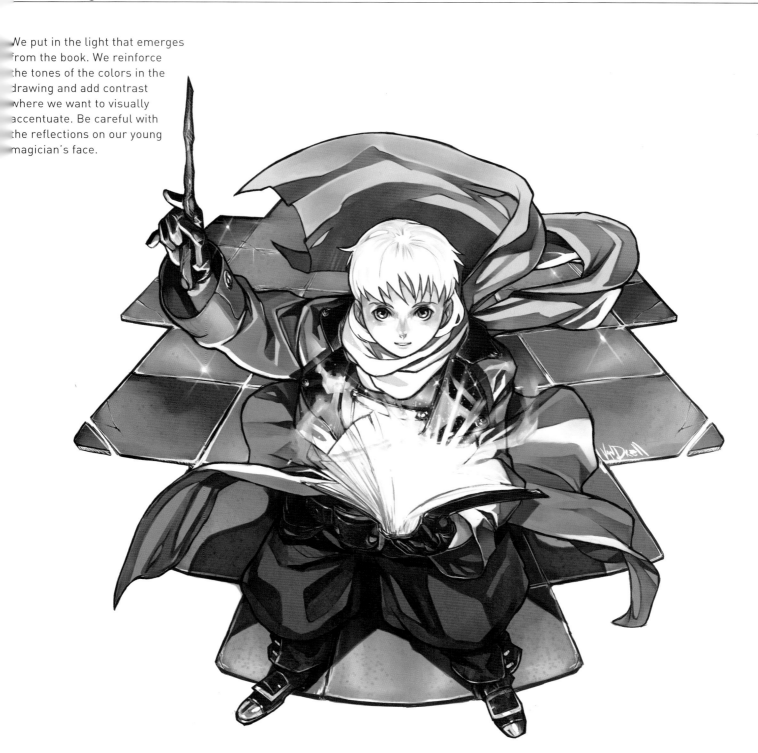

BOY & PET

Tireless adventurers, the values of this type of character are camaraderie, friendship, and sacrifice. One way or another, these youngsters acquire a pet, or various pets, and automatically they become the pet's trainer and friend. For this role we have chosen a boy of 10 or 12 years. With him, are two of his pets. The first one is a kind of dragon or large snake that seems aggressive and tough. The second is the typical stuffed animal that in spite of its sweet appearance hides an unsuspected power. In manga we find examples of this type of character in tittles such as *Pokemon* or *Digimon*.

1. Shape

For the upper pet, we draw a circle.

We start from the bottom part, drawing an S-shaped line for the snake. We mark two diagonals (the boy's legs) over the line forming a triangle.

2. Volume

This is a very dynamic image, so to represent movement, we pay attent on to the volumes in the clothes which float in the wind. The skins of the pets are hard and scaly for one, and soft and velvety for the other.

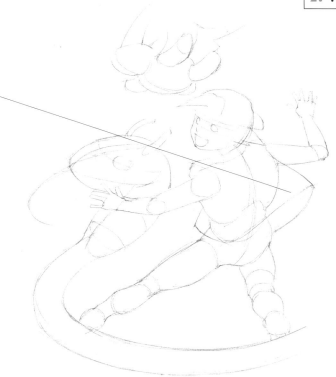

Our character still keeps a kid's
typical small frame, but his
muscles already start to show
some form since the boy exercises
a lot while training his pets.

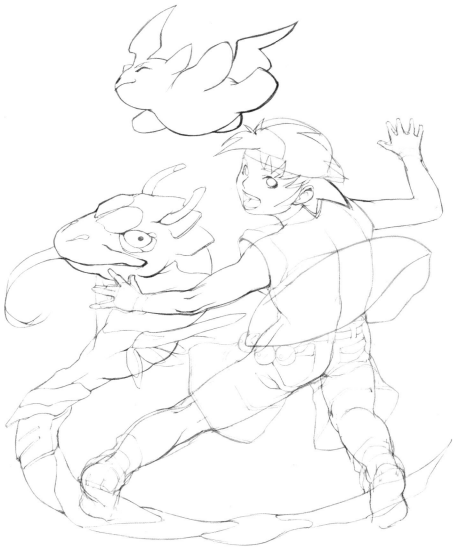

4. Clothes

Our main character wears
comfortable clothes so he can run
across fields. Nevertheless, he is
trendy: practical but with style.
We add accessories such as a
baseball cap worn backwards,
common among bad boys.
Careful with the volumes!

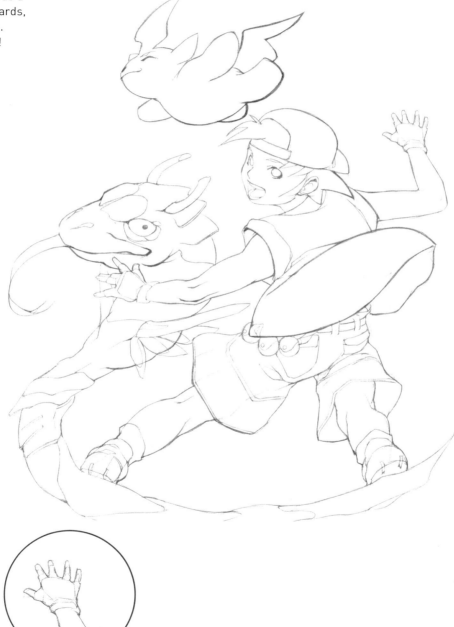

Source of light

The image in the background is lit with an ambient light that the mist puts in a second plane. Lighting for the characters comes from the upper left corner. It is a white natural light that originates in the sky.

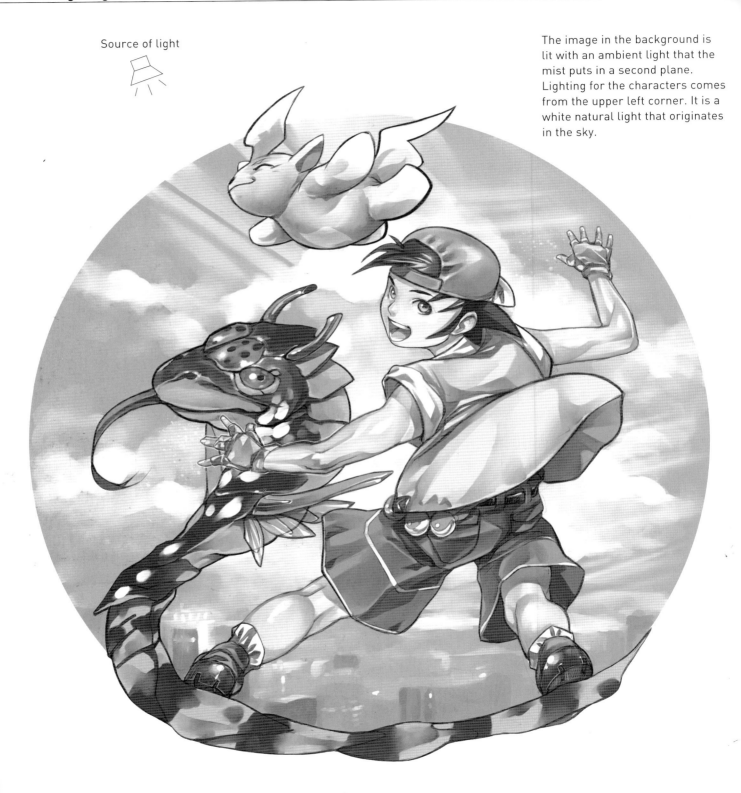

We choose luminous and varied colors. For the background, blues and whites. For the pets, baby blue (gentleness) as well as brown and red tones (aggressiveness and toughness). For the boy, flat and cheerful colors which emphasize his energy.

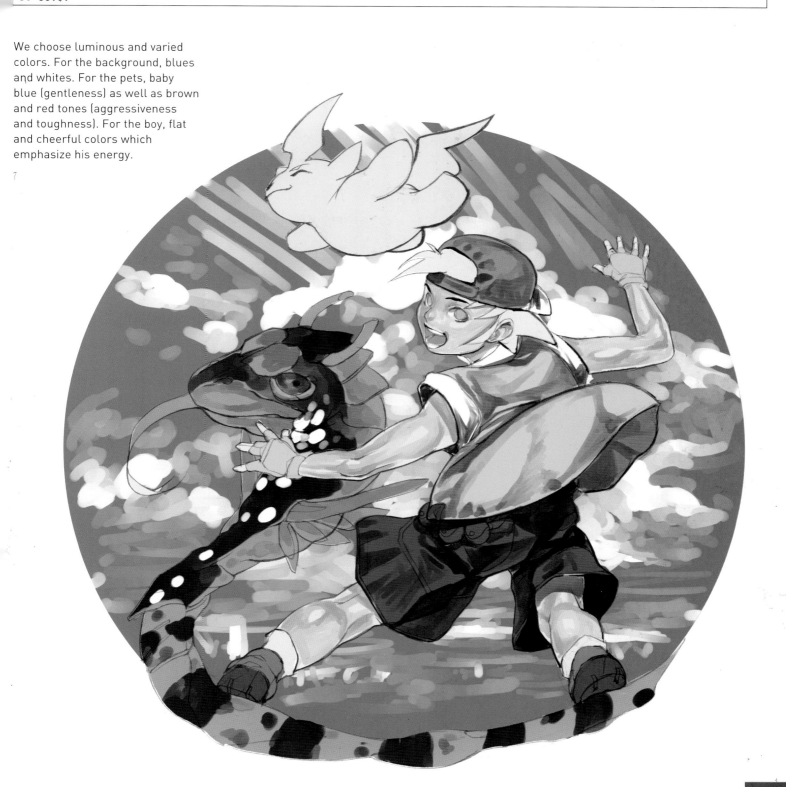

We develop the color with more intense tones. For the snake, we blend the colors, but the lights are sharper when bouncing on the hard and scaly skin. The color for the fluffy little pet gets much lighter.

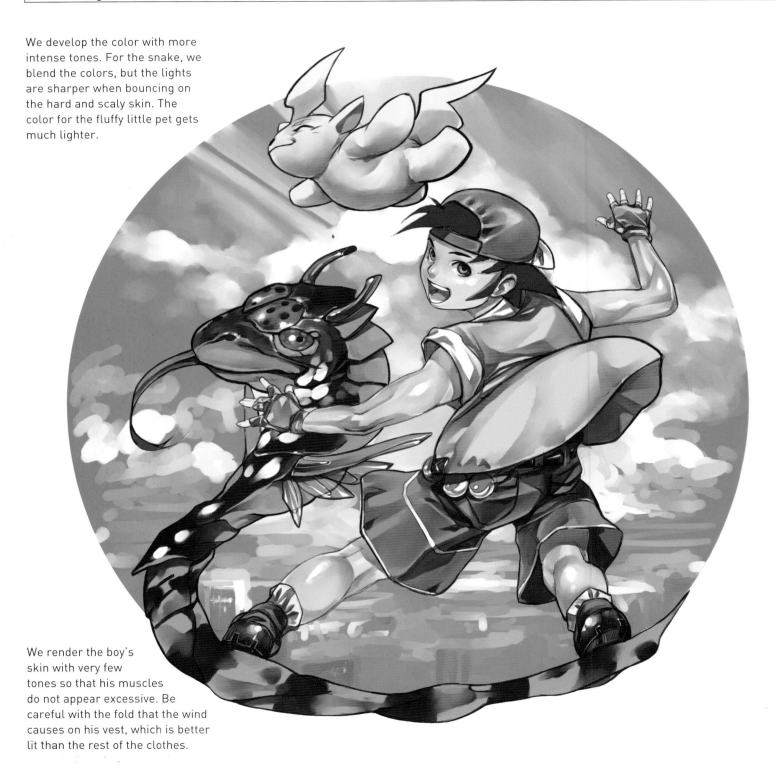

We render the boy's skin with very few tones so that his muscles do not appear excessive. Be careful with the fold that the wind causes on his vest, which is better lit than the rest of the clothes.

We delineate the sky and the city in the background. We include new lights which enliven our illustration.

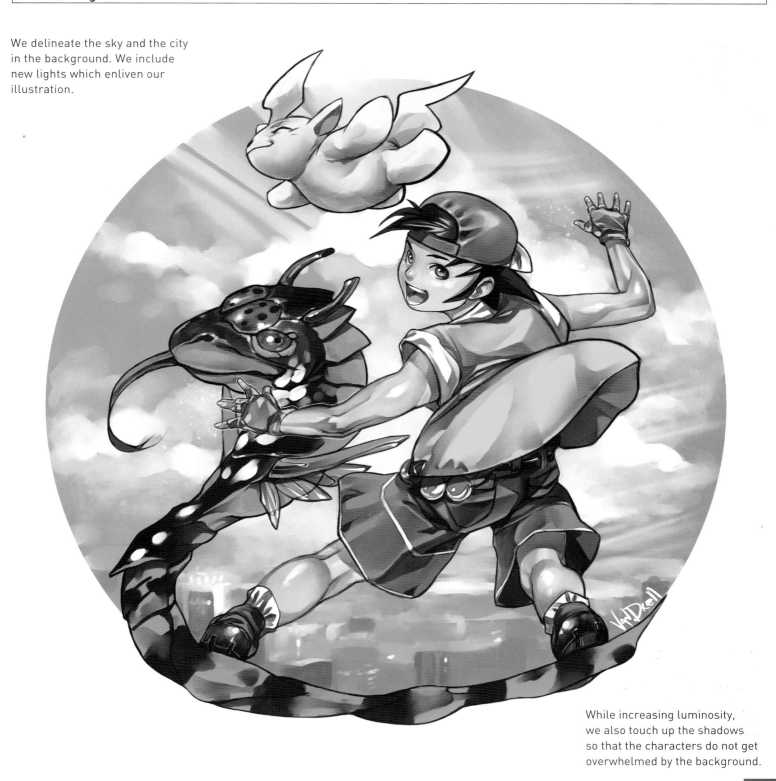

While increasing luminosity, we also touch up the shadows so that the characters do not get overwhelmed by the background.

MAGIC CARD FIGHTER

A well-known genre in Japan is that of duels with magic cards, where people frequently play tournaments. These youngsters, high school students, become real fighters when they have a deck in their hands. Our character can have any physical appearance we want since it isn't necessary for him to appear to be special. However, it is important to provide him with a defined character and to design a good deck with magical beings emerging from it. The more imaginative and extravagant, the better. A clear example in this genre is the famous manga *Yu Gi-Ho*, which is also in anime and decks of cards.

We place the teenager in the center of the composition and we also draw a fantastic being.

We trace two diagonal lines that form, along with the character, an equilateral triangle.

2. Volume

We pick a point of view from a slightly low angle, taking into account the perspective of the illustration and the planes, since we see in the foreground the young man's foreshortened hand and the invoked dragon.

The character's body is not fully developed. The proportions are similar to those of an adult, but our hero is more subtle and has an infantile air.

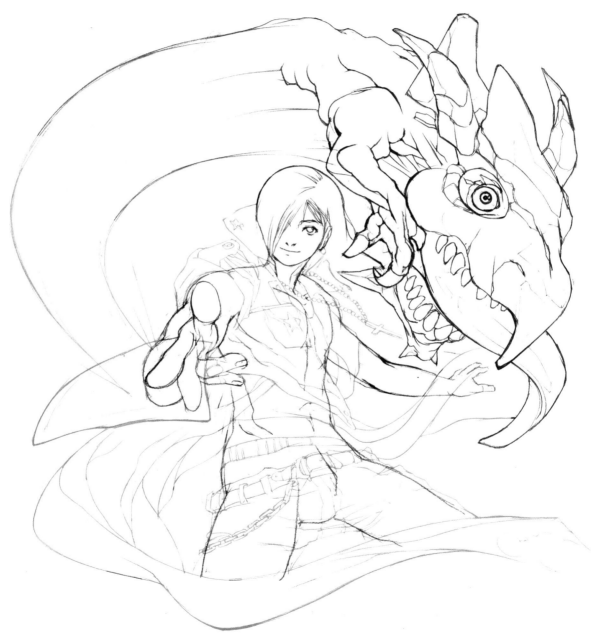

4. Clothes

Our dueler wears a striking vest and conventional jeans. We add accessories such as the belt, the pendant, and the chain.

Source of light

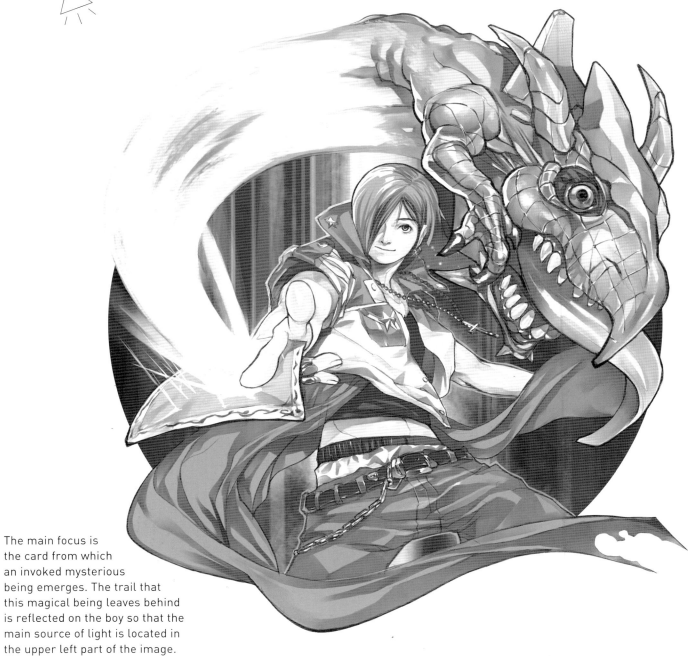

The main focus is the card from which an invoked mysterious being emerges. The trail that this magical being leaves behind is reflected on the boy so that the main source of light is located in the upper left part of the image.

In this illustration, green and blue predominate in the background and the dragon. We develop some of the animal's tones, which will facilitate the viscous and shiny texture of its skin.

Once we have the base finished, we add the mid tones and we blend them to form the volumes. We develop with great care the luminous effect that emerges from the card as if it were a waterfall.

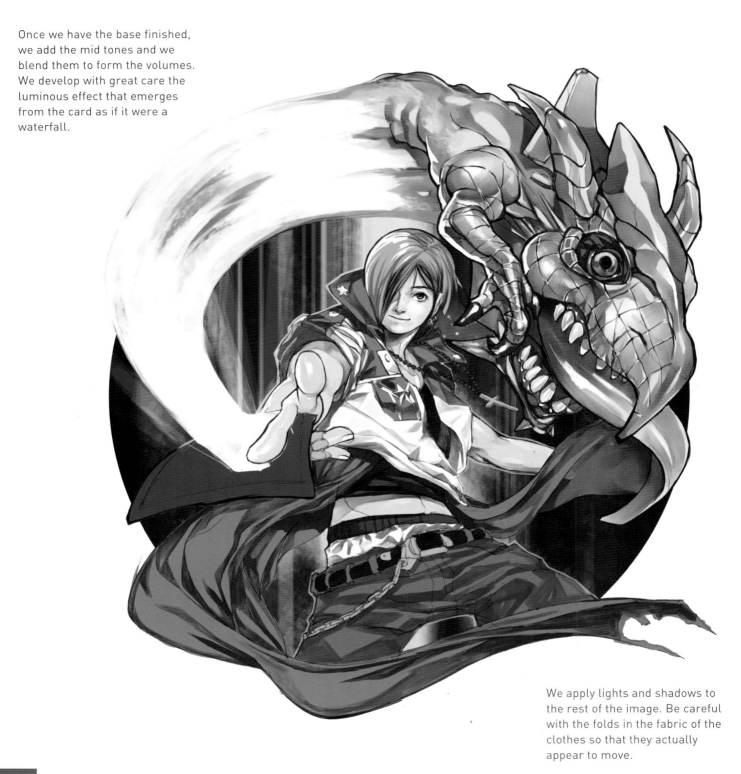

We apply lights and shadows to the rest of the image. Be careful with the folds in the fabric of the clothes so that they actually appear to move.

We place the light source over the card, which will attract the reader's attention. We develop the last details, such as the highlights on the dragon and the blue trimming that makes the boy to stand out from the background.

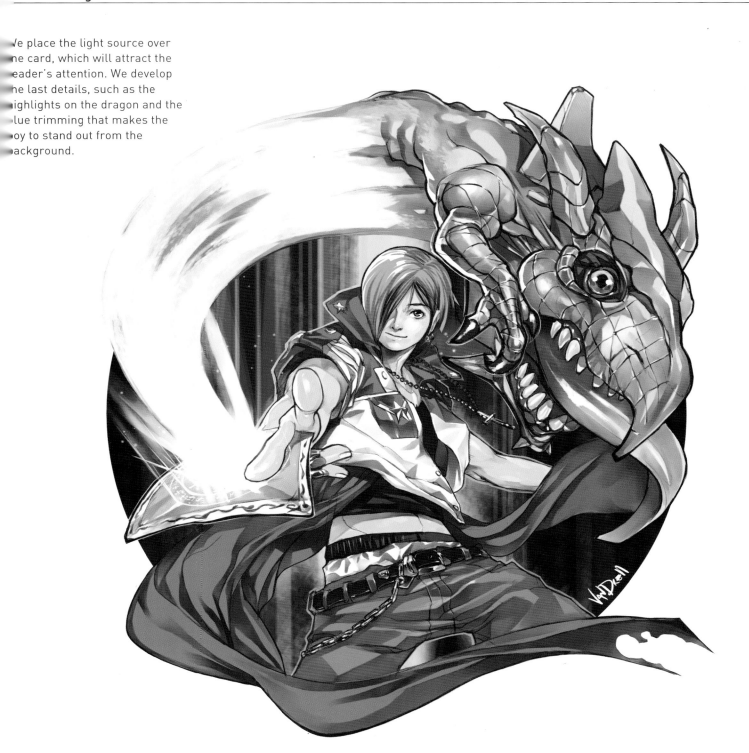

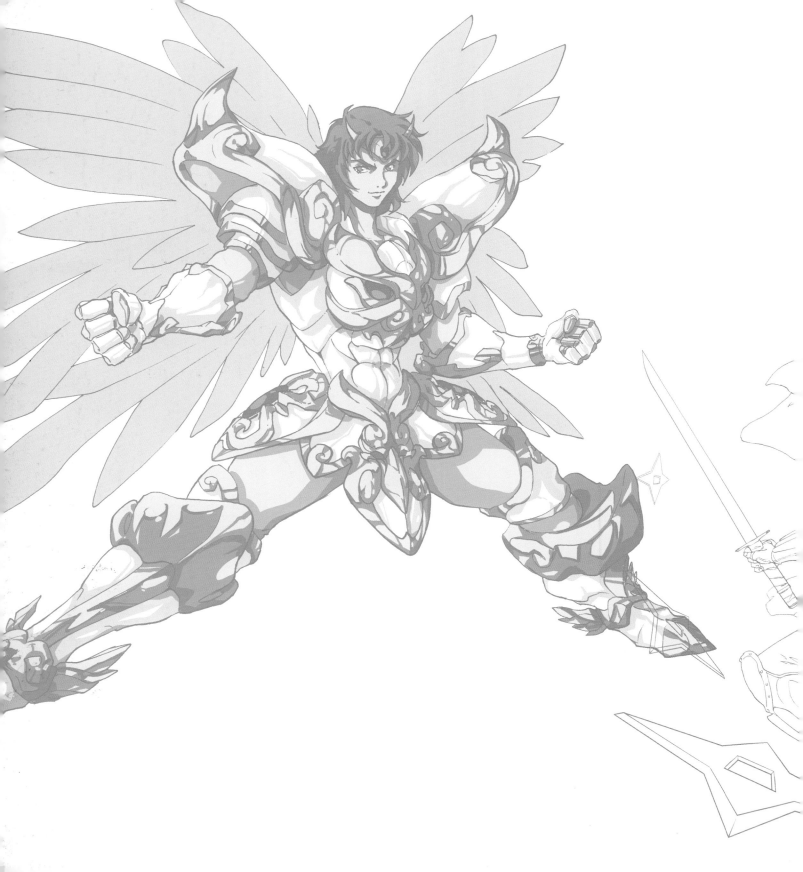

HEROES IN TIME

MEDIEVAL KNIGHT

Mangas and animes set in the Middle Ages are usually more inspired by the heroic fantasy archetypes and the sword and sorcery legends than by historical and documentary sources. One of the great inspirational sources is the epic literature and the worlds created by J.R.R. Tolkien. This genre mixes in an eclectic way elements belonging to medieval times and others much more modern. On the other hand, in the video games of this genre, we can find the most innovative and fantastic designs, like the one we develop in th s exercise.

1. Shape

We choose an epic scene with a lot of tension. The lines of the body structure are not curved or loose since the posture has to suggest weight, security, and consistency. We quickly block out the weapons and the helmet.

2. Volume

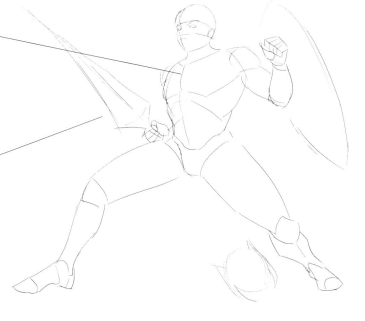

We draw volumes of a considerable size because our character is short and very muscular.

The arm that holds the spear is completely hidden, but it is recommended to draw it so we can draw the hand at the right height.

Our character is of wide and robust proportions. We give him a huge back and a similar chest that helps him support the weight of the weapons and of the armor. We draw the main thorax muscles.

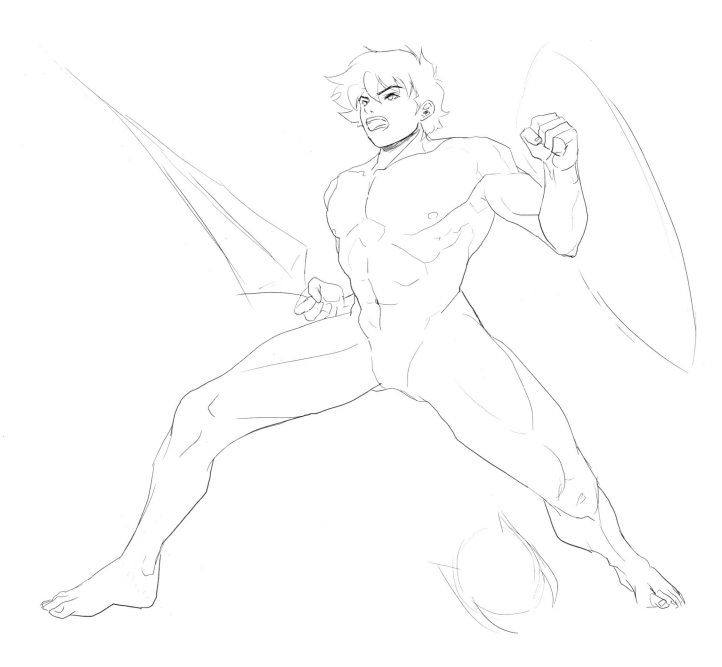

4. Clothes

We develop the armor and clothes of a traditional medieval knight and we modify the forms until we achieve an attractive mix of old and modern elements. However, we should not lose the characteristic medieval essence.

To achieve the highlight effects on the metals, it is necessary to use contrasting tones because they better represent the reflection of light. Other types of materials such as the clothes and the skin do not reflect light as well.

Source of light

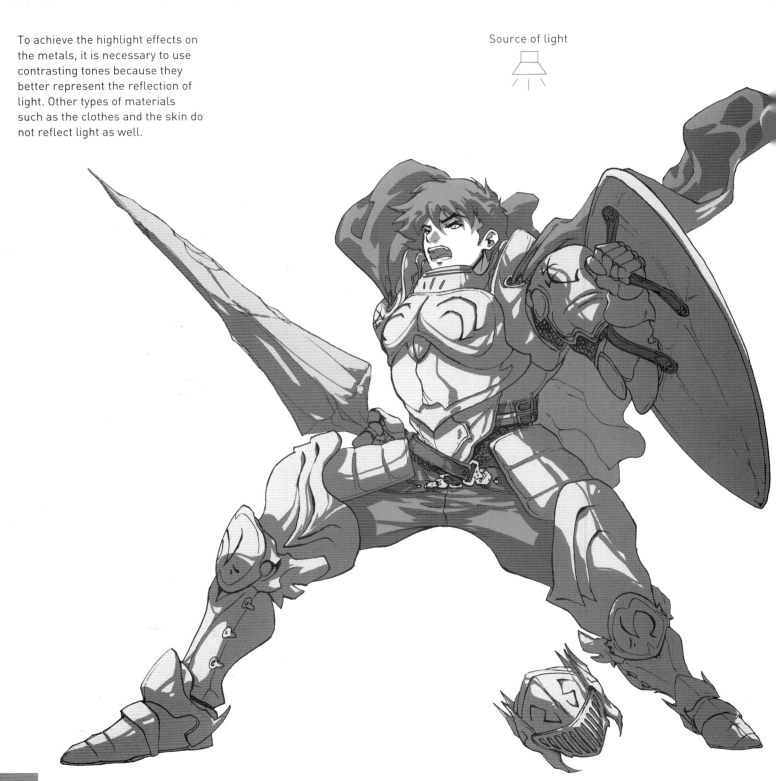

A striking chromatic range takes the character to the land of the fantastic. We opt for unusual and complementary colors with a high contrasting level. The luminous green of the armor provides a futuristic touch.

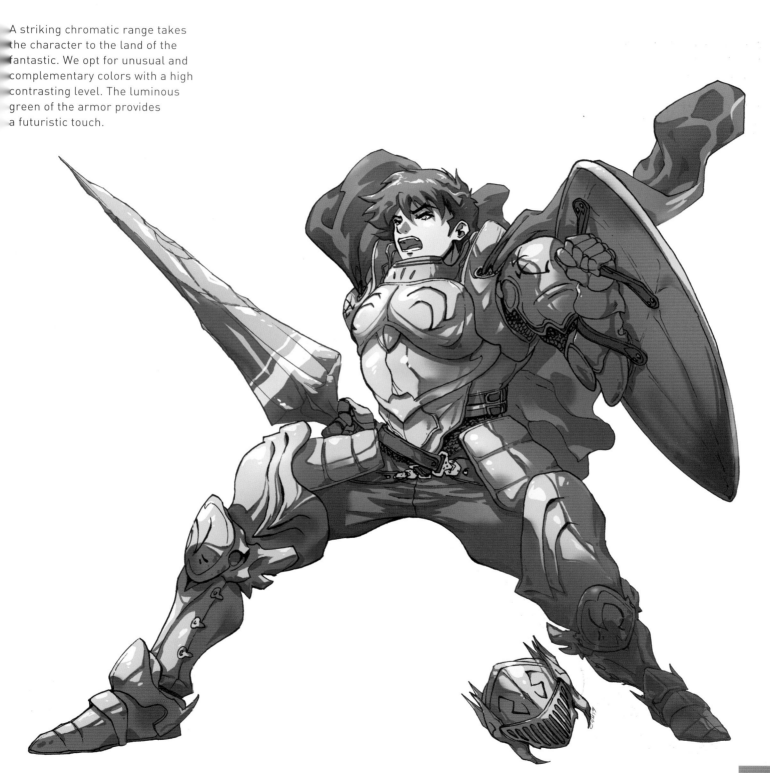

NINJA

The ninjas were mercenaries trained for war. Their work included assassination, spying, sabotage, and reconnaissance with guerrilla tactics to destabilize the enemy's army. Ninjas use a wide range of arms and artifacts. They are also experts in creating bombs, poisons, and potions in addition to having mastered the "art of disguise". Ninjas are feared and used by the military leaders. Stories about ninjas are abundant in manga and in anime. There is also many video games with these characters as protagonists, such as *Ninja Gaiden* and *Shinobi*.

1. Shape

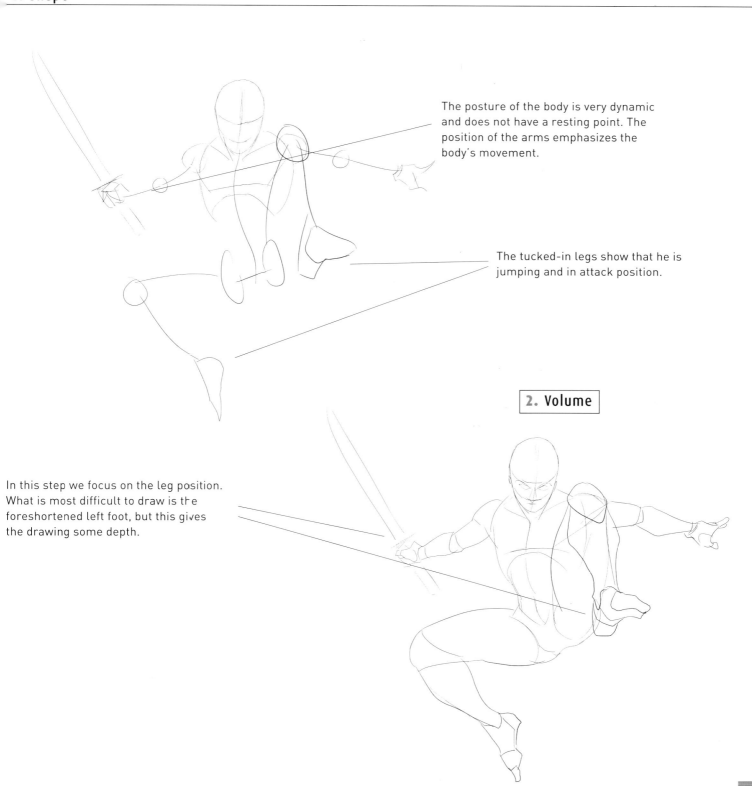

The posture of the body is very dynamic and does not have a resting point. The position of the arms emphasizes the body's movement.

The tucked-in legs show that he is jumping and in attack position.

2. Volume

In this step we focus on the leg position. What is most difficult to draw is the foreshortened left foot, but this gives the drawing some depth.

We give him an athletic build emphasizing the abdominals as well as the muscles in the legs and arms, but without suggesting hypertrophy, since ninjas are strong but very flexible and agile.

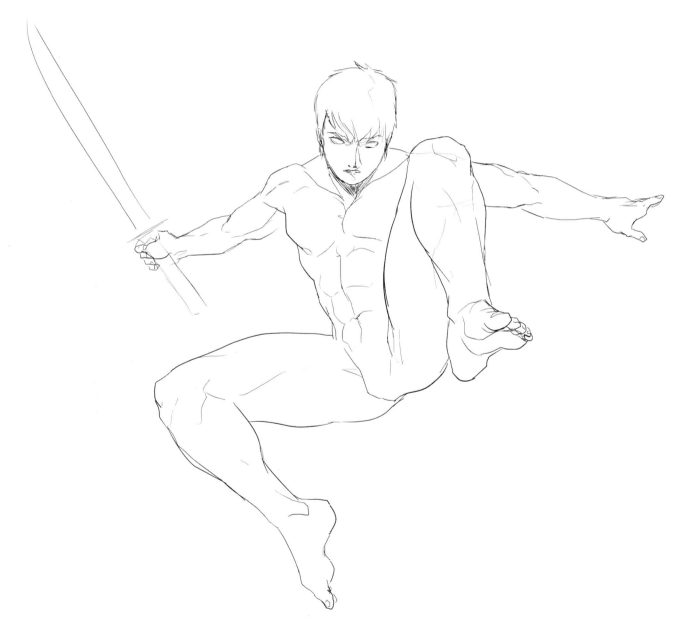

We model the folds in the clothes to provide the character with volume. By adding some *shuriken* aimed at the reader, we create an interaction between the reader and the illustration.

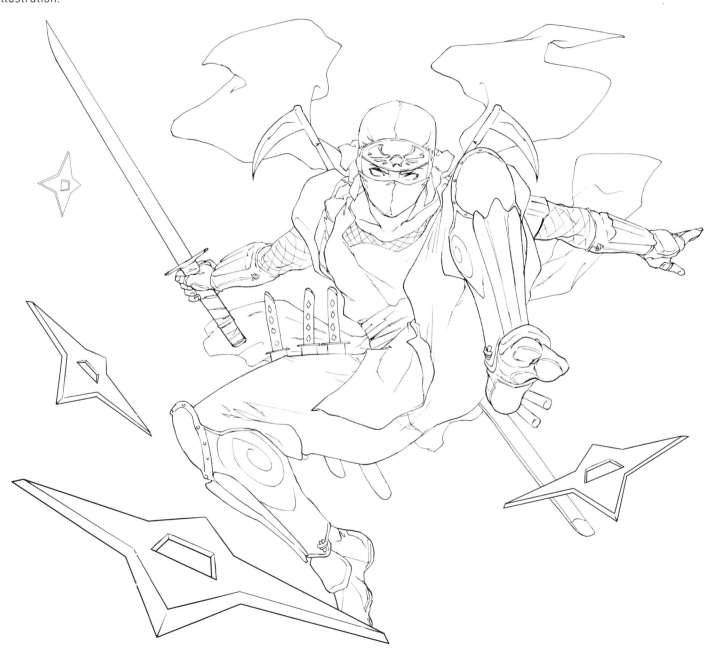

We place the light source just
above the character, which will
create a lot of shadow.

Source of light

The shadows are hard and
accentuated but not too
contrasting in some areas of the
clothes because of the matte
finish.

With a combination of grays and highlights we achieve the metallic effect on the sword and of the ninja stars, to which we have added a soft trail to indicate the movement when they are thrown by our character.

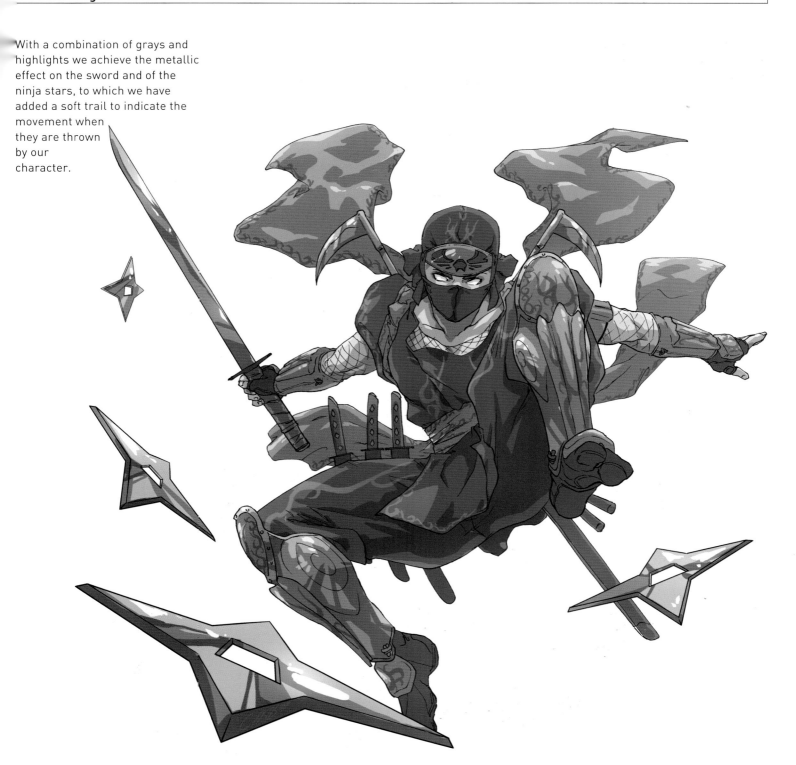

SPACE ADVENTURER

Human beings have always dreamed about new civilizations that go beyond the limits of the known universe. Here is the only character who has achieved it so far: the space adventurer. Shameless and intrepid, this Indiana Jones of the stars has his own spaceship, weapons and a valiant and unbridled character. When the time comes to create a space adventurer, we will have to take into account his clothes and, especially, his characteristically shameless expressions. The ultimate example of the space adventurer in manga is Captain Harlock. But we should not forget Cobra, who is much more cunning. *Cowboy Bebop* is another example of the modern spaceman in manga.

1. Shape

We pay careful attention to the curvature of the adventurer's pose to suggest movement and to include some foreshortened body parts, such as the legs. We also pay special attention to these when we define the character's role.

2. Volume

We add elements that belong with the figure and give them volume. The metallic weapon that the character holds has dimensions and weight that are not the same as a human's and therefore needs to be treated differently.

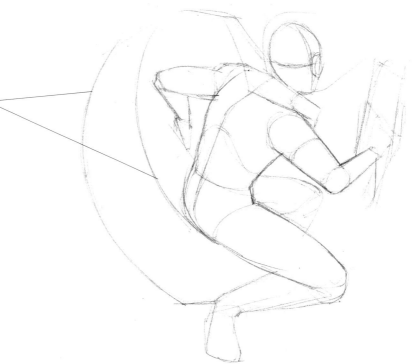

Our space adventurer has a strong constitution. Notice the muscle structure: the character is in good physical shape but is not excessively hefty, but rather dynamic and agile. The legs are solid and robust.

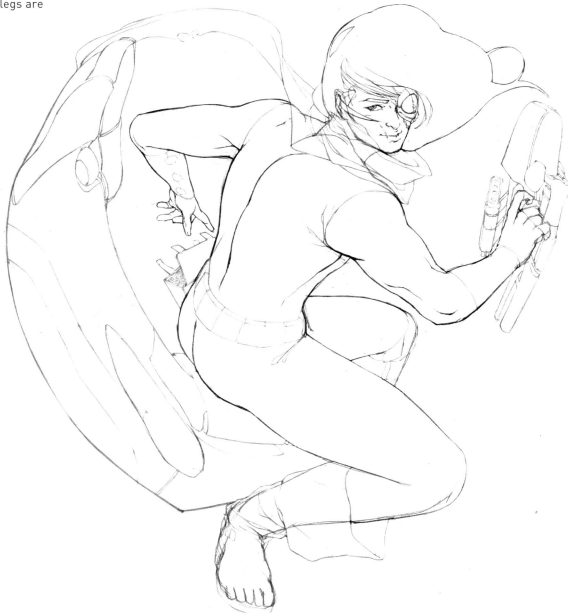

Our hero wears a kind of jumpsuit made of viscose, very tight, so there is no need to worry much about the attire. We incorporate the typical accessories of the space traveler: the boots, the belt with ammunition, and the weapons.

Source of light

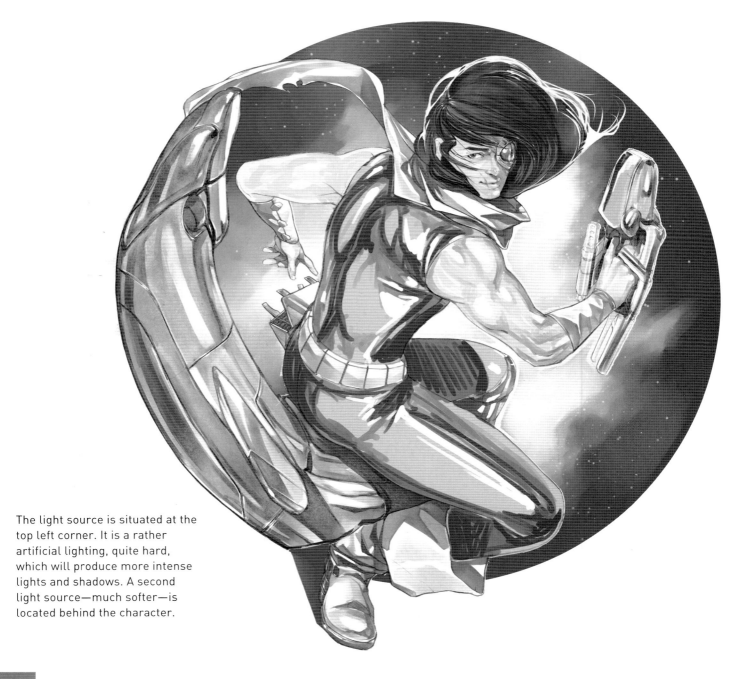

The light source is situated at the top left corner. It is a rather artificial lighting, quite hard, which will produce more intense lights and shadows. A second light source—much softer—is located behind the character.

6. Color

We distinguish three predominant colors: the background, the green costume, and the metallic gray to the left of the character. Using the different tonalities of these colors, we will give the space adventurer greater contour.

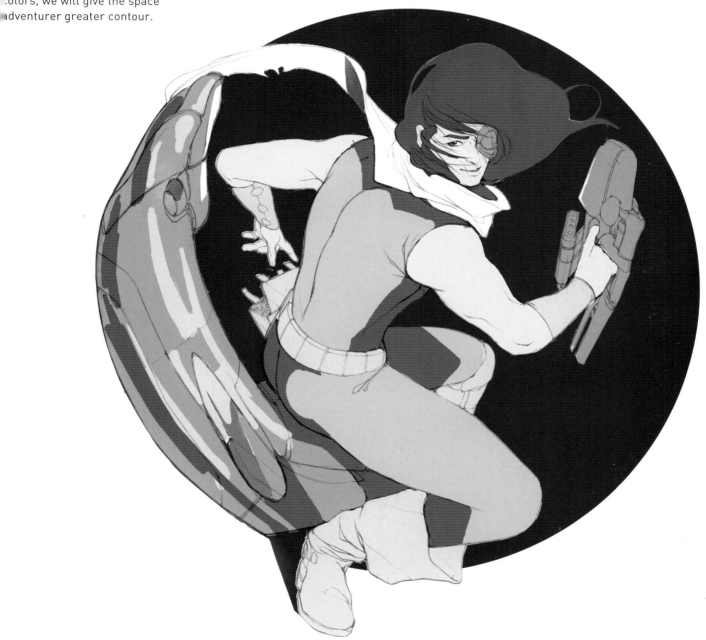

Light has an intense and contrasting effect on the character's costume, which is a material similar to vinyl. We develop the background in the same way we have done for the figure, to create a global tonality.

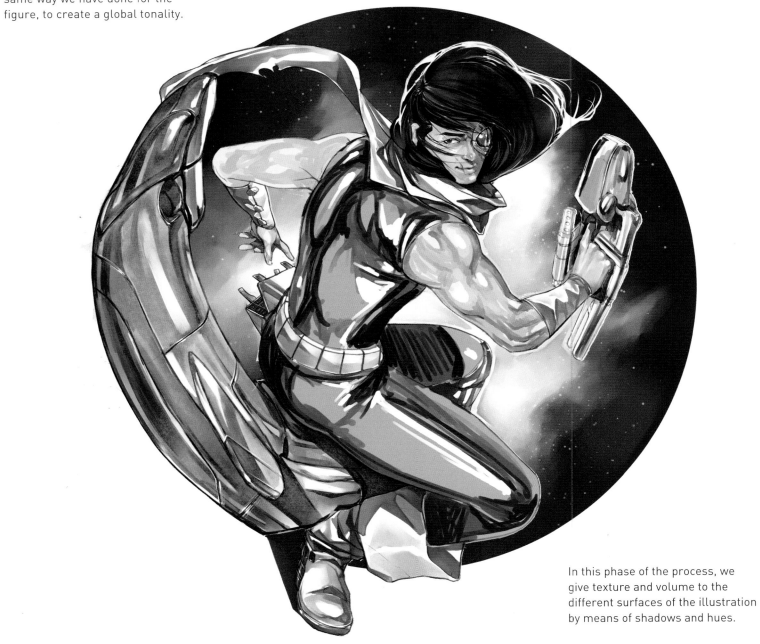

In this phase of the process, we give texture and volume to the different surfaces of the illustration by means of shadows and hues.

We create textures and give the metal some shine. We revise the effects of chiaroscuro to give the image force and confer the character with a stronger personality and reinforce this effect on the viewer.

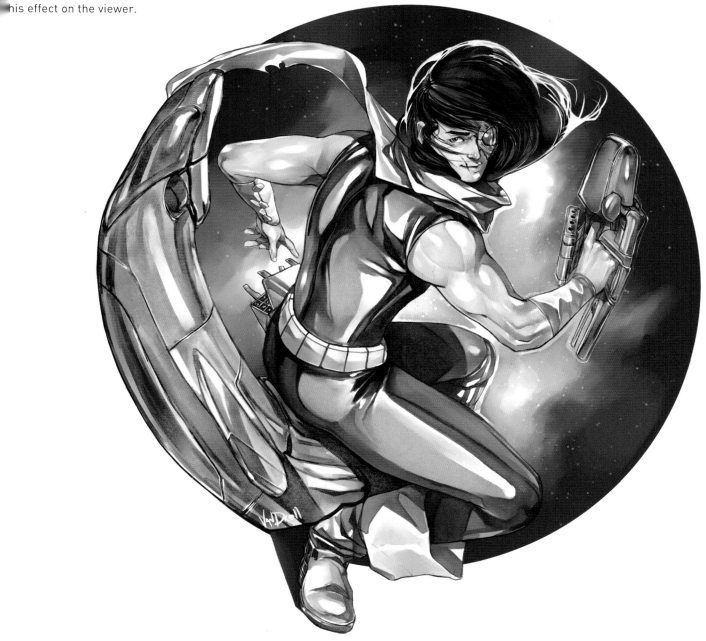

MYSTIC AMOR

There are many manga stories and Japanese animation in which mysticism is mixed with adventure, action, combats, traditional martial arts, superpowers, and magic. Similar to what happens with Greek mythology and the Arthurian legends, in these stories the power of the gods is linked to an object that gives whomever carries it strength; for example, the weapons and armor capable of becoming the source of immense power when used correctly. The armor shines with its own light in the mangas that narrate this type of story. Examples are the classics *Saint Seiya* and *Shurato*.

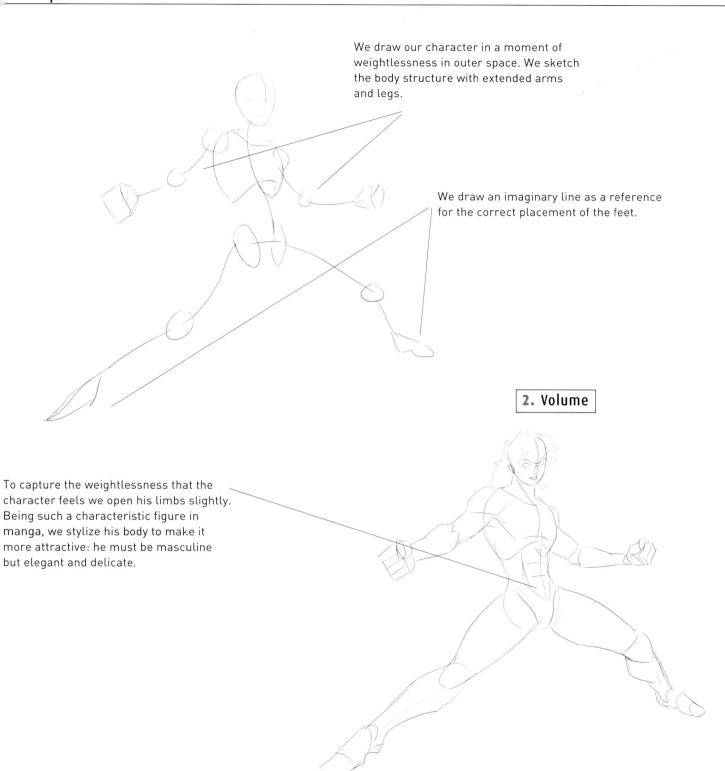

We draw our character in a moment of weightlessness in outer space. We sketch the body structure with extended arms and legs.

We draw an imaginary line as a reference for the correct placement of the feet.

2. Volume

To capture the weightlessness that the character feels we open his limbs slightly. Being such a characteristic figure in manga, we stylize his body to make it more attractive: he must be masculine but elegant and delicate.

We accentuate the muscles
but we emphasize the abdominals
and the muscles in the arms since
these are the areas where tension
is produced. We draw long legs
and increase the size of the fist
closest to the spectator.

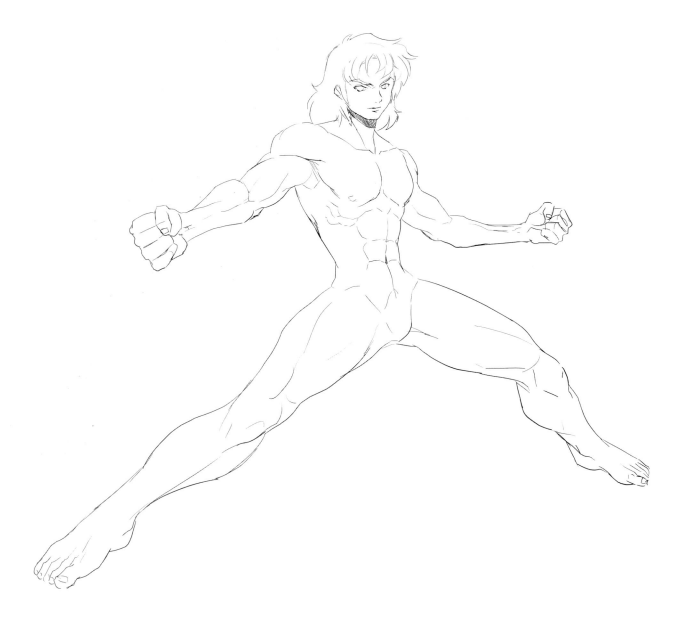

4. Clothes

We draw an armor that in reality
would not be comfortable but
visually is spectacular. We draw the
volumes of the armor and we add
accessories and decorations to it.
To finalize, we draw the wings.

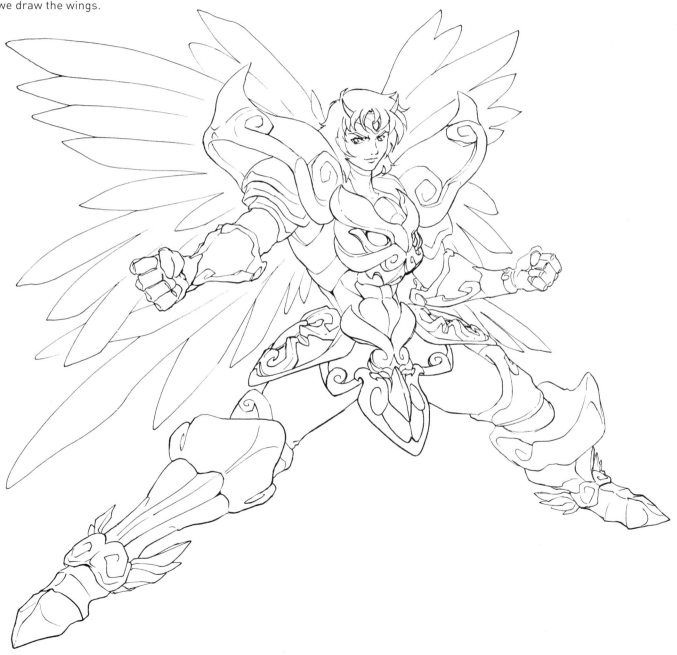

We apply the shadows in such a way that the volume of the clothes remains defined. We take into account that the light accents shadow on the armor differently than those on the fabric under the armor. The light comes from the front.

Source of light

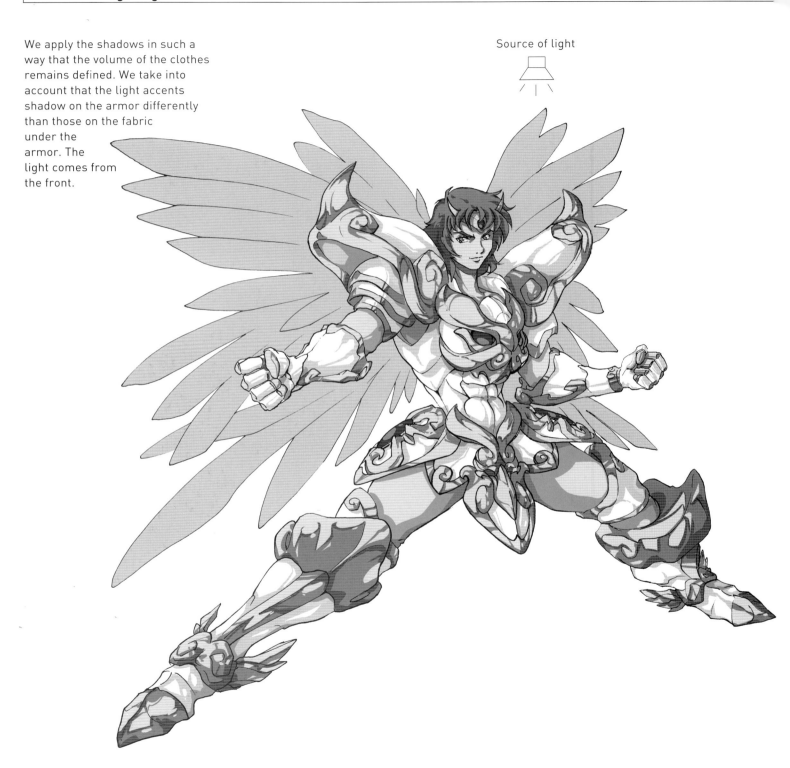

For the color base we choose a selection of soft, luminous but non-saturated tones. It is a very warm range of tonalities. The predominating color is white, which mixed with blue and gold exemplifies purity and a celestial air.

We use two saturated tones to render the shadows. To achieve all the shining effects over metal, we employ contrasting tones. The face is left with few shadows so that the result is very fine.

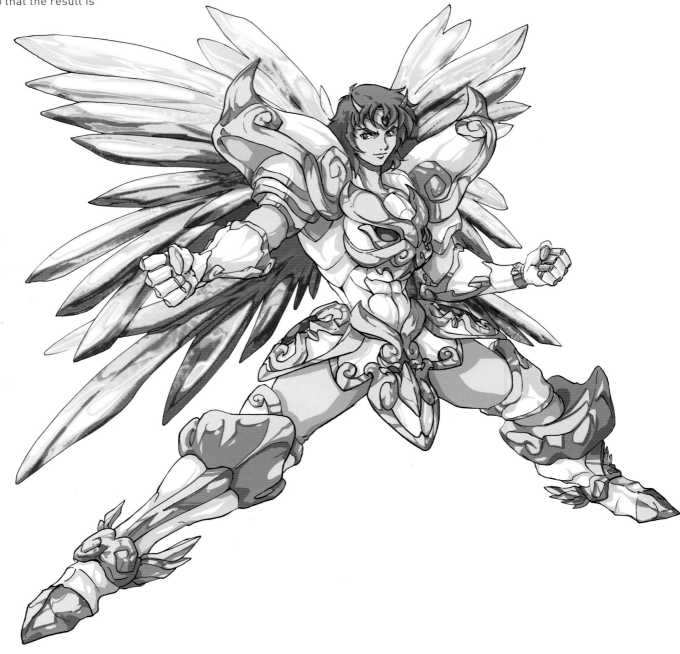

We draw the stellar background to situate the character. We add a red aura around the fist as if he were showing one of his special attacks, small highlights on the wings, and a flying figure of fire among the stars.

COWBOY

Originally, cowboys were in charge of herding livestock in the American West. These characters are the indisputable protagonists in the western genre although they often share the spotlight with bandits, sheriffs, and bounty hunters. This genre is very common in manga but always with a futuristic approach, in imaginary settings or in space. Action scenes are frequent, whether they are fantastic combats or hand-to-hand fights. Two of the most famous manga and anime in this genre are *Trigun* and *Cowboy Bebop*.

1. Shape

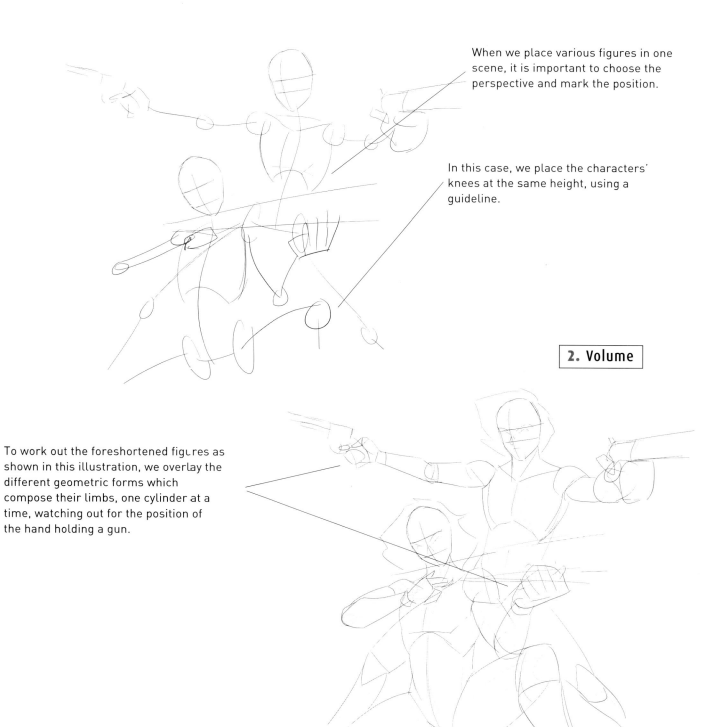

When we place various figures in one scene, it is important to choose the perspective and mark the position.

In this case, we place the characters' knees at the same height, using a guideline.

2. Volume

To work out the foreshortened figures as shown in this illustration, we overlay the different geometric forms which compose their limbs, one cylinder at a time, watching out for the position of the hand holding a gun.

In this genre of manga, the male characters are usually very stylized, young, and attractive. We therefore use the typical proportions of an adolescent with a body the height of eight heads, adding a rakish hairstyle.

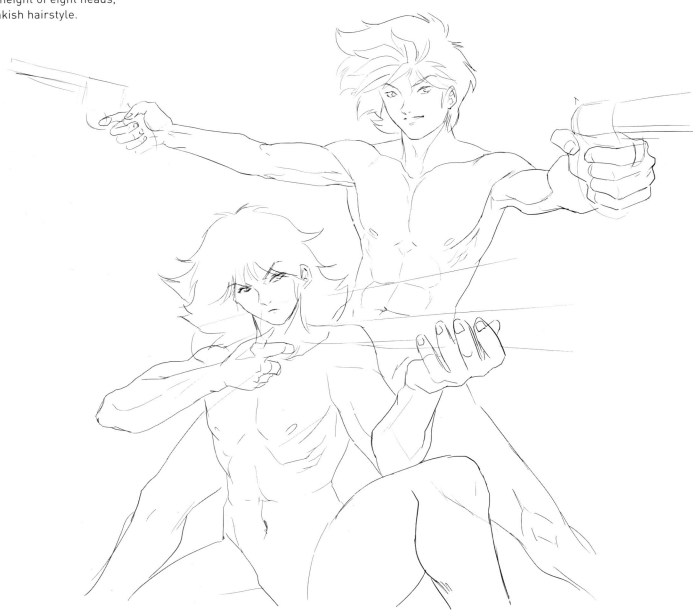

We dress up the cowboy, mixing traditional and modern elements. The gun, the hat, and the handkerchief around his neck take us to the Old West, while the buckles indicate that he is a young cowboy of the future.

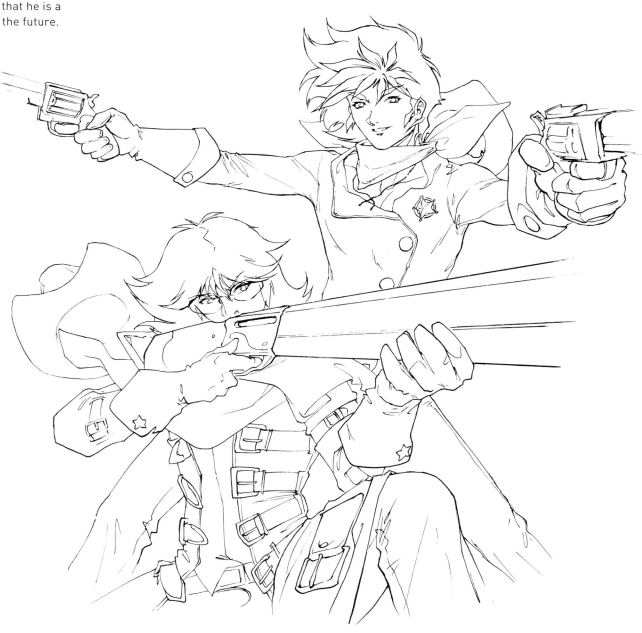

The work of shadow and light provides as much information about the different textures and materials as possible.

Source of light

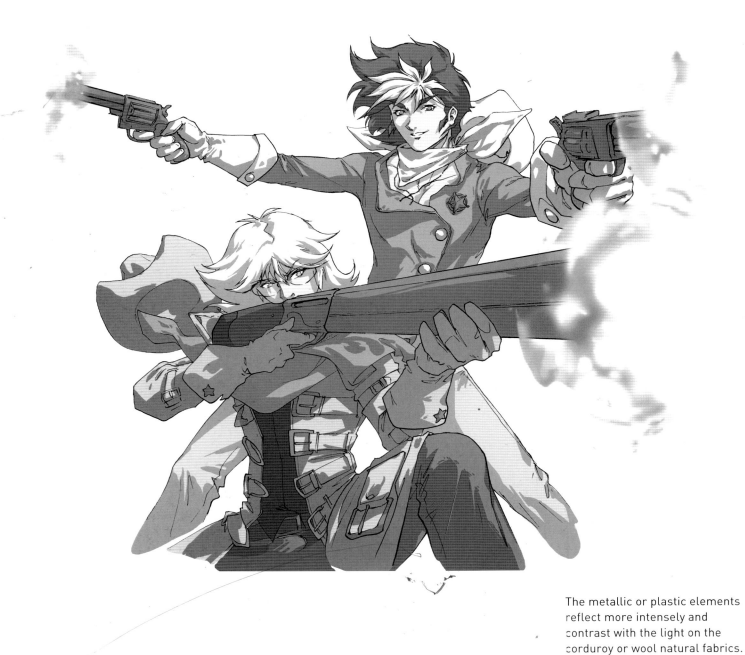

The metallic or plastic elements reflect more intensely and contrast with the light on the corduroy or wool natural fabrics.

We apply sharply contrasting grays and highlights on the metals. With loose yellow and orange brush strokes, we create the effect of weapons firing.

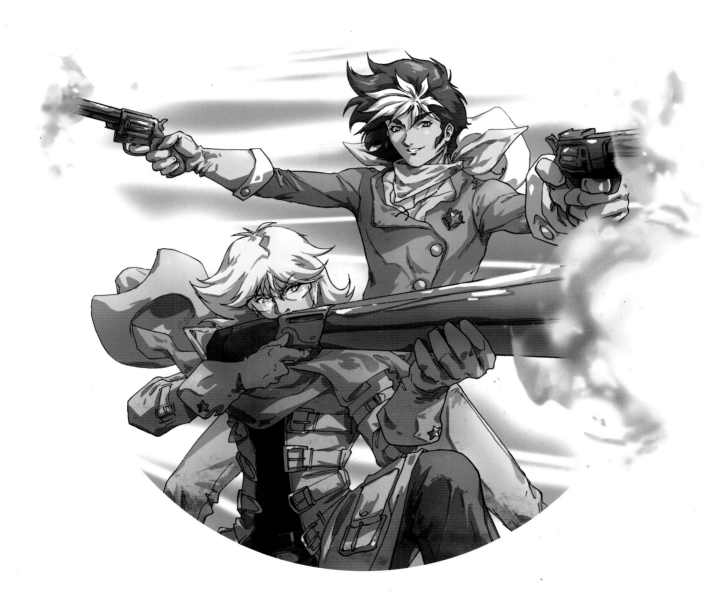

MYTHOLOGICAL HERO

The mythological characters like Perseus or Hercules and their heroic deeds are the precedent for contemporary super-heroes. Their abilities are taken to the extreme and the characters are elevated to the level of the divine. They are beings with extraordinary physical capabilities, so when representing them we exaggerate their features. They must impose and induce immediate respect, perceptible by the reader, so that their presence fills the scene. As for the clothes, we give special attention to the details, which will require a great deal of research. The animated movie *Arion* is representative of the types of mythological heroes in contemporary manga.

The figure displays foreshortened body parts, so we compose it one shot at a time.

The upper part of the body moves forward along with one of the legs, and the rest of the body stays behind to give the impression that the character is moving toward us.

2. Volume

Almost all the character's parts are in motion. Our robust hero fills most of the available space, so it is recommended to emphasize the floating and light feeling of the cape.

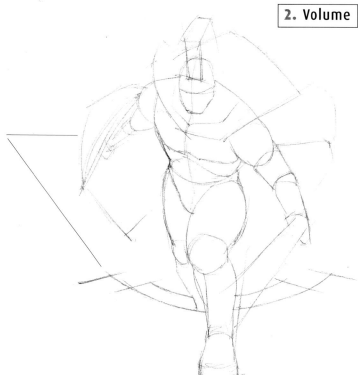

His anatomy is muscular and volumetric. We develop the areas that are in the foreground, such as the chest and the forward leg, with greater precision. We have to be especially meticulous when drawing muscles, which need to look robust and in tension.

We use as reference the attire of the Trojan and Spartan warriors. We develop the boots and the helmet, covering them with rich details. The fabrics fall freely and intuitively but without forgetting about their folds and motion.

The light, soft and natural, bathes the metals and the areas of the character's skin closest to the light source. The left leg progressively blurs out and eventually merges with the background so the drawing gains in depth.

Source of light

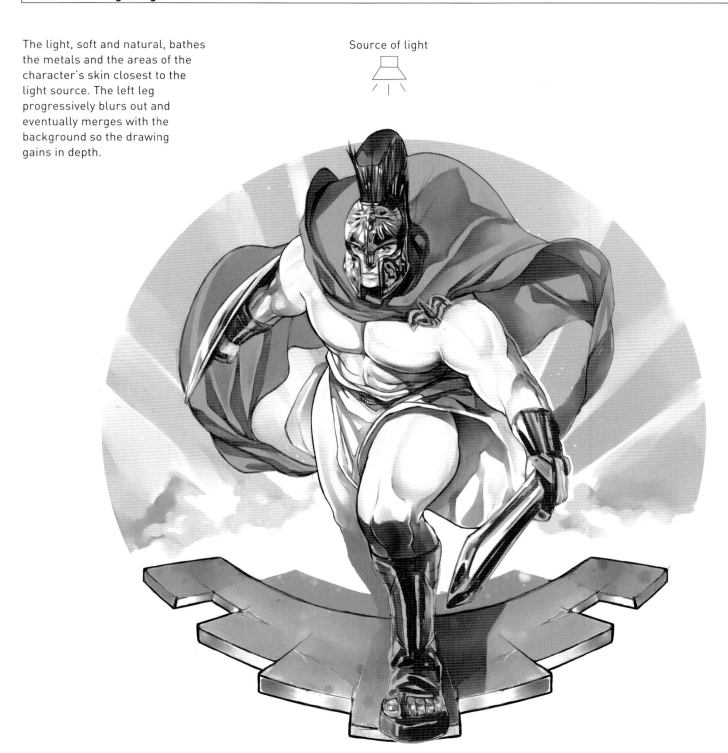

We choose very bright colors, but not garish. In this illustration, our hero looks as if he is ascending to the sky, explaining the use of pleasant colors filled with light.

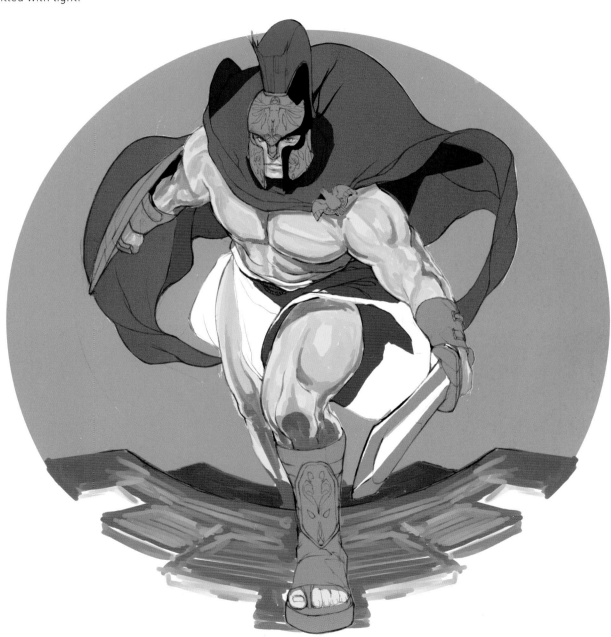

We develop the background with blue and white blotches to enrich the sky. We pick warm tones for the clouds, making them lively and gestural, without much precision because they are only the background.

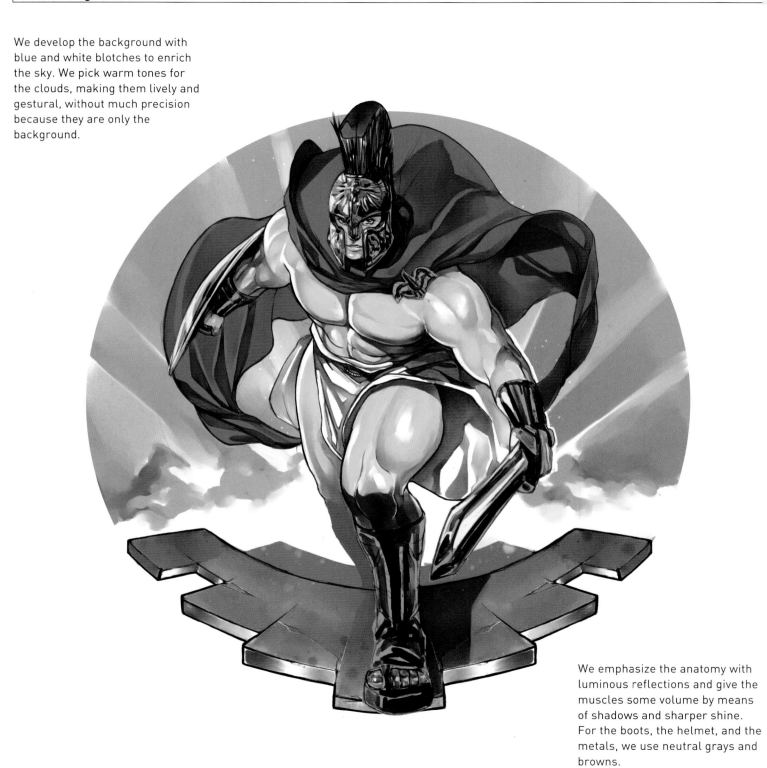

We emphasize the anatomy with luminous reflections and give the muscles some volume by means of shadows and sharper shine. For the boots, the helmet, and the metals, we use neutral grays and browns.

We darken up some shadows to give the body even more contour, and then focus on the metallic details. We intensify the color of the figure so that the background does not stand out excessively and add the highlights as well as textures on the ground.

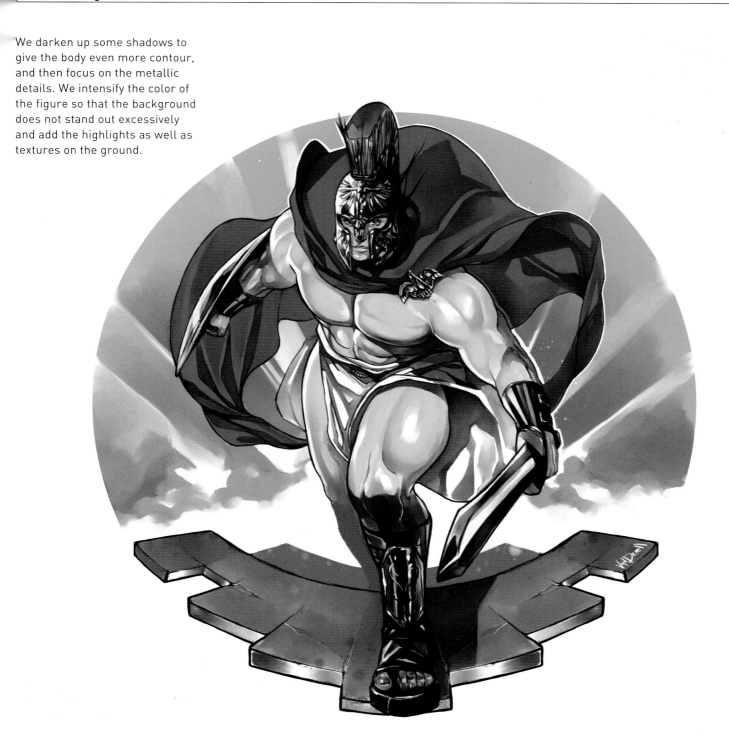

SENTAI HERO

The Japanese word *sentai* can be translated as "fighting squadron." This type of character is common in the *tokusatsu* genre, which offers a lot of action and special effects. These stories are generally about the unending fight between good and evil. The main characters in these stories are often a group of five friends who normally have magical powers and wear brightly colored special outfits, and who fight against gigantic villains from other planets. Each *sentai* in the group is based on a particular fictitious universe. In this exercise, we draw one of them using as inspiration some Japanese series such as *Kamen Raider*.

1. Shape

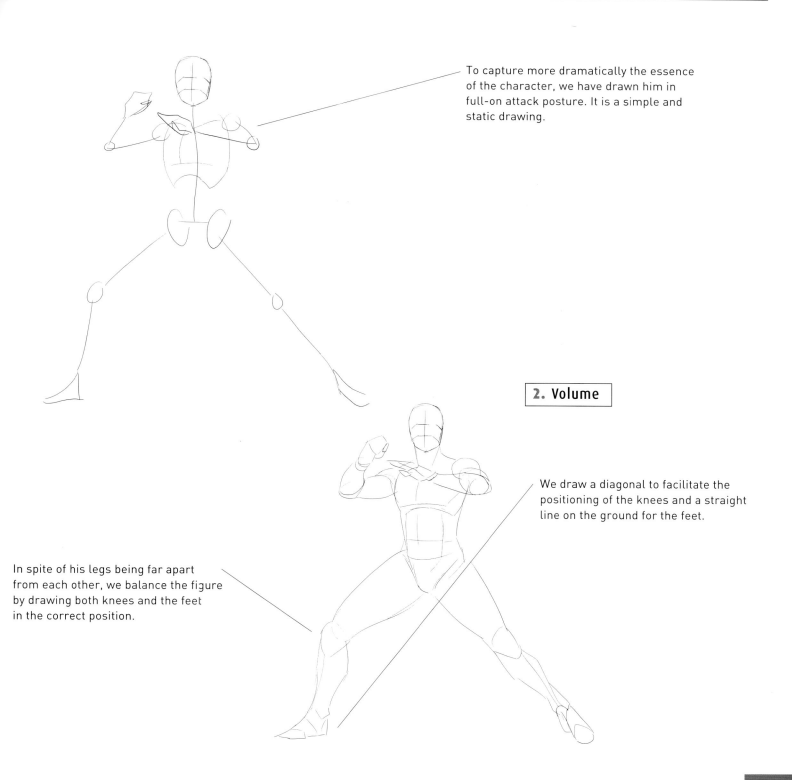

To capture more dramatically the essence of the character, we have drawn him in full-on attack posture. It is a simple and static drawing.

2. Volume

We draw a diagonal to facilitate the positioning of the knees and a straight line on the ground for the feet.

In spite of his legs being far apart from each other, we balance the figure by drawing both knees and the feet in the correct position.

The main character is slightly turned sideways to the left. He is a typical character in Japan so the stylization of his figure is basically obligatory. We draw again a hybrid body, thin but strong.

In this genre, one has to be creative because fans imitate the outfits, the movements, and the choreographies. We choose a characteristic posture and opt for a helmet of geometric forms inspired by a penguin.

The light bathes the body of our *sentai* to emphasize the shapes of his outfit. We add very visible contrasts since bright colors characterize these figures' costumes.

Source of light

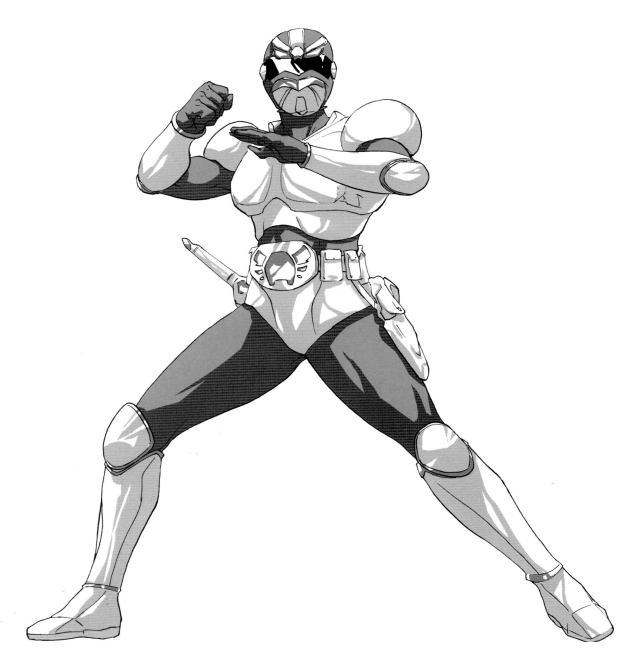

We apply very vivid tonalities and high contrasts, and give our character some volume by means of shadows. We use rectilinear and sharp forms for the shading of the armor to create a harsh effect.

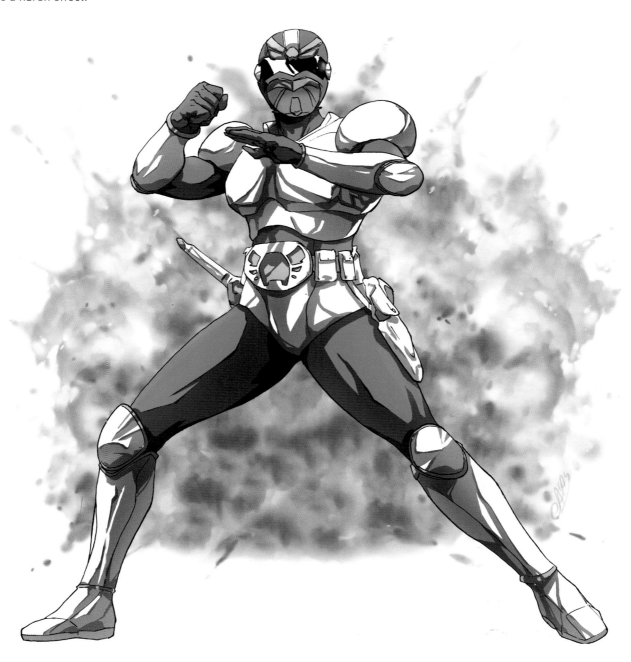

EVIL

WARLORD

He is feared by all and only loyal to himself. With his dexterity with weapons and his fierce demeanor, he wreaks destruction and chaos along his way. Bringing death and desolation, he is known for casting black magic spells. His origin is uncertain, which gives us relative freedom when it comes to developing the character. He usually adopts an antagonistic position to the hero and represents the dark side. He is an essential character in all heroic fantasies charged with epic and heroic deeds. Although we can find the warlord in an infinity of mangas, his archetype is Sauron from *The Lord of the Rings*.

The low angle magnifies the sensation of the character's boundless power. We draw a central line with a light curvature.

For the back and the arms, we also use simple lines with little movement.

2. Volume

The character has a foreshortened figure, playing with perspective and bringing forward the elements that are closer to where we stand, like the rock, and setting back the head of the character, for example.

The constitution of the warlord
is robust and very muscular. We
must not forget any detail when
drawing his body, and concentrate
on his buff and muscular torso.

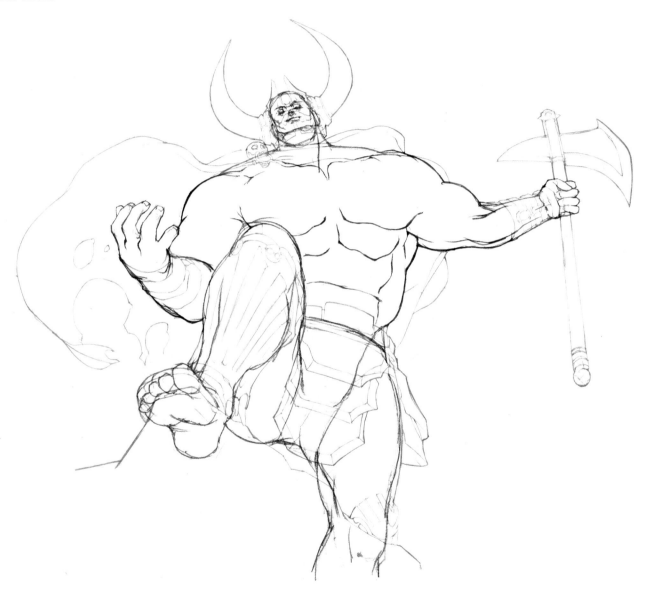

4. Clothes

This type of character does not usually wear much clothing, but it would not be a bad idea to consult some books on medieval armor for the design of the helmet and the weapons. The bigger and more horrifying, the better.

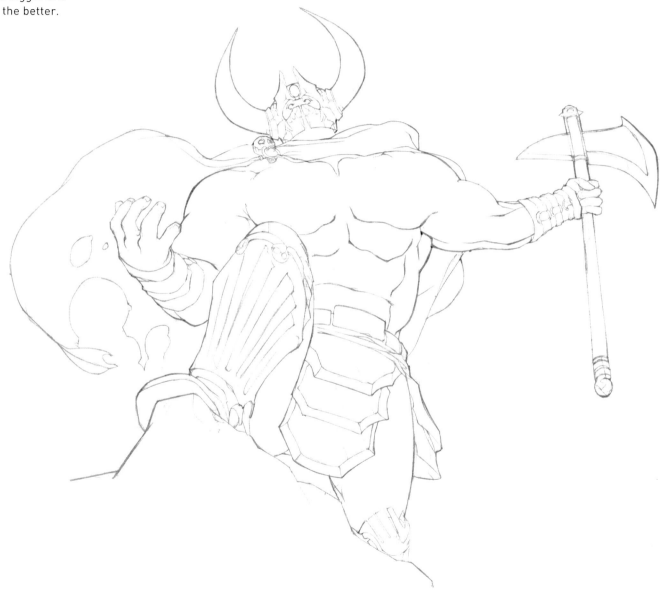

The brightest light source is the ball of fire that the character holds in his hands, without forgetting the trail that it gives off. The elements that are closest to it shine with greater intensity that the others.

Source of light

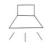

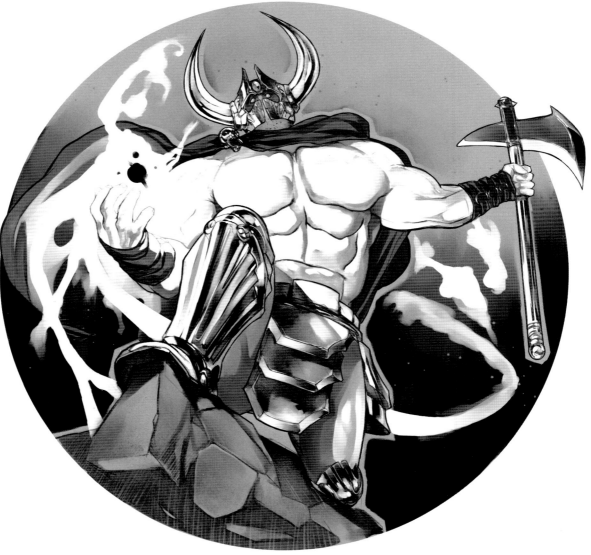

We use warm colors for the background to emphasize the feeling of danger and the fierceness of the warlord.

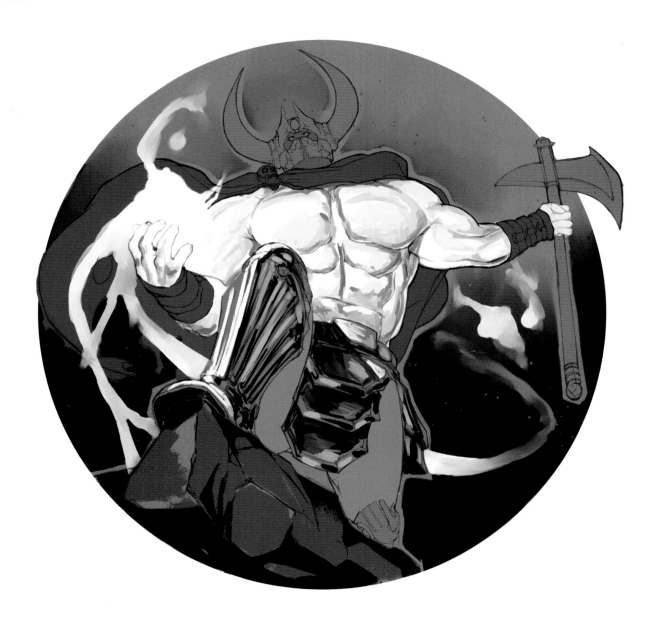

Once we have most of the illustration done in masses of color, we define the shadows. We add the ball of fire because without it we will not be able to correctly place the lights and shadows.

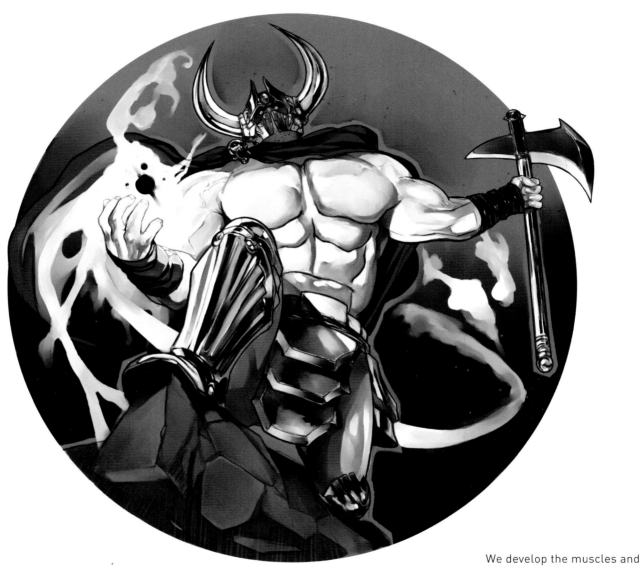

We develop the muscles and emphasize them using darker colors. We also work on the armor and the metallic accessories, and subtly draw the fire trail.

We focus on the background and give it a feeling of movement by means of circular strokes. We stress the most intense lights and bring out details such as the veins of the character.

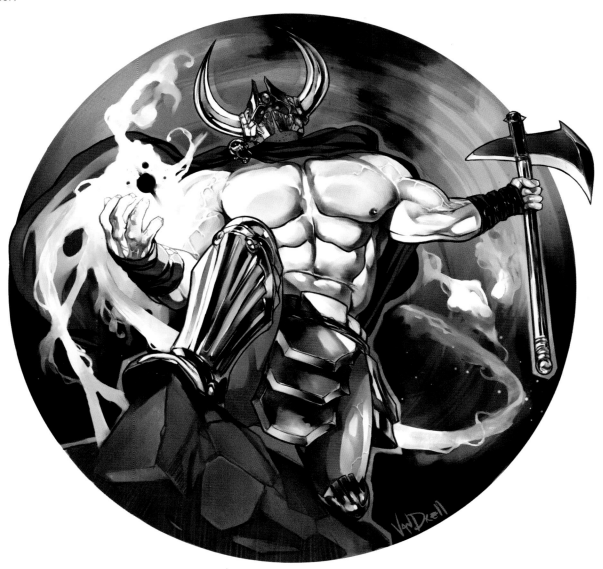

DARK WIZARD

The word *magician* often refers to male sorcerers, whether benevolent (white magic) or malevolent (black magic). Whoever does black magic intends, via malicious spells, to harm society and alter all kinds of organic and nonorganic matter. This magic gets its power from the hierarchies of darkness, which allow the effects to happen. Magic is very common in manga; there are dozens of nonconventional magicians and sorcerers. All are inspired by the traditional heroic fantasy and by *Dungeons & Dragons*, which is a modern complement to Tolkien's mythology.

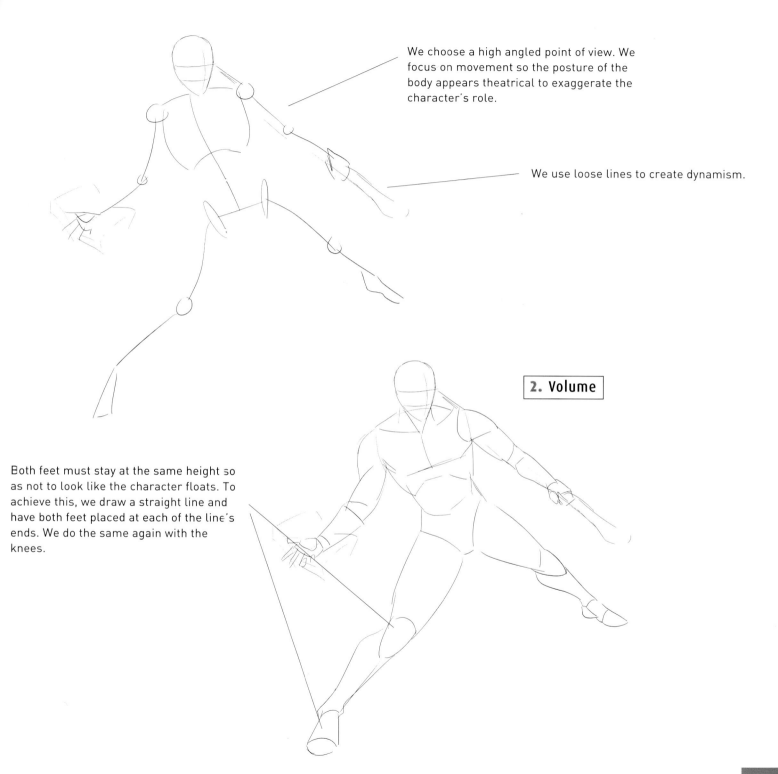

We choose a high angled point of view. We focus on movement so the posture of the body appears theatrical to exaggerate the character's role.

We use loose lines to create dynamism.

2. Volume

Both feet must stay at the same height so as not to look like the character floats. To achieve this, we draw a straight line and have both feet placed at each of the line's ends. We do the same again with the knees.

The character has an athletic build, a stylized figure and very attractive features because in this type of story the black magicians, in spite of being malevolent beings and in some cases nonhuman, are endowed with great beauty.

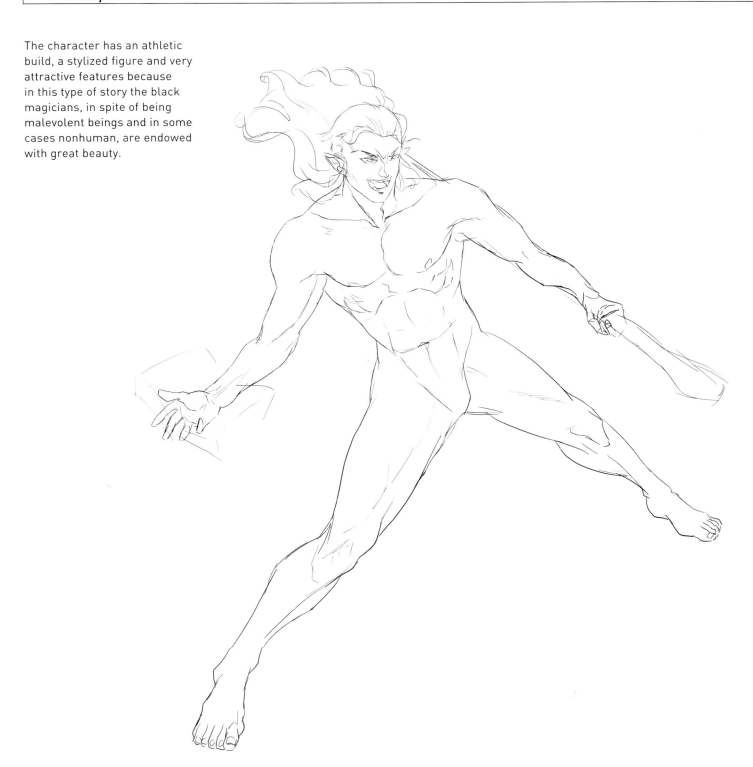

Clothes

We characterize our magician with elfin traits and dress him up with an elaborate and extravagant costume inspired by the Middle Ages, although we add our own details of modern heroic fantasy and gothic designs.

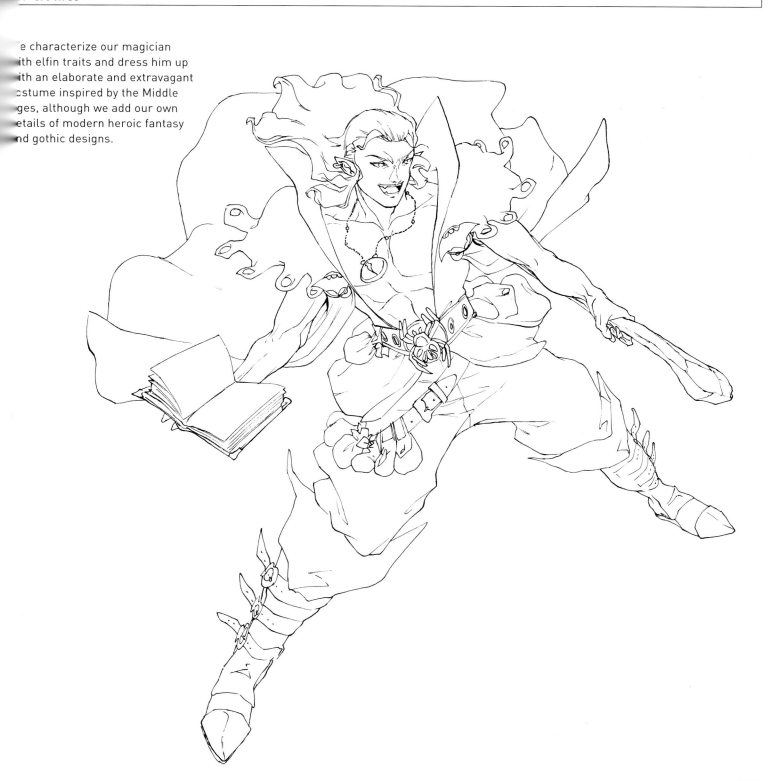

We use light to define the character's attire. We also model the draping of the clothes, taking into account the type of fabric. Using a frontal light source we reinforce the mysterious and dark aspect of the character.

Source of light

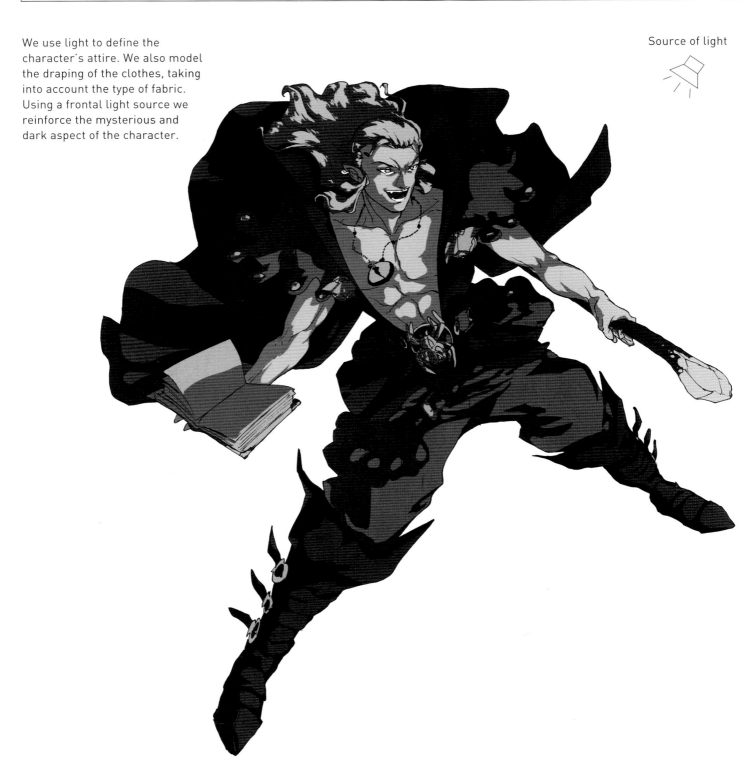

We apply a combination of gray, black, and purple. The hair is silver and the magician's skin and his clothes contrast vividly. We use some matte tones to make the costume look historic.

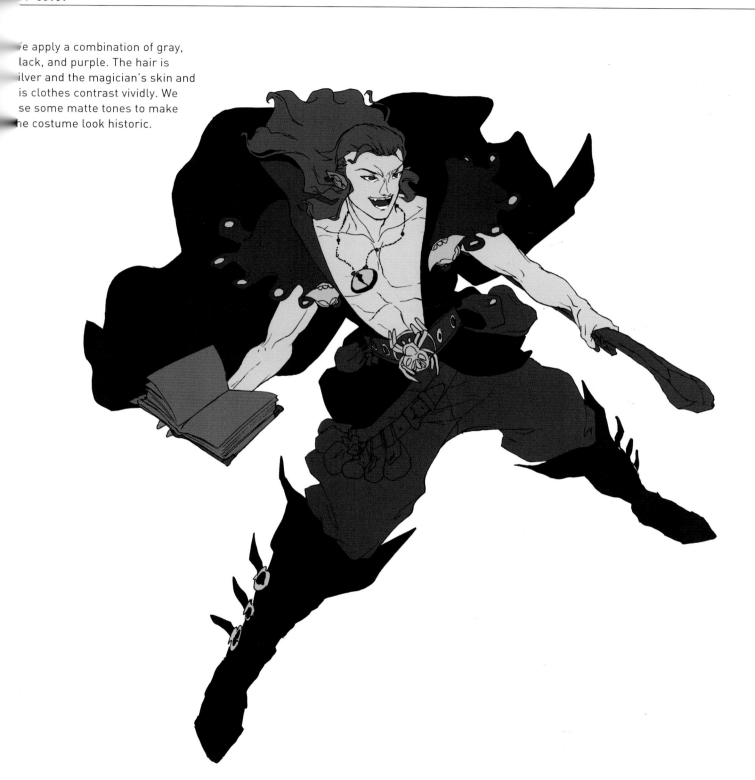

The selection of colors is determined by the type of light. In this case, we don't model the shadows but the bright spots since the light source we have chosen will make painting the lighter areas much simpler.

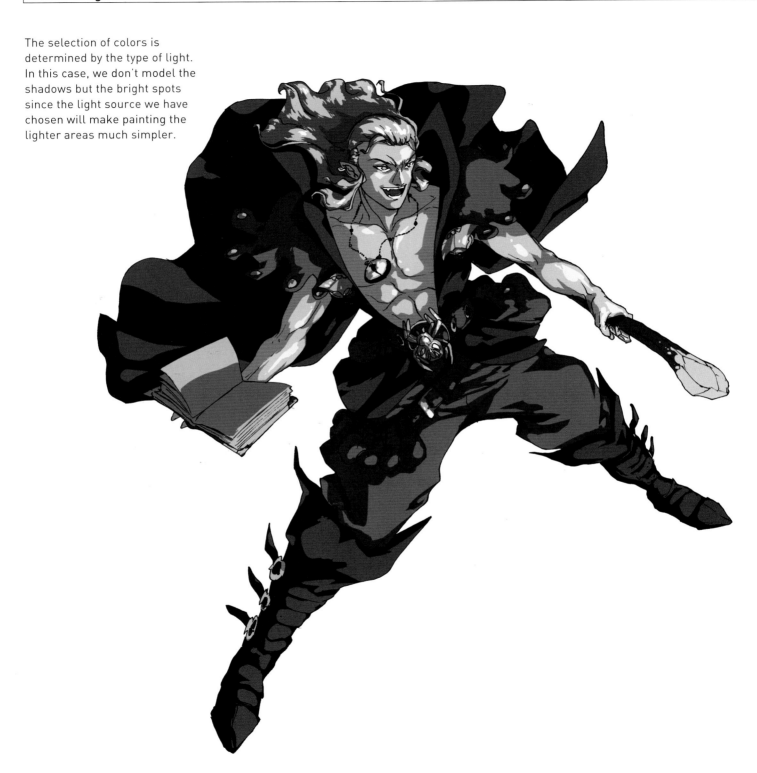

We create the effect of the spell by means of thin gray rays that form a sphere on the tip of the magic wand. We add magical symbols in the book and small highlights on the hair and on the skin to emphasize the luminosity of the scene.

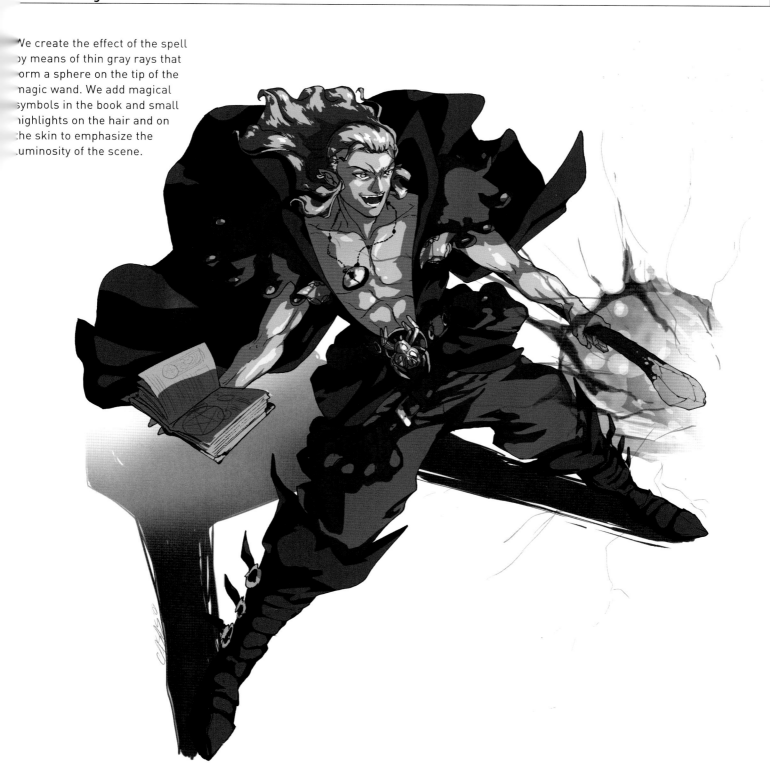

YAKUZA

Yakuza is the Japanese version of the American gangster. The leader of the gang, nicknamed *oyabun*, and those close to him as well as those at the lowest rungs of the gang hierarchy—the hired assassins—are key in this genre. Respectful in business and with traditions, they are usually represented in a very elegant way in manga and have a profound knowledge of the ancestral martial arts. Therefore, it is not surprising that elements such as tattoos, power emblems, and personality-identifying symbols in combat are emphasized. The most relevant works in which a yakuza is the main character are *Crying Freeman* and *Santuario.*

1. Shape

We get a close-up of the character's waist. We block out the basic shapes and sketch out the defining elements such as the dragon in the background, and even some body shapes such as the arm.

2. Volume

The illustrations with close-ups allow us to add much more detail, for example, on the face.

We delineate the main facial features and we do the same with the rest of elements in the drawing.

We opt for a very realistic style,
appropriate for the character.
His body is buff, not too
exaggerated but eye-catching,
with well-developed muscles.
He is young but tough, which may
explain the scar.

4. Clothes

Elements such as the pants, the sunglasses, and the wrinkled shirt provide the character with a sort of elegance. We focus especially on elements such as the tattoo and the dragon in the background. We play with the idea that his tattoo has a life of its own.

There are two sources of light: one is ambient light and the other comes from the back. Both lack in tonalities of their own, so they basically frame highlights and shadows depending on the effect over the yakuza's body. We use a third light coming from above for the dragon.

Source of light

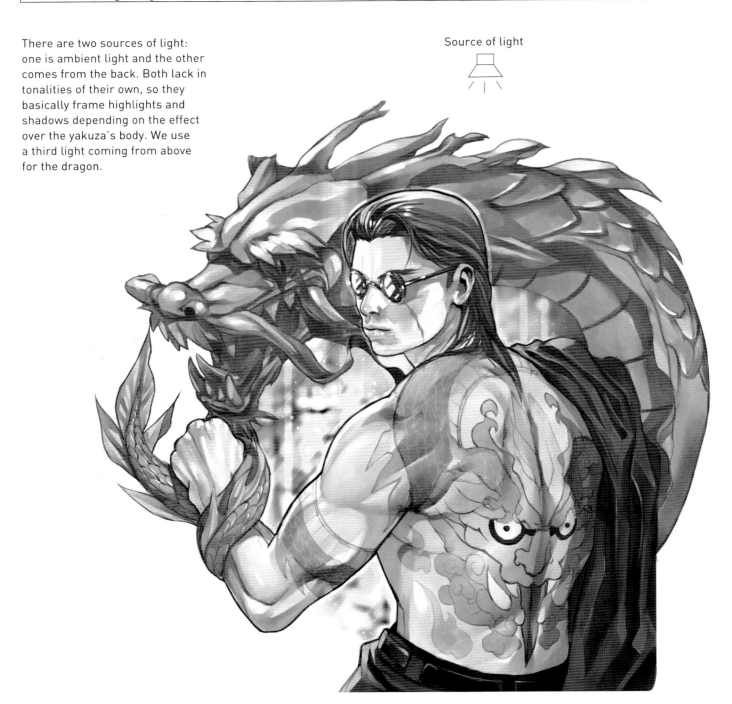

We use very vivid colors. We add contrasts to the illustration and play with the planes, one that generates the background with blotches and a second that incorporates the elements closest to the reader. We draw lights similar to those on a stage.

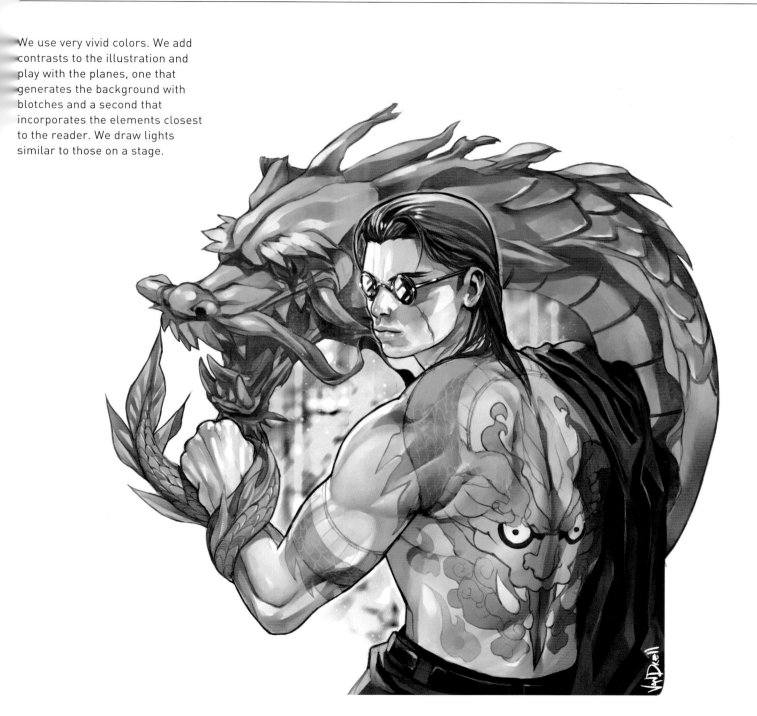

GALACTIC EMPEROR

Outer space and science fiction are popular themes in manga. Hundreds of Japanese authors have opted for what appears to be the sure bet of taking the reader on explorations of new worlds and universes in future times. In this type of story we find gigantic robots, new dimensions, cyborgs, unknown extraterrestrial species, space operas, fights between enormous spacecraft, and all that the boundless imagination of *mangakas* allow. In these manga the characters are usually very attractive and wear striking futuristic outfits. They also have special powers.

1. Shape

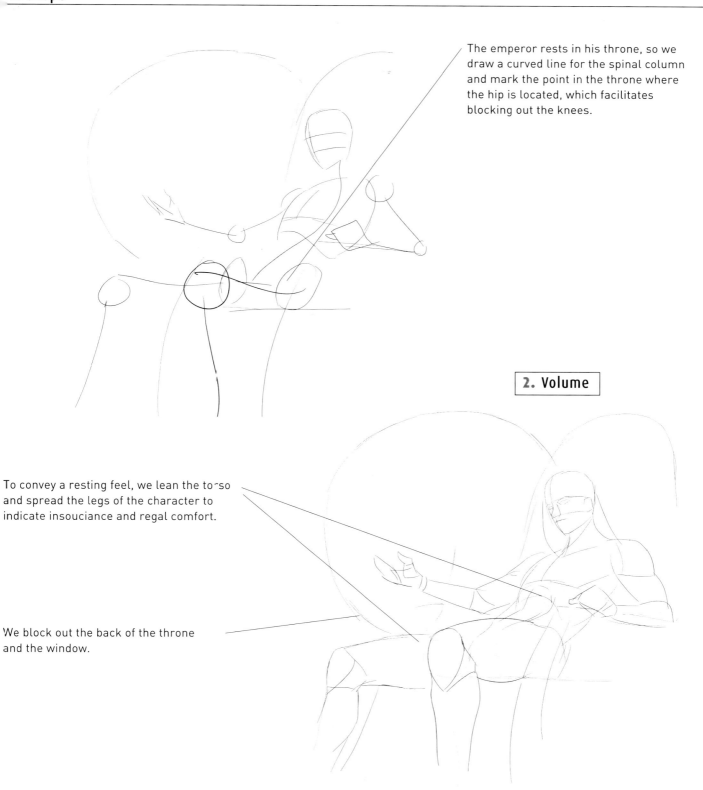

The emperor rests in his throne, so we draw a curved line for the spinal column and mark the point in the throne where the hip is located, which facilitates blocking out the knees.

2. Volume

To convey a resting feel, we lean the torso and spread the legs of the character to indicate insouciance and regal comfort.

We block out the back of the throne and the window.

The secret of getting a pose to show what we really want is in the little details. In this case, we draw a subtle smile. The long straight hair hangs heavily and reinforces the previous idea.

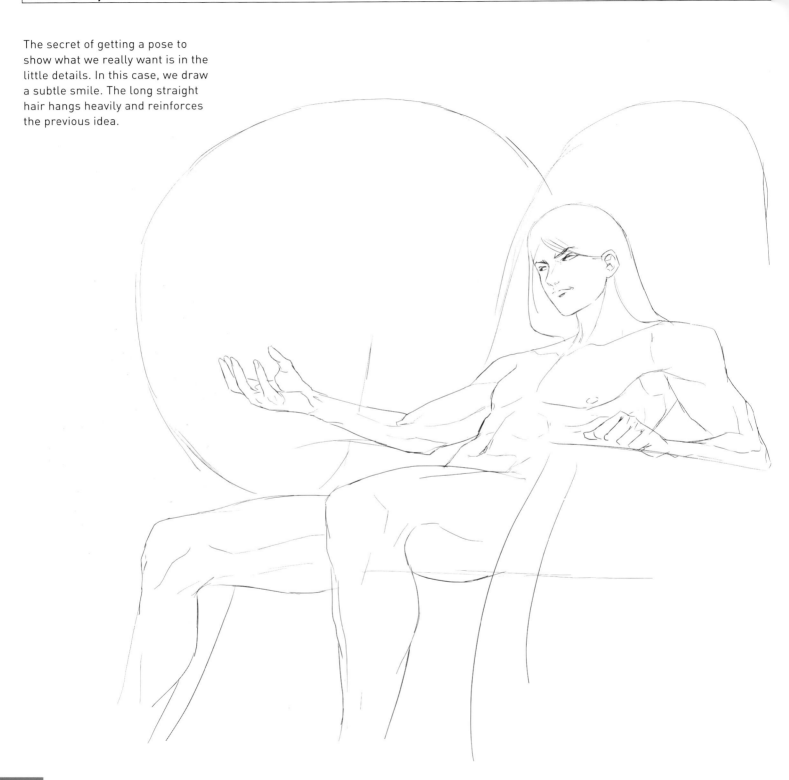

4. Clothes

We define the clothes with simple forms. We add little armor pieces that give the character some military touches mixed with aristocratic details, such as the large shoulder pads, the precious stone embroideries, and the head decorations.

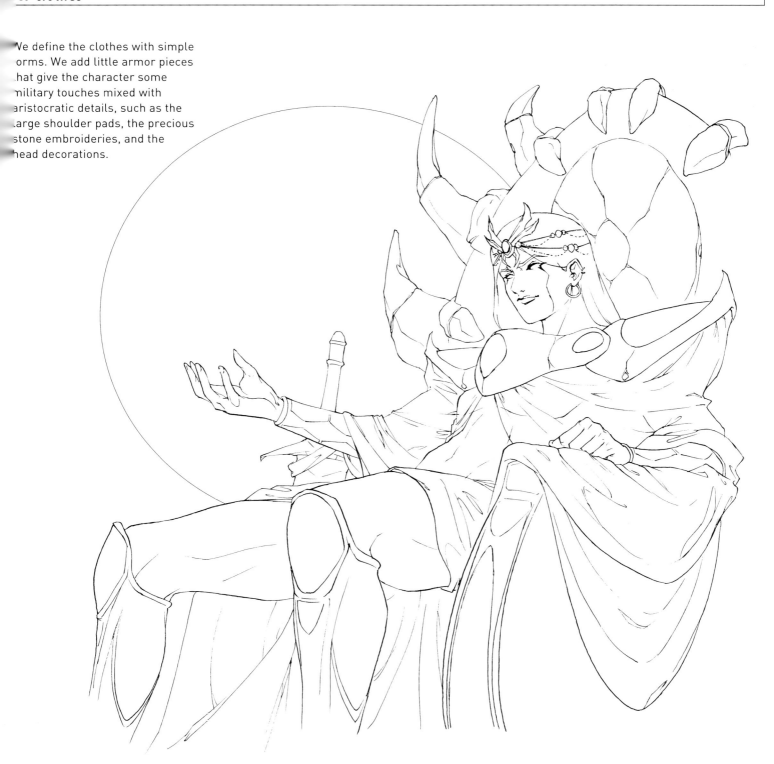

To achieve the highlight effects on the metals and the glass it is advisable to use very contrasting tones. We opt for lighter and brighter colors where we want to capture the reflection of light.

Source of light

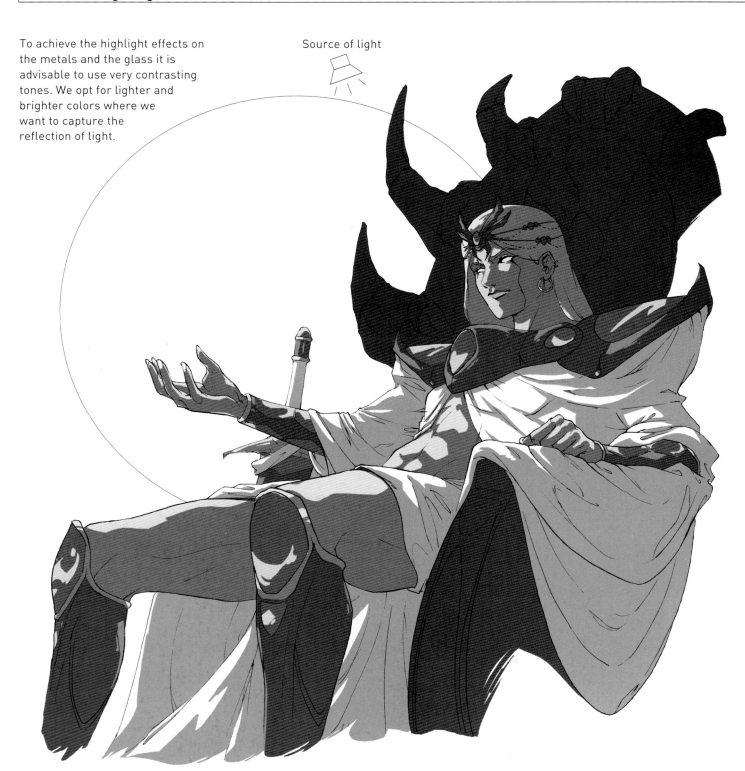

n outer space, black and dark
lue predominate, which may
esult in a dull illustration. What
ve actually opt for is a wide
chromatic variety, which is
musing and even
unconventional.

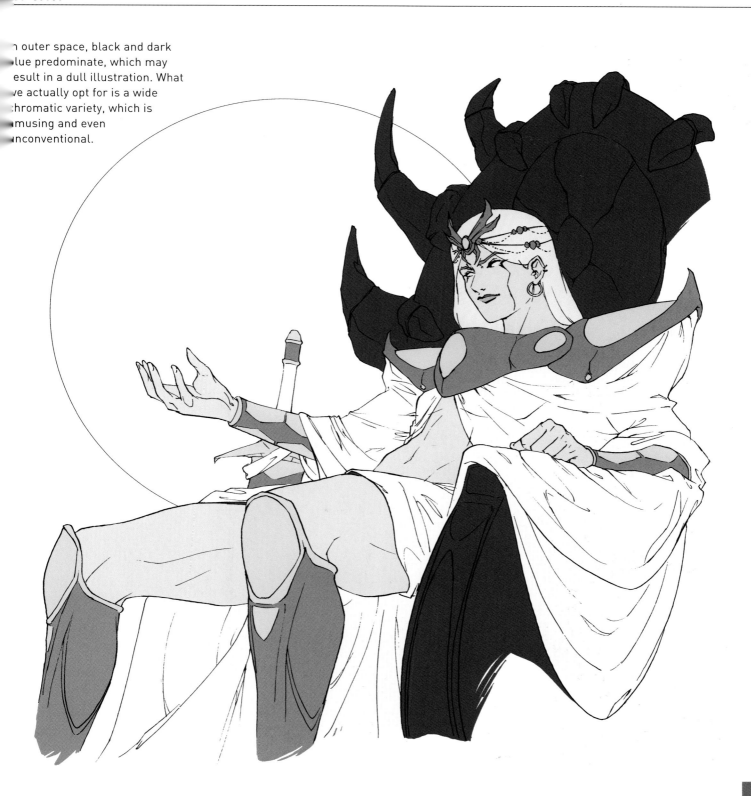

On the semi-translucent fabric that covers our character, we apply very subdued tones and a shadow, not too contrasting, to achieve this transparency effect. On the armor and on the precious stones, we use high contrast.

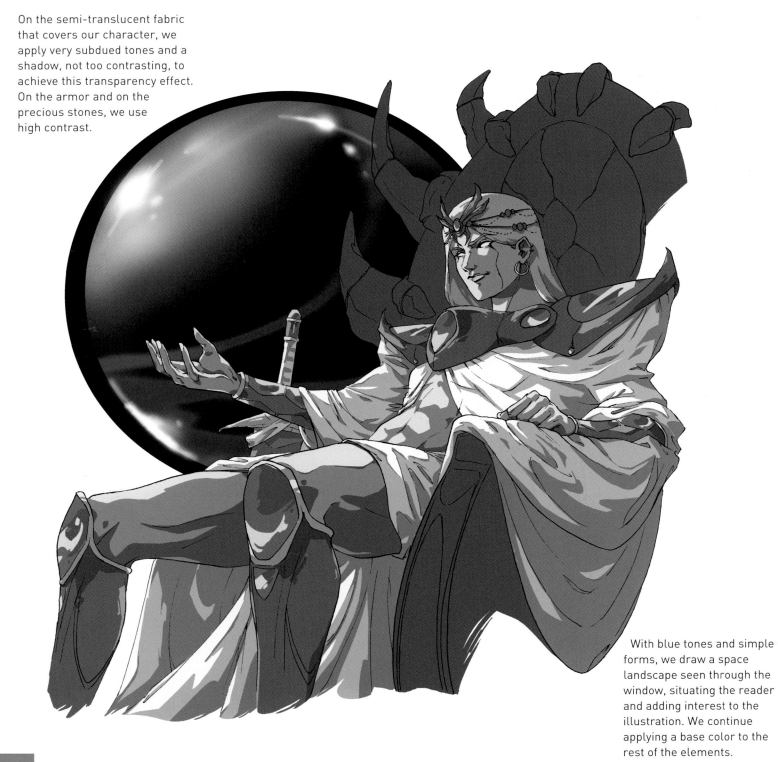

With blue tones and simple forms, we draw a space landscape seen through the window, situating the reader and adding interest to the illustration. We continue applying a base color to the rest of the elements.

8. Finishing Touches

We render the throne and blend the different blue tonalities to achieve a texture similar to marble. Finally, we add a nebula in the space landscape and white highlights on the precious stones of the armor.

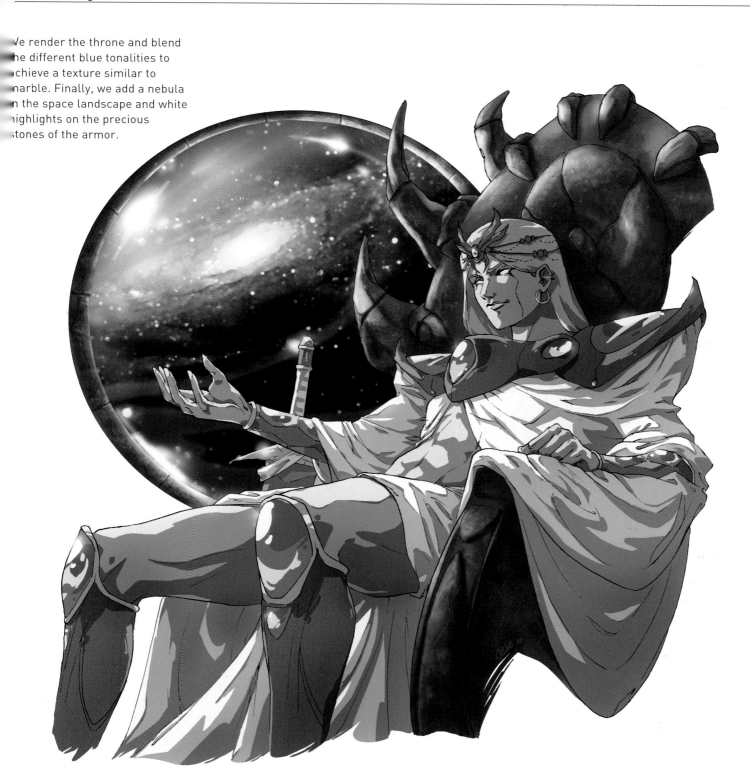

VAMPIRE LORD

Mysterious and seductive, the vampire is the protagonist in novels and horror stories from Romanticism. This character combines contradictory traits, although in manga he is usually given an androgynous aspect: soft facial features and white skin. His personality is very cold except in moments in which he hears the call of blood and shows himself fierce and impatient. Nowadays the vampires in the movies from Hammer Productions have been abandoned, while the aesthetics as well as the personality of Bram Stoker's *Dracula*, much more stylized, has been revived. *Vampire Hunter D* is a clear example of this.

1. Shape

The fact that our composition includes two characters forces us to pose their bodies so that they appear as natural as possible.

We pay special attention to the curvature of the girl's back.

2. Volume

In this step, greatest importance is given to the physique of the characters. The physique of the vampire is much more forcefully constructed than that of his victim. We emphasize clothing, intuitively sketching the lines that will become his costume.

We build the bodies and pay special attention to the visible parts, such as the vampire's hand. We draw sinuous and provocative curves for the young woman. Notice the girl's sharp chin.

4. Clothes

We research Victorian era clothing, decorating the girl's dress with lace or flounce for elegance. One must be careful about how the cloth hangs: it is different drawing a thick velvet dress as opposed to a silk handkerchief.

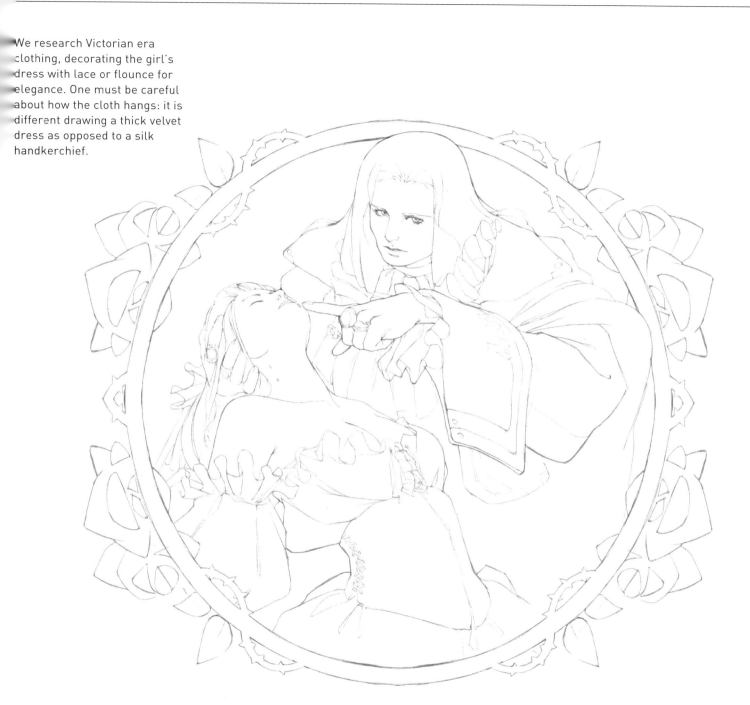

The light source is located in the top front of the illustration so that the light bathes the characters more dramatically than normal. This way we achieve greater chiaroscuro.

Source of light

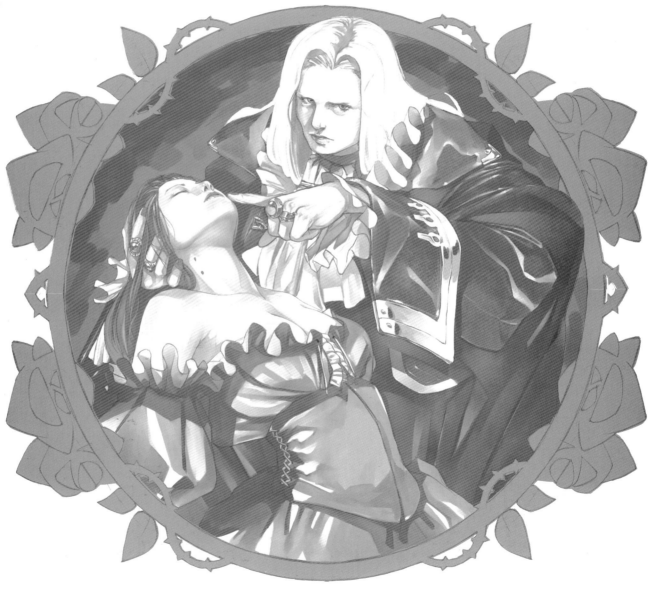

We choose a color palette that
ranges from earth tones to oxide
colors to give the illustration a
classic feel. We mark the highlights,
the shadows, and some medium
tones that we will further develop.

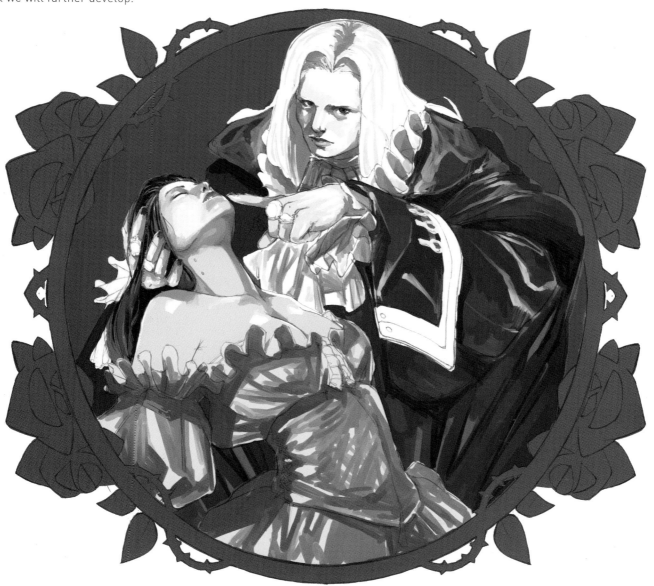

We shall focus on the lighting, which will grow in intensity. We give the characters' skin a soft texture, similar to that of porcelain. We shall pay special attention to the play of light over the folds of fabric on the costumes.

We treat separately the color masses of the different surfaces: the character's hair, his wardrobe, his skin. In this phase of the process we add the medium tones that we will polish in the last step.

We focus on details: the pattern printed on the girl's dress and the background. Also, we add textures. If we want, we can further develop the depth of the shading and lighting.

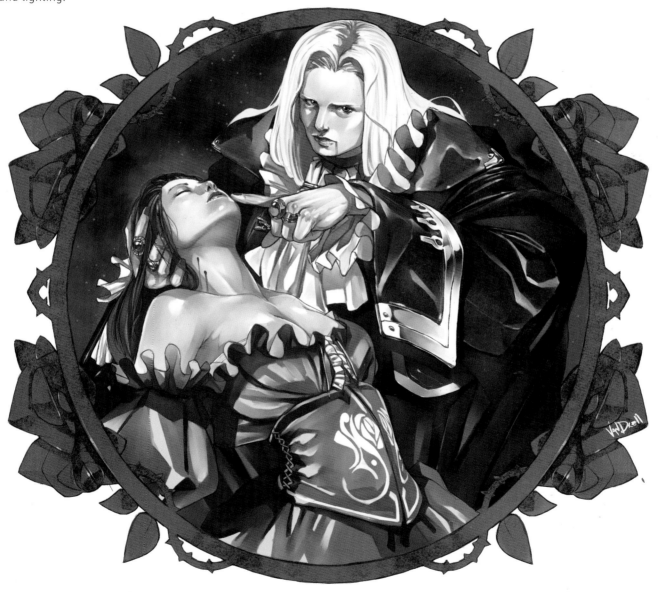

POST-APOCALYPTIC PUNK

Post-apocalyptic punk is a science fiction sub-genre in manga. These stories usually deal with the death of established regimes and the rise of others, chaotic and savage, which force people to fight in order to survive. All laws have disappeared to become just one rule: survival of the fittest. The tales are set in a devastated and violent world, where strength is the instrument for domination used by people, mutants, and cyborgs. This type of manga is influenced by the punk aesthetics and the stereotypes from movies of the eighties such as *Mad Max*.

1. Shape

Our character leans forward in a threatening posture. His back is arched, so we draw a curve to indicate the position of the spine.

We tilt the pelvis and draw forward one of his legs since the character is walking.

2. Volume

With a succession of cylinders, we form the left hand and geometrically quickly sketch the rest of the body to verify the size, establishing an idea of the character's proportions.

We develop the lines of the sketch to achieve a good rendition of the anatomy. He is a character, a brute, incredibly strong and almost savage, so we make use of hypertrophy to draw his muscles so they don't seem human.

4. Clothes

We combine fine and thick lines to achieve a clean line. We dress our character to look very aggressive, with spikes and a mask inspired by the aesthetics of the eighties movies. Also, we draw a mechanical arm.

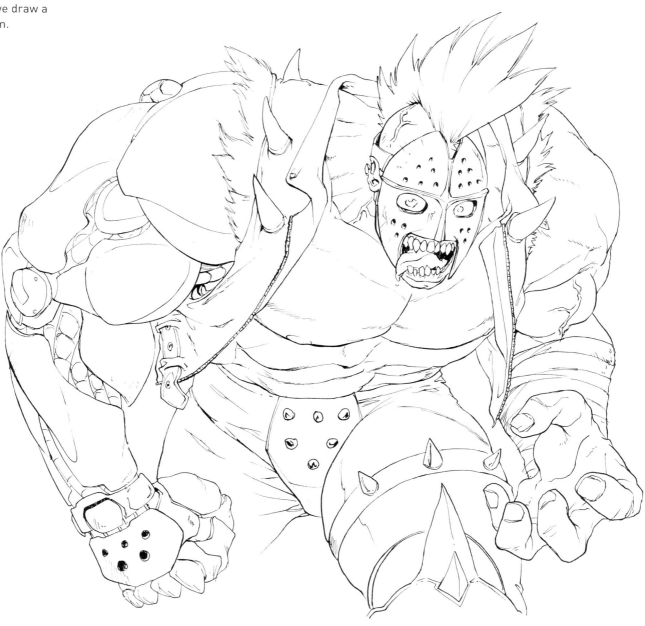

The light is from directly above, which puts parts of the character in the dark. However, the areas that the light hits call the reader's attention and stand out more than the rest.

Source of light

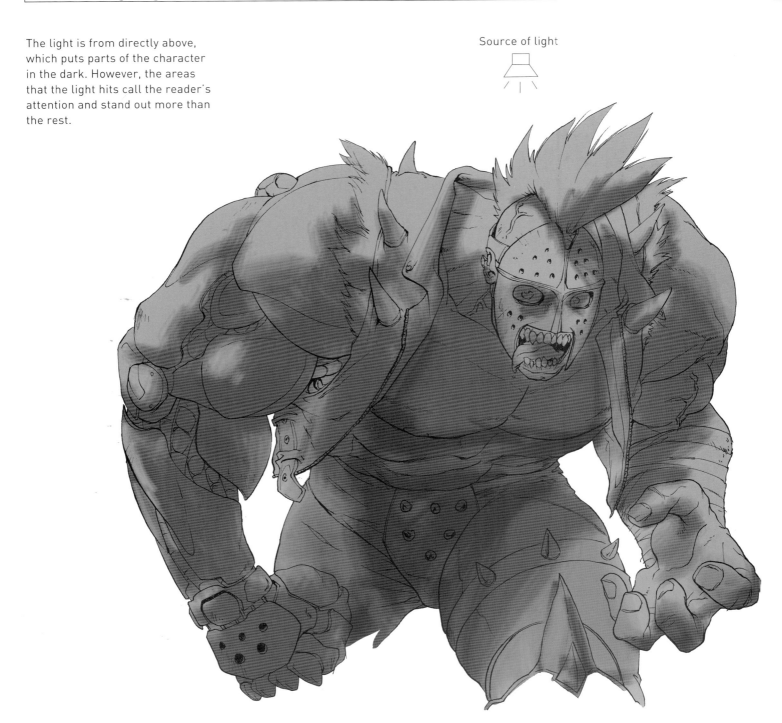

In this drawing we have not started with a white base but from a colored one, in this case a very flat dark purple, which begins the illustration. We add more colors and we use them to model our character.

We apply some color to the Mohawk hairstyle and to the hair stitched on the vest. These are the only two details that bring color (and greater personality) to our character.

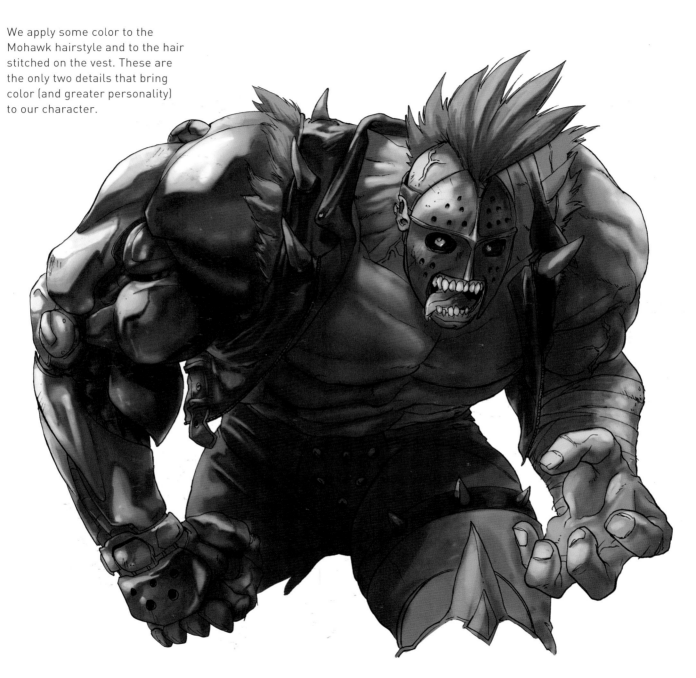

The posture and lighting combination is intended to show the character appearing from the dark, adding a feeling of mystery and anxiety to the illustration.

We apply more shadow tones to reinforce the twilight areas and render with lighter tones the areas where the light is reflected to create greater contrast. We polish the combination of colors and highlights on the metallic arm.

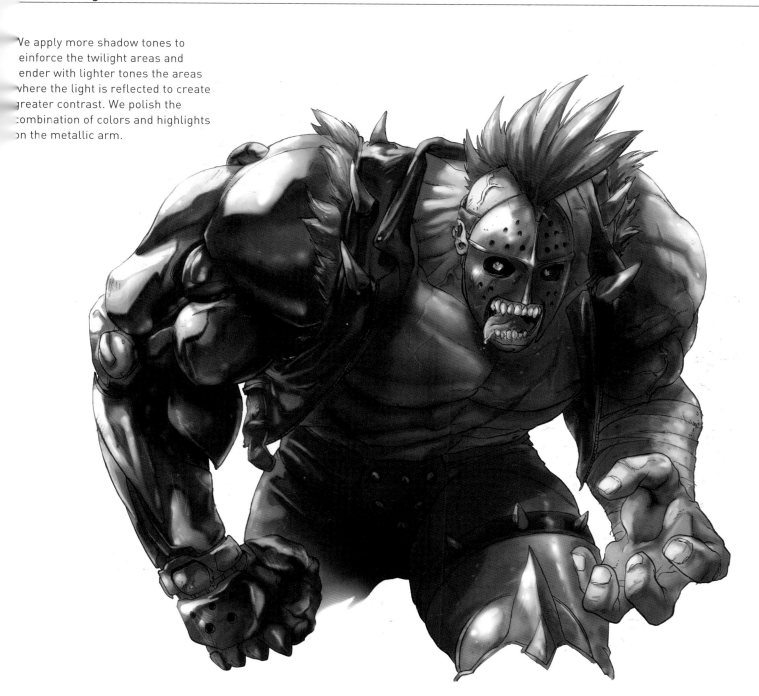

MAD DOCTOR

This malevolent genius, capable of the worst, extravagant and sometimes ridiculous, is usually the protagonist in terrible tragedies or the cause of other people's misfortunes. Bitter enemy of humanity, he never tires from inventing tremendous artifacts to satisfy his own longing for power: from malevolent robots to bombs capable of reducing everything to dust. Fortunately, there is always some hero willing to stop him. He is generally created by another rival scientist. We can find some examples of this kind of character in *Tatsujin 28*, *Mazinger Z* and *Astro Boy*, or more recently, Dr. Willy from the *Megaman* saga and Robotnick from the *Sonic* saga.

We opt to give the character a somewhat puppet aspect without employing the superdeformed aesthetic.

We use proportions similar to a child and exaggerate elements such as the hands, the feet, and the head.

2. Volume

We provide the wicked figure with volumes according to what was done in the previous step, but taking into account that these will also serve as base to draw the clothes.

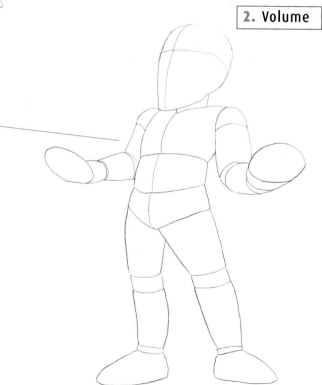

We emphasize the face of the
doctor, which needs to show his
principal distinctive traits:
madness, vanity, and cockiness.
To accentuate his personality
even further we have him make a
very expressive hand gesture.

4. Clothes

The attire consists of the typical doctor's white coat, a tie, and even details such as his official identification. Around him robots of simple character reinforce the personality of the protagonist.

One single source of light is sufficient because the scene is not framed within a specific scenario. To bring out the synthetic material used in the fabrication of the robots, we pay special attention to the highlights on their surfaces.

Source of light

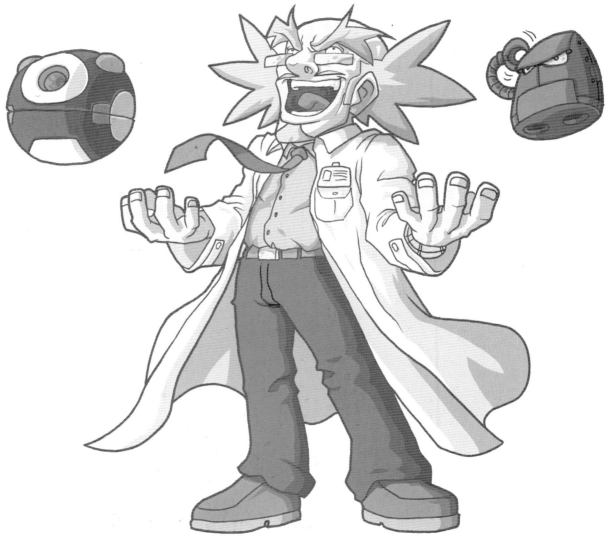

The use of light tones and pure basic colors permits a very simple rendition of the illustration, which might be associated with an infantile style.

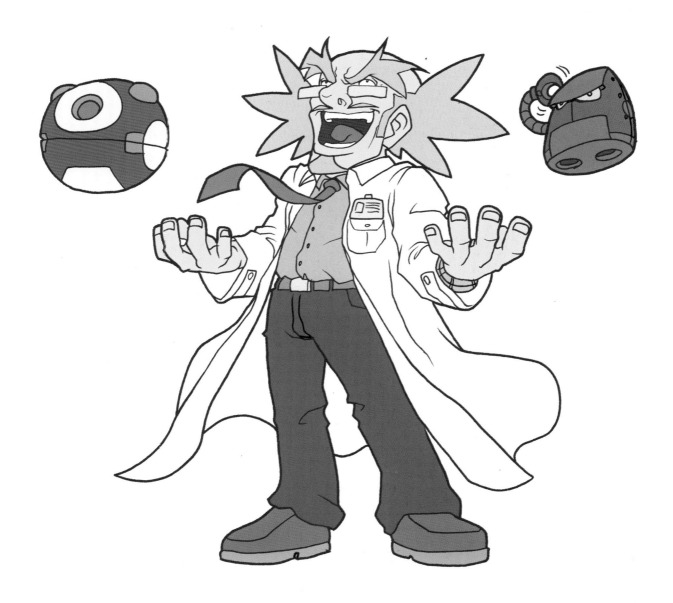

Because this illustration's most important aspect is the expression of the character, the colors are very simple. The greatest degree of detail falls on the facial features of the mad doctor.

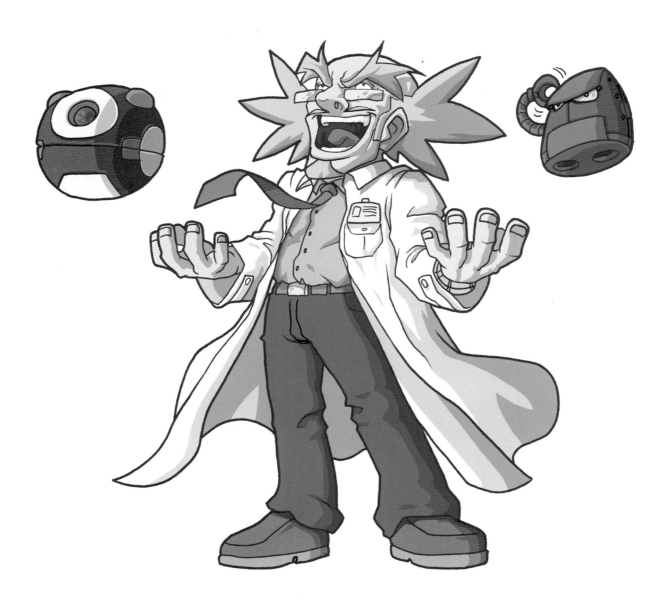

To complete the illustration we add a generic background that frames the drawing without showing anything clearly. The objective here is to ensure that the character does not float.

DARK ARMOR

Born from suffering and resentment, this type of warrior is blameworthy. Their hearts are dark like their splendid armor, and their only aim is vengeance. They satisfy their thirst for evil to achieve interior peace, knowing that in the long term they will pay a high price in hell. These warriors are practically indestructible, capable of confronting any threat without ever making a kink in their armor. But they suffer enormously and this makes them the perfect characters to illustrate the conflicted morality of the warrior. An example is Siegfried, from the video games saga *SoulCalibur*, or Gatsu, from *Berserk*.

1. Shape

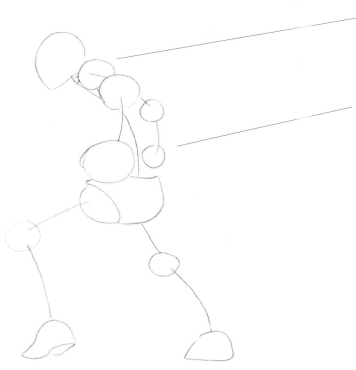

We focus on the main character's figure and we ignore for now the rest of the elements.

We trace the curved line of the back and sketch the main lines that frame the posture of the warrior.

2. Volume

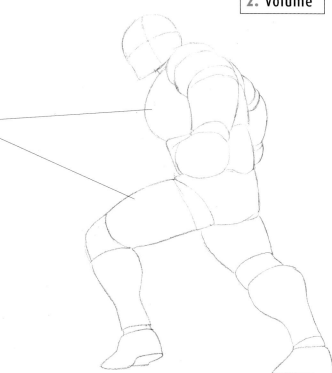

We provide the character with heavy and robust volumes so that in the next step the malicious-looking armor can be sketched out appropriately.

A warrior, whether he is a gentleman, a guerrilla fighter, or a barbarian, is usually muscular and robust, toughened by a life of fights and physical exercise. His anatomy, therefore, must be heavy and suggest physical strength.

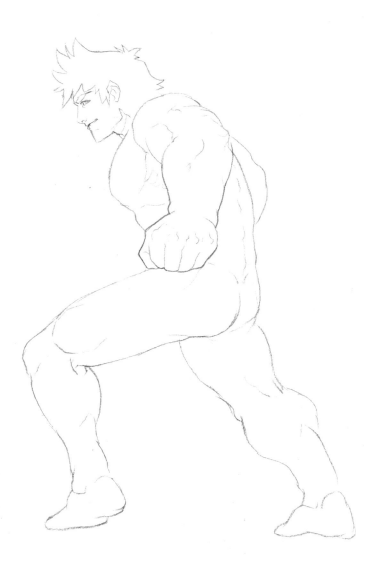

4. Clothes

We opt for an integral armor. Armor is usually very difficult to draw due to the minuscule details and the complexity of its forms, so it is recommended to find a visual reference to facilitate the task.

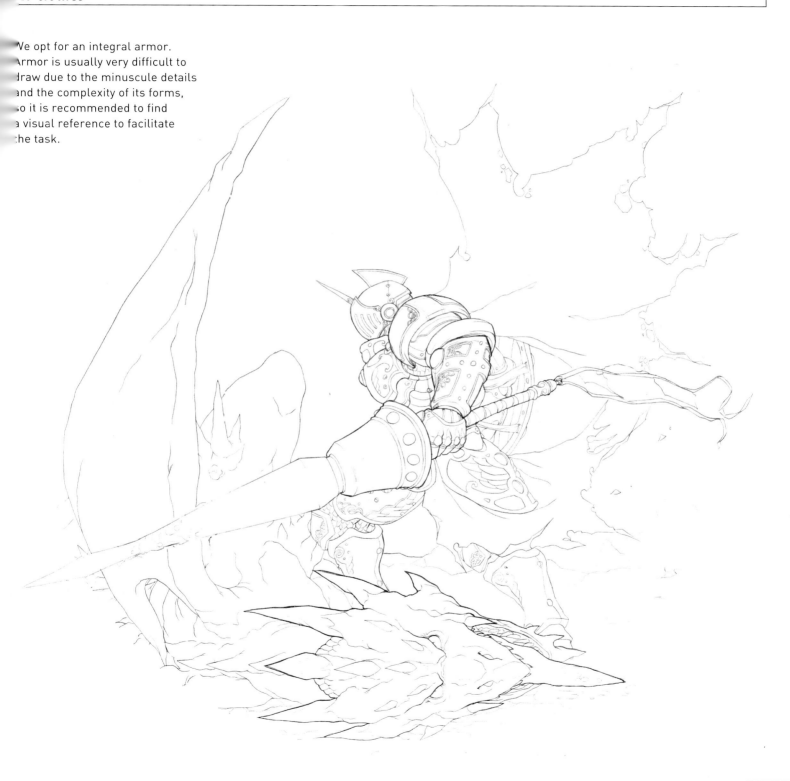

In the image background, an intense light emerges from the ground and dies off in the dark clouds in the sky. Because of this, we can differentiate the elements of the illustration with no need to draw an outline in a lighter color.

Source of light

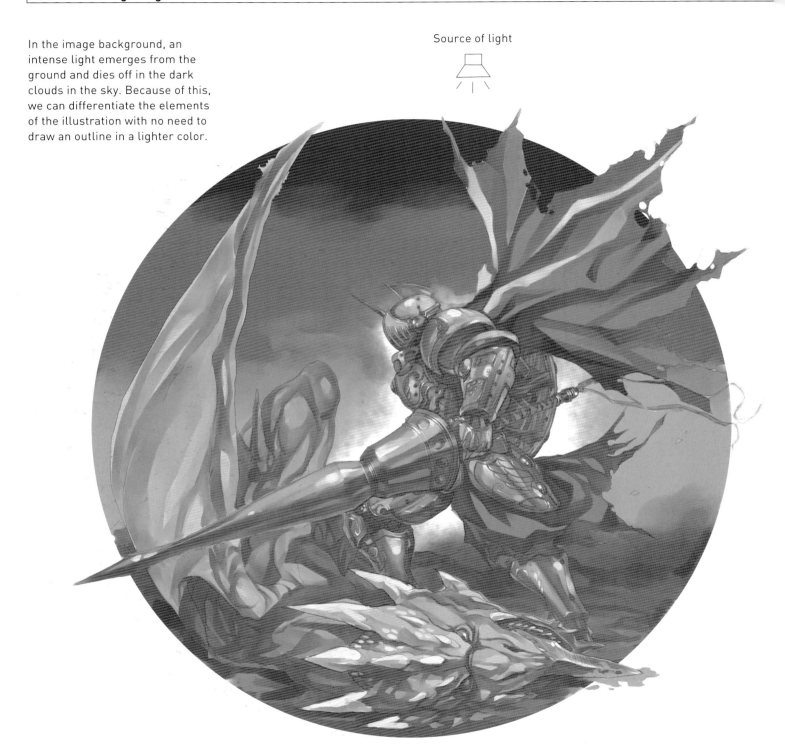

In this illustration of sinister overtone, the predominant range is the earthy colors. We draw the two characters in different colors to clearly differentiate one from the other.

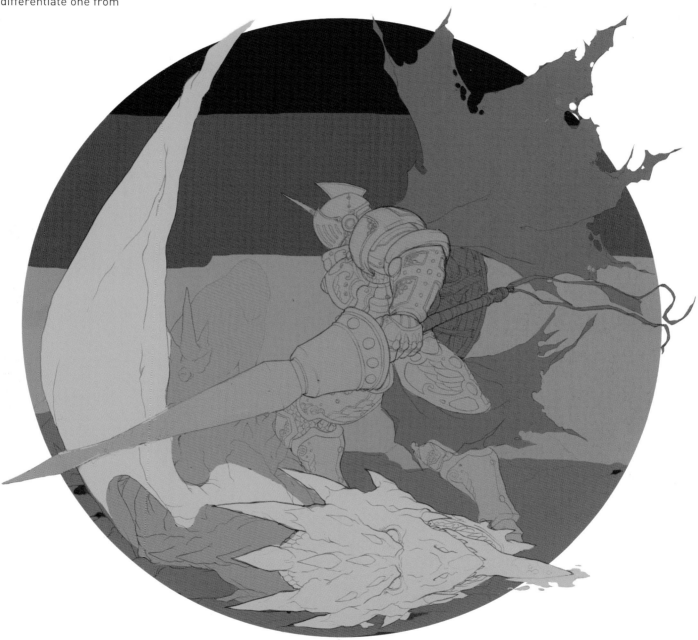

When painting the armor, it is important to correctly represent the way the light hits the metallic surface. To better differentiate the figures, we select red shades for the armor, and green and yellow for the dragon.

8. Finishing Touches

We blend the color and create the different textures. We finish the background by adding a greater level of detail. We draw the veins in the dragon's wings and the blood that bathes the spear.

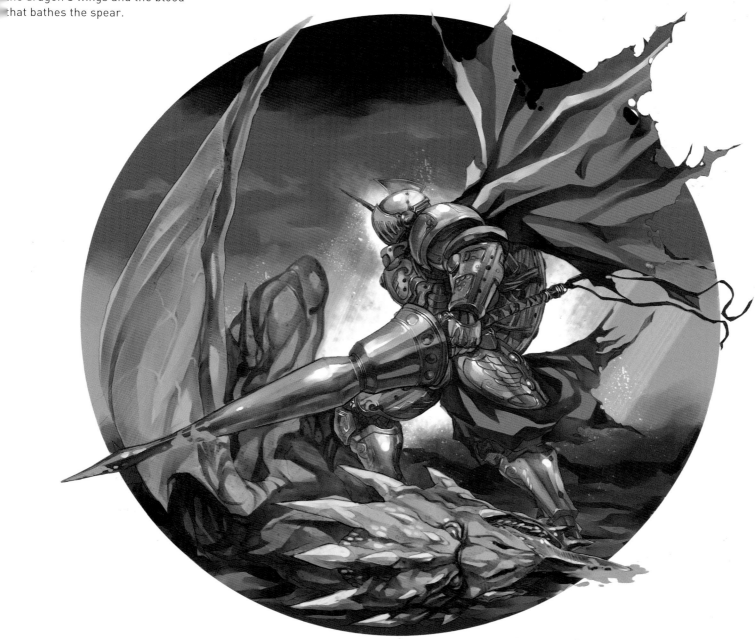

Acknowledgments:
To those who take part or will at some point at Ikari Studio.